Eyewitnessing

Eyewitnessing

The Uses of Images as Historical Evidence

Peter Burke

CORNELL UNIVERSITY PRESS
ITHACA, NEW YORK

In memory of Bob Scribner

First published in the United States of America
in 2001 by Cornell University Press
512 East State Street, Ithaca, NY 14850

Originally published in Great Britain in 2001 by
Reaktion Books, London,
in the Picturing History Series,
edited by Peter Burke, Sander L. Gilman,
Ludmilla Jordanova and Roy Porter

Copyright © Peter Burke 2001

ISBN 0-8014-3968-X

Series design by Humphrey Stone
Printed and bound in Great Britain by
Biddles Limited, Guildford and King's Lynn

Librarians: A CIP catalog record for this book is available from the
Library of Congress

Contents

Preface and Acknowledgements 7

Introduction 9

1 Photographs and Portraits 21

2 Iconography and Iconology 34

3 The Sacred and the Supernatural 46

4 Power and Protest 59

5 Material Culture through Images 81

6 Views of Society 103

7 Stereotypes of Others 123

8 Visual Narratives 140

9 From Witness to Historian 157

10 Beyond Iconography? 169

11 The Cultural History of Images 178

References 191

Select Bibliography 205

Photographic Acknowledgements 215

Index 217

Preface and Acknowledgements

A Chinese painter of bamboo is said to have been advised by a colleague to study the bamboo for many days, but to complete the painting in a few minutes. This book was written relatively quickly, but my preoccupation with the subject goes back more than thirty years, when I was studying the rise of a sense of anachronism in European culture, and realized that while texts might not raise the question whether the past was remote or distant, painters could not avoid the issue and had to decide whether to paint Alexander the Great (say) in the costume of their own time or in something different. Unfortunately the series for which I was writing at the time did not include illustrations.

Since that time I have had many opportunities to use images as historical evidence and even to teach a course on the subject to first-year Cambridge undergraduates. Out of that course, devised and taught with the late Bob Scribner, comes this book, a contribution to a series of which Bob was one of the editors. We had hoped to write a book of this kind together and I now dedicate it to his memory.

I should like to thank my wife Maria Lúcia, who has taught me the meaning of the phrase 'my best critic', together with Stephen Bann and Roy Porter for their constructive comments on the first draft of this book, and José García González for drawing my attention to Diego de Saavedra Fajardo's reflections on political horsemanship.

Introduction: The Testimony of Images

Ein Bild sagt mehr als 1000 Worte [A picture says more than a thousand words].
KURT TUCHOLSKY

This book is primarily concerned with the use of images as historical evidence. It is written both to encourage the use of such evidence and to warn potential users of some of the possible pitfalls. In the last generation or so, historians have widened their interests considerably to include not only political events, economic trends and social structures but also the history of mentalities, the history of everyday life, the history of material culture, the history of the body and so on. It would not have been possible for them to carry out research in these relatively new fields if they had limited themselves to traditional sources such as official documents, produced by administrations and preserved in their archives.

For this reason, increasing use is being made of a broader range of evidence, in which images have their place alongside literary texts and oral testimonies. Take the history of the body, for example. Pictures are a guide to changing ideas of sickness and health, and they are even more important as evidence of changing standards of beauty, or the history of the preoccupation with personal appearance on the part of men and women alike. Again, the history of material culture, discussed in Chapter 5 below, would be virtually impossible without the testimony of images. Their testimony also makes an important contribution to the history of mentalities, as Chapters 6 and 7 will try to demonstrate.

The Invisibility of the Visual?

It may well be the case that historians still do not take the evidence of images seriously enough, so that a recent discussion speaks of 'the

invisibility of the visual'. As one art historian puts it, 'historians … prefer to deal with texts and political or economic facts, not the deeper levels of experience that images probe', while another refers to the 'condescension towards images' which this implies.[1]

Relatively few historians work in photographic archives, compared to the numbers who work in repositories of written and typewritten documents. Relatively few historical journals carry illustrations, and when they do, relatively few contributors take advantage of this opportunity. When they do use images, historians tend to treat them as mere illustrations, reproducing them in their books without comment. In cases in which the images are discussed in the text, this evidence is often used to illustrate conclusions that the author has already reached by other means, rather than to give new answers or to ask new questions.

Why should this be the case? In an essay describing his discovery of Victorian photographs, the late Raphael Samuel described himself and other social historians of his generation as 'visually illiterate'. A child in the 1940s, he was and remained, in his own phrase, 'completely pre-televisual'. His education, in school and university alike, was a training in reading texts.[2]

All the same, a significant minority of historians were already using the evidence of images at this time, especially the specialists in periods where written documents are sparse or non-existent. It would be difficult indeed to write about European prehistory, for instance, without the evidence of the cave paintings of Altamira and Lascaux, while the history of ancient Egypt would be immeasurably poorer without the testimony of tomb paintings. In both cases, images offer virtually the only evidence of social practices such as hunting. Some scholars working on later periods also took images seriously. For example, historians of political attitudes, 'public opinion' or propaganda have long been using the evidence of prints. Again, a distinguished medievalist, David Douglas, declared nearly half a century ago that the Bayeux Tapestry was 'a primary source for the history of England' which 'deserves to be studied alongside the accounts in the *Anglo-Saxon Chronicle* and in William of Poitiers'.

The employment of images by a few historians goes back much further. As Francis Haskell (1928–2000) pointed out in *History and its Images*, the paintings in the Roman catacombs were studied in the seventeenth century as evidence of the early history of Christianity (and in the nineteenth century, as evidence for social history).[3] The Bayeux Tapestry (illus. 78) was already taken seriously as a historical source by scholars in the early eighteenth century. In the middle of

the century, a series of paintings of French seaports by Joseph Vernet (to be discussed below, Chapter 5), was praised by a critic who remarked that if more painters followed Vernet's example, their works would be useful to posterity because 'in their paintings it would be possible to read the history of manners, of arts and of nations'.[4]

The cultural historians Jacob Burckhardt (1818–1897) and Johan Huizinga (1872–1945), amateur artists themselves, writing respectively about the Renaissance and the 'autumn' of the Middle Ages', based their descriptions and interpretations of the culture of Italy and the Netherlands on paintings by artists such as Raphael and van Eyck as well as on texts from the period. Burckhardt, who wrote about Italian art before turning to the general culture of the Renaissance, described images and monuments as 'witnesses of past stages of the development of the human spirit', objects 'through which it is possible to read the structures of thought and representation of a given time'.

As for Huizinga, he gave his inaugural lecture at Groningen University in 1905 on 'The Aesthetic Element in Historical Thought', comparing historical understanding to 'vision' or 'sensation' (including the sense of direct contact with the past), and declaring that 'What the study of history and artistic creation have in common is a mode of forming images.' Later on, he described the method of cultural history in visual terms as 'the mosaic method'. Huizinga confessed in his autobiography that his interest in history was stimulated by collecting coins in his boyhood, that he was drawn to the Middle Ages because he visualized that period as 'full of chivalrous knights in plumed helmets', and that his turn away from oriental studies towards the history of the Netherlands was stimulated by an exhibition of Flemish paintings in Bruges in 1902. Huizinga was also a vigorous campaigner on behalf of historical museums.[5]

Another scholar of Huizinga's generation, Aby Warburg (1866–1929), who began as an art historian in the style of Burckhardt, ended his career attempting to produce a cultural history based on images as well as texts. The Warburg Institute, which developed out of Warburg's library, and was brought from Hamburg to London after Hitler's rise to power, has continued to encourage this approach. Thus the Renaissance historian Frances Yates (1899–1981), who began to frequent the Institute in the late 1930s, described herself as being 'initiated into the Warburgian technique of using visual evidence as historical evidence'.[6]

The evidence of pictures and photographs was also employed in the 1930s by the Brazilian sociologist-historian Gilberto Freyre

(1900–1987), who described himself as a historical painter in the style of Titian and his approach to social history as a form of 'impressionism', in the sense of an 'attempt to surprise life in movement'. Following in Freyre's tracks, an American historian of Brazil, Robert Levine, has published a series of photographs of life in Latin America in the late nineteenth and early twentieth centuries with a commentary that not only locates the photographs in context but discusses the major problems raised by the use of this kind of evidence.[7]

Images were the starting-point for two important studies by the self-styled 'Sunday historian' Philippe Ariès (1914–1982), a history of childhood and a history of death, in both of which visual sources were treated as 'evidence of sensibility and life', on the same basis as 'literature and documents in archives'. The work of Ariès will be discussed in more detail in a later chapter. His approach was emulated by some leading French historians in the 1970s, among them Michel Vovelle, who has worked both on the French Revolution and the old regime which preceded it, and Maurice Agulhon, who is especially concerned with nineteenth-century France.[8]

This 'pictorial turn', as the American critic William Mitchell has called it, is also visible in the English-speaking world.[9] It was in the middle of the 1960s, as he confesses, that Raphael Samuel and some of his contemporaries became aware of the value of photographs as evidence for nineteenth-century social history, helping them construct a 'history from below' focusing on the everyday life and experiences of ordinary people. However, taking the influential journal *Past and Present* as representative of new trends in historical writing in the English-speaking world, it comes as something of a shock to discover that from 1952 to 1975, none of the articles published there included images. In the 1970s, two illustrated articles were published in the journal. In the 1980s, on the other hand, the number increased to fourteen.

That the 1980s were a turning-point in this respect is also suggested by the proceedings of a conference of American historians held in 1985 and concerned with 'the evidence of art'. Published in a special issue of the *Journal of Interdisciplinary History*, the symposium attracted so much interest that it was quickly republished in book form.[10] Since then, one of the contributors, Simon Schama, has become well known for his use of visual evidence in studies ranging from an exploration of seventeenth-century Dutch culture, *The Embarrassment of Riches* (1987), to a survey of western attitudes to landscape over the centuries, *Landscape and Memory* (1995).

The 'Picturing History' series itself, which was launched in 1995,

and includes the volume you are now reading, is further evidence of the new trend. In the next few years it will be interesting to see how historians from a generation which has been exposed to computers, as well as television, virtually from birth and has always lived in a world saturated with images will approach the visual evidence for the past.

Sources and Traces

Traditionally, historians have referred to their documents as 'sources', as if they were filling their buckets from the stream of Truth, their stories becoming increasingly pure as they move closer to the origins. The metaphor is a vivid one but it is also misleading, in the sense of implying the possibility of an account of the past which is uncontaminated by intermediaries. It is of course impossible to study the past without the assistance of a whole chain of intermediaries, including not only earlier historians but also the archivists who arranged the documents, the scribes who wrote them and the witnesses whose words were recorded. As the Dutch historian Gustaaf Renier (1892–1962) suggested half a century ago, it might be useful to replace the idea of sources with that of 'traces' of the past in the present.[11] The term 'traces' refers to manuscripts, printed books, buildings, furniture, the landscape (as modified by human exploitation), as well as to many different kinds of image: paintings, statues, engravings, photographs.

The uses of images by historians cannot and should not be limited to 'evidence' in the strict sense of the term (as discussed in particular detail in Chapters 5, 6 and 7). Room should also be left for what Francis Haskell has called 'the impact of the image on the historical imagination'. Paintings, statues, prints and so on allow us, posterity, to share the non-verbal experiences or knowledge of past cultures (religious experiences, for example, discussed in Chapter 3 below). They bring home to us what we may have known but did not take so seriously before. In short, images allow us to 'imagine' the past more vividly. As the critic Stephen Bann puts it, our position face-to-face with an image brings us 'face-to-face with history'. The uses of images in different periods as objects of devotion or means of persuasion, of conveying information or giving pleasure, allows them to bear witness to past forms of religion, knowledge, belief, delight and so on. Although texts also offer valuable clues, images themselves are the best guide to the power of visual representations in the religious and political life of past cultures.[12]

This book will therefore investigate the uses of different kinds of

image as what the lawyers call 'admissible evidence' for different kinds of history. The legal analogy has a point. After all, in the last few years, bank robbers, football hooligans and violent policemen have all been convicted on the evidence of videos. Police photographs of crime scenes are regularly used as evidence. By the 1850s, the New York Police Department had created a 'Rogue's Gallery' allowing thieves to be recognized.[13] Indeed, before 1800, French police records already included portraits in their personal files on major suspects.

The essential proposition this book seeks to support and illustrate is that images, like texts and oral testimonies, are an important form of historical evidence. They record acts of eyewitnessing. There is nothing new about this idea, as a famous image demonstrates, the so-called 'Arnolfini portrait' of a husband and wife in the National Gallery in London. The portrait is inscribed *Jan van Eyck fuit hic* (Jan van Eyck was here), as if the painter had acted as a witness to the couple's marriage. Ernst Gombrich has written about 'the eyewitness principle', in other words the rule which artists in some cultures have followed, from the ancient Greeks onwards, to represent what – and only what – an eyewitness could have seen from a particular point at a particular moment.[14]

In similar fashion, the phrase 'the eyewitness style' was introduced into a study of the paintings of Vittore Carpaccio (c. 1465–c. 1525), and some of his Venetian contemporaries, in order to refer to the love of detail these paintings display and the desire of artists and patrons for 'a painting that looked as truthful as possible, according to prevailing standards of evidence and proof'.[15] Texts sometimes reinforce our impression that an artist was concerned to give accurate testimony. For example, in an inscription on the back of his *Ride for Liberty* (1862), showing three slaves on horseback, man, woman and child, the American painter Eastman Johnson (1824–1906) described his painting as the record of 'a veritable incident in the Civil War, seen by myself'. Terms such as a 'documentary' or 'ethnographic' style have also been used to characterize equivalent images from later periods (below pp 19, 130, 138).

Needless to say, the use of the testimony of images raises many awkward problems. Images are mute witnesses and it is difficult to translate their testimony into words. They may have been intended to communicate a message of their own, but historians not infrequently ignore it in order to read pictures 'between the lines', and learn something that the artists did not know they were teaching. There are obvious dangers in this procedure. To use the evidence of images safely, let alone effectively, it is necessary – as in the case of other kinds of

source – to be aware of its weaknesses. The 'source criticism' of written documents has long formed an essential part of the training of historians. By comparison, the criticism of visual evidence remains undeveloped, although the testimony of images, like that of texts, raises problems of context, function, rhetoric, recollection (whether soon or long after the event), secondhand witnessing and so on. Hence some images offer more reliable evidence than others. Sketches, for example, drawn directly from life (illus. 1, 2), and freed

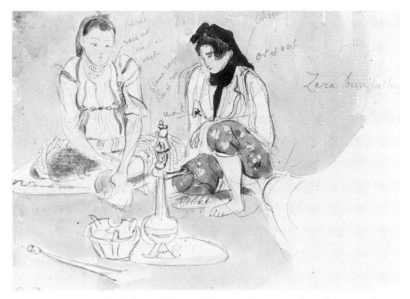

1 Eugène Delacroix, Sketch for *The Women of Algiers*, *c*. 1832, watercolour with traces of graphite. Musée du Louvre, Paris.

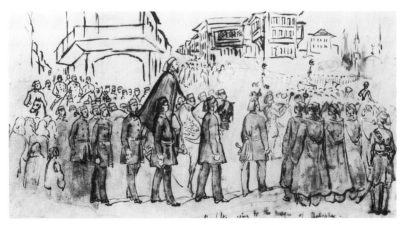

2 Constantin Guys, Watercolour sketch of the Sultan going to the Mosque, 1854. Private collection.

from the constraints of the 'grand style' (discussed in Chapter 8 below), are more trustworthy as testimonies than are paintings worked up later in the artist's studio. In the case of Eugène Delacroix (1798–1863), this point may be illustrated by the contrast between his sketch, *Two Seated Women*, and his painting, *The Women of Algiers* (1834), which looks more theatrical and, unlike the original sketch, makes references to other images.

To what extent, and in what ways, do images offer reliable evidence of the past? It would obviously be foolish to attempt a simple general answer to such a question. A sixteenth-century icon of the Virgin Mary and a twentieth-century poster of Stalin both tell historians something about Russian culture, but – despite certain intriguing similarities – there are obviously enormous differences both in what these two images tell us and in what they omit. We ignore at our peril the variety of images, artists, uses of images and attitudes to images in different periods of history.

Varieties of Image

This essay is concerned with 'images' rather than with 'art', a term which only began to be used in the West in the course of the Renaissance, and especially from the eighteenth century onwards, as the aesthetic function of images, at least in elite circles, began to dominate the many other uses of these objects. Irrespective of its aesthetic quality, any image may serve as historical evidence. Maps, decorated plates, ex-votos (illus. 16), fashion dolls and the pottery soldiers buried in the tombs of early Chinese emperors all have something to say to students of history.

To complicate the situation, it is necessary to take into account changes in the kind of image available in particular places and times, and especially two revolutions in image production, the rise of the printed image (woodcut, engraving, etching and so on) in the fifteenth and sixteenth centuries, and the rise of the photographic image (including film and television) in the nineteenth and twentieth. It would take a large book to analyse the consequences of these two revolutions in the detail they deserve, but a few general observations may be useful all the same.

For example, the appearance of images changed. In the early stages of the woodcut and the photograph alike, black and white images replaced coloured paintings. To speculate for a moment, it might be suggested, as has been suggested in the case of the transition from oral to printed messages, that the black and white image is, in

Marshall McLuhan's famous phrase, a 'cooler' form of communication than the more illusionistic coloured one, encouraging greater detachment on the part of the viewer. Again, printed images, like later photographs, could be made and transported much more rapidly than paintings, so that images of current events could reach viewers while the events were still fresh in the memory, a point which will be developed in Chapter 8 below.

Another important point to bear in mind in the case of both revolutions is that they made possible a quantum leap in the number of images available to ordinary people. Indeed, it has become difficult even to imagine how few images were in general circulation during the Middle Ages, since the illuminated manuscripts now familiar to us in museums or in reproductions were usually in private hands, leaving only altarpieces and frescos in churches visible to the general public. What were the cultural consequences of these two leaps?

The consequences of printing have commonly been discussed in terms of the standardization and the fixing of texts in permanent form, and similar points might be made about printed images. William M. Ivins Jr (1881–1961), a curator of prints in New York, made a case for the importance of sixteenth-century prints as 'exactly repeatable pictorial statements'. Ivins pointed out that the ancient Greeks, for instance, had abandoned the practice of illustrating botanical treatises because of the impossibility of producing identical images of the same plant in different manuscript copies of the same work. From the late fifteenth century, on the other hand, herbals were regularly illustrated with woodcuts. Maps, which began to be printed in 1472, offer another example of the way in which the communication of information by images was facilitated by the repeatability associated with the press.[16]

In the age of photography, according to the German Marxist critic Walter Benjamin (1892–1940) in a famous essay of the 1930s, the work of art changed its character. The machine 'substitutes a plurality of copies for a unique existence' and produces a shift from the 'cult value' of the image to its 'exhibition value'. 'That which withers in the age of mechanical reproduction is the aura of the work of art.' Doubts may be and have been raised about this thesis. The owner of a woodcut, for example, may treat it with respect as an individual image, rather than thinking of it as one copy among many. There is visual evidence, from seventeenth-century Dutch paintings of houses and inns, for example, showing that woodcuts and engravings were displayed on walls just as paintings were. More recently, in the age of the photograph, as Michael Camille has argued, reproduction of an

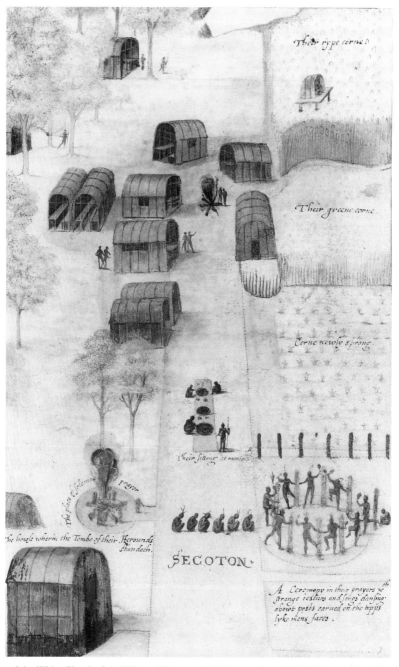

Their ripe corne t̃

Their greene corne

Corne newly sprong.

Their sitting at meate

The place of solemne
prayer

The house wherin the Tombe of their Herounds
standeth.

SECOTON

A Ceremony in their prayers w̃
strange gestures and songs dansīg
abowt posts carued on the topps
lyke mens faces.

3 John White, Sketch of the Village of Secoton, Virginia, *c.* 1585–7. British Museum, London.

image may actually increase its aura – just as repeated photographs add to the glamour of a film star rather than subtracting from it. If we take individual images less seriously than our ancestors did, a point that still remains to be proved, this may be the result not of reproduction in itself, but of the saturation of our world of experience by more and more images.[17]

'Study the historian before you begin to study the facts,' the author of the well-known textbook, *What is History?*, told his readers.[18] In similar fashion, one might advise anyone planning to utilize the testimony of images to begin by studying the different purposes of their makers. Relatively reliable, for example, are works that were made primarily as records, documenting the remains of ancient Rome, for instance, or the appearance or customs of exotic cultures. The images of the Indians of Virginia by the Elizabethan artist John White (fl. 1584–93), for example (illus. 3), were made on the spot, like the images of Hawaiians and Tahitians by the draughtsmen who accompanied Captain Cook and other explorers, precisely in order to record what had been discovered. 'War artists', sent to the field to portray battles and the life of soldiers on campaign (Chapter 8) and, active from the emperor Charles V's expedition to Tunis to the American intervention in Vietnam, if not later, are usually more reliable witnesses, especially in details, than their colleagues who work exclusively at home. We might describe works of the kinds listed in this paragraph as 'documentary art'.

All the same, it would be unwise to attribute to these artist-reporters an 'innocent eye' in the sense of a gaze which is totally objective, free from expectations or prejudices of any kind. Both literally and metaphorically, these sketches and paintings record a 'point of view'. In the case of White, for instance, we need to bear in mind that he was personally involved in the colonization of Virginia and may have tried to give a good impression of the place by omitting scenes of nakedness, human sacrifice and whatever might have shocked potential settlers. Historians using documents of this kind cannot afford to ignore the possibility of propaganda (Chapter 4), or that of stereotyped views of the 'Other' (Chapter 7), or to forget the importance of the visual conventions accepted as natural in a particular culture or in a particular genre such as the battle-piece (Chapter 8).

In order to support this critique of the innocent eye, it may be useful to take some examples where the historical testimony of images is, or at any rate appears to be, relatively clear and direct: photographs and portraits.

1 Photographs and Portraits

While photographs may not lie, liars may photograph.
LEWIS HINE

If you would like to understand the history of Italy completely,
you should look carefully at portraits ... In people's faces there
is always something of the history of their time to be read, if
one knows how to read it.
GIOVANNI MORELLI

The temptations of realism, more exactly of taking an image for reality,
are particularly seductive in the case of photographs and portraits. For
this reason these kinds of image will now be analysed in some detail.

Photographic Realism

From an early date in the history of photography, the new medium
was discussed as an aid to history. In a lecture delivered in 1888, for
example, George Francis urged the systematic collection of
photographs as 'the best possible picturing of our lands, buildings
and ways of living'. The problem for historians is whether, and to
what extent, these pictures can be trusted. It has often been said that
'the camera never lies'. There still remains a temptation in our 'snap-
shot culture', in which so many of us record our families and holidays
on film, to treat paintings as the equivalent of these photographs and
so to expect realistic representations from historians and artists alike.

Indeed, it is possible that our sense of historical knowledge has
been transformed by photography. As the French writer Paul Valéry
(1871–1945) once suggested, our criteria of historical veracity have
come to include the question, 'Could such and such a fact, as it is
narrated, have been photographed?' Newspapers have long been
using photographs as evidence of authenticity. Like television images,
these photographs make a powerful contribution to what the critic

Roland Barthes (1915–1980) has called the 'reality effect'. In the case of old photographs of cities, for example, especially when they are enlarged to fill a wall, the viewer may well experience a vivid sensation that he or she could enter the photograph and walk down the street.[1]

The problem with Valéry's question is that it implies a contrast between subjective narrative and 'objective' or 'documentary' photography. This view is widely shared, or at least it used to be. The idea of objectivity, put forward by early photographers, was supported by the argument that the objects themselves leave traces on the photographic plate when it is exposed to the light, so that the resulting image is not the work of human hands but of the 'pencil of nature'. As for the phrase 'documentary photography', it came into use in the 1930s in the USA (shortly after the phrase 'documentary film'), to refer to scenes from the everyday life of ordinary people, especially the poor, as seen through the lenses of, for instance, Jacob Riis (1849–1914), Dorothea Lange (1895–1965), and Lewis Hine (1874–1940), who studied sociology at Columbia University and called his work 'Social Photography'.[2]

However, these 'documents' (illus. 63, for example) need to be placed in context. This is not always easy in the case of photographs, since the identity of the sitters and the photographers is so often unknown, and the photographs themselves, originally – in many cases, at least – part of a series, have become detached from the project or the album in which they were originally displayed, to end up in archives or museums. However, in famous cases like the 'documents' made by Riis, Lange and Hine, something can be said about the social and political context of the photographs. They were made as publicity for campaigns of social reform and in the service of institutions such as the Charity Organisation Society, the National Child Labour Committee and the California State Emergency Relief Administration. Hence their focus, for instance, on child labour, on work accidents and on life in slums. (Photographs made a similar contribution to campaigns for slum clearance in England.) These images were generally designed to appeal to the sympathies of the viewers.

In any case, the selection of subjects and even the poses of early photographs often followed that of paintings, woodcuts and engravings, while more recent photographs quoted or alluded to earlier ones. The texture of the photograph also conveys a message. To take Sarah Graham-Brown's example, 'a soft sepia print can produce a calm aura of "things past"', while a black-and-white image may 'convey a sense of harsh "reality"'.[3]

The film historian Siegfried Kracauer (1889–1966) once compared Leopold von Ranke (1795–1886), for a long time the symbol of objective history, with Louis Daguerre (1787–1851), who was more or less his contemporary, in order to make the point that historians, like photographers, select which aspects of the real world to portray. 'All great photographers have felt free to select motif, frame, lens, filter, emulsion and grain according to their sensibilities. Was it otherwise with Ranke?' The photographer Roy Stryker had made the same essential point in 1940. 'The moment that a photographer selects a subject', he wrote, 'he is working upon the basis of a bias that is parallel to the bias expressed by a historian.'[4]

On occasion, photographers have gone well beyond mere selection. Before the 1880s, in the age of the tripod camera and twenty-second exposures, photographers composed scenes by telling people where to stand and how to behave (as in group photographs to this day), whether they were working in the studio or in the open air. They sometimes constructed their scenes of social life according to the familiar conventions of genre painting, especially Dutch scenes of taverns, peasants, markets and so on (Chapter 6). Looking back on the discovery of photographs by British social historians in the 1960s, Raphael Samuel commented somewhat ruefully on 'our ignorance of the artifices of Victorian photography', noting that 'much of what we reproduced so lovingly and annotated (as we believed) so meticulously was fake – painterly in origin and intention even if it was documentary in form'. For example, to create O. G. Rejlander's famous image of a shivering street urchin, the photographer 'paid a Wolverhampton boy five shillings for the sitting, dressed him up in rags and smudged his face with the appropriate soot'.[5]

Some photographers intervened more than others to arrange objects and people. For example, in the images she shot of rural poverty in the USA in the 1930s, Margaret Bourke-White (1904–1971), who worked for the magazines *Fortune* and *Life*, was more interventionist than Dorothea Lange. Again, some of the 'corpses' to be seen in photographs of the American Civil War (illus. 5) were apparently living soldiers who obligingly posed for the camera. The authenticity of the most famous photograph of the Spanish Civil War, Robert Capa's *Death of a Soldier*, first published in a French magazine in 1936 (illus. 4), has been challenged on similar grounds. For these and other reasons it has been argued that 'Photographs are never evidence of history: they are themselves the historical.'[6]

This is surely too negative a judgement: like other forms of evidence, photographs are both. They are particularly valuable, for

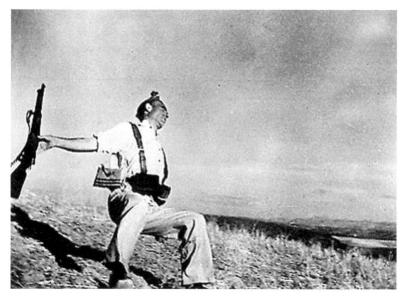

4 Robert Capa, *Death of a Soldier*, 1936, photograph.

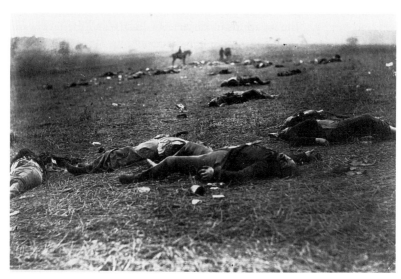

5 Timothy O'Sullivan (negative) and Alexander Gardner (positive), *A Harvest of Death, Gettysburg, July, 1863*, pl. 36 of Gardner's *Photographic Sketch Book of the War*, 2 vols (Washington, DC, 1865–6).

instance, as evidence of the material culture of the past (Chapter 5). In the case of Edwardian photographs, as the historical introduction to a book of reproductions has pointed out, 'we can see how the rich dressed, their posture and demeanour, the restrictiveness of Edwardian dress for women, the elaborate materialism of a culture which believed that wealth, status and property ought to be openly paraded'. The phrase 'candid camera', coined in the 1920s, makes a genuine point, even though the camera has to be held by someone and some photographers are more candid than others.

Source criticism is essential. As the art critic John Ruskin (1819–1900) perceptively observed, the evidence of photographs 'is of great use if you know how to cross-examine them'. A spectacular example of this kind of cross-examination is the use of aerial photography (originally developed as a means of reconnaissance in the First and Second World Wars), by historians, notably historians of medieval agriculture and monasticism. The aerial photograph, which 'combines the data of a photograph with that of a plan' and records variations in the surface of the land which are invisible to people on the ground, has revealed the arrangement of the strips of land cultivated by different families, the locations of deserted villages, and the layout of abbeys. It makes possible the reconnaissance of the past.[7]

The Portrait, Mirror or Symbolic Form?

As in the case of photographs, many of us have a strong impulse to view portraits as accurate representations, snapshots or mirror images of a particular sitter as he or she looked at a particular moment. This impulse needs to be resisted for several reasons. In the first place, the painted portrait is an artistic genre that, like other genres, is composed according to a system of conventions which changes only slowly over time. The postures and gestures of the sitters and the accessories or objects represented in their vicinity follow a pattern and are often loaded with symbolic meaning. In that sense a portrait is a symbolic form.[8]

In the second place, the conventions of the genre have a purpose, to present the sitters in a particular way, usually favourable – although the possibility that Goya was satirizing the sitters in his famous *Charles IV and Family* (1800) should not be forgotten. The fifteenth-century Duke of Urbino, Federico da Montefeltre, who had lost an eye in a tournament, was always represented in profile. The protruding jaw of the emperor Charles V is known to posterity only through the unflattering reports of foreign ambassadors, since painters

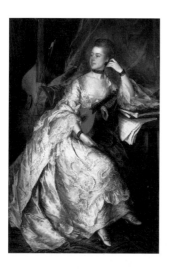

6 Thomas Gainsborough, *Mrs. Philip Thicknesse, née Anne Ford*, 1760, oil on canvas. Cincinatti Art Museum.

(including Titian) disguised the deformity. Sitters generally put on their best clothes to be painted, so that historians would be ill advised to treat portraits as evidence of everyday costume.

It is likely that sitters were also on their best behaviour, especially in portraits made before 1900, in the sense of making gestures, or of allowing themselves to be represented as making gestures, which were more elegant than usual. Thus the portrait is not so much a painted equivalent of a 'candid camera' as a record of what the sociologist Erving Goffman has described as 'the presentation of self', a process in which artist and sitter generally colluded. The conventions of self-representation were more or less informal according to the sitter or indeed the period. In England in the later eighteenth century, for example, there was a moment of what might be called 'stylized informality', which may be illustrated by the painting of Sir Brooke Boothby lying on the ground in a forest with a book (illus. 51). However, this informality had its limits, some of them revealed by the shocked reactions of contemporaries to Thomas Gainsborough's portrait of Mrs Thicknesse, who was represented crossing her legs under her skirt (illus. 6). One lady remarked that 'I should be sorry to have any one I loved set forth in such a manner'. By contrast, in the later twentieth century, the same posture on the part of Princess Diana in Bryan Organ's famous portrait could be taken to be normal.

The accessories represented together with the sitters generally reinforce their self-representations. These accessories may be regarded as 'properties' in the theatrical sense of the term. Classical columns stand for the glories of ancient Rome, while throne-like chairs give

the sitters a regal appearance. Certain symbolic objects refer to specific social roles. In an otherwise illusionistic portrait by Joshua Reynolds, the huge key held by the sitter is there to signify that he is the Governor of Gibraltar (illus. 7). Living accessories also make their appearance. In Italian Renaissance art, for example, a large dog in a male portrait is generally associated with hunting and so with aristocratic masculinity, while a small dog in a portrait of a woman or a married couple probably symbolizes fidelity (implying that wife is to husband as dog is to human). [9]

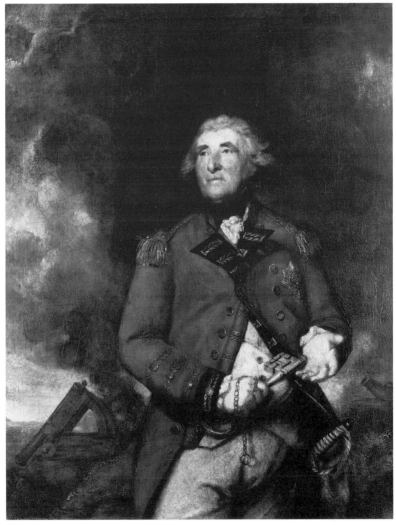

7 Joshua Reynolds, *Lord Heathfield, Governor of Gibraltar*, 1787, oil on canvas. National Gallery, London.

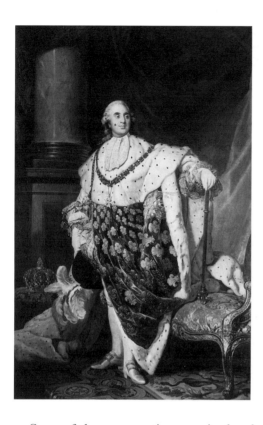

8 Joseph-Siffréde Duplessis, *Louis XVI in Coronation Robes*, *c.* 1770s, oil on canvas. Musée Carnavalet, Paris.

Some of these conventions survived and were democratized in the age of the photographic studio portrait, from the mid nineteenth century onwards. Camouflaging the differences between social classes, the photographers offered their clients what has been called 'temporary immunity from reality'.[10] Whether they are painted or photographic, what portraits record is not social reality so much as social illusions, not ordinary life but special performances. But for this very reason, they offer priceless evidence to anyone interested in the history of changing hopes, values or mentalities.

This evidence is particularly illuminating in those cases when it is possible to study a series of portraits over the long term and so to note changes in the manner of representing the same kinds of people, kings for example. The large portrait of Richard II at Westminster, for instance, is unusual in its size, but the frontal image of a king enthroned, wearing a crown and holding a sceptre in one hand and an orb in the other was commonplace on medieval coins and seals. However stiff it may look today, the famous portrait of Louis XIV in his coronation robes by Hyacinthe Rigaud (1659–1743) made a conscious move towards informality by placing the crown on a cush-

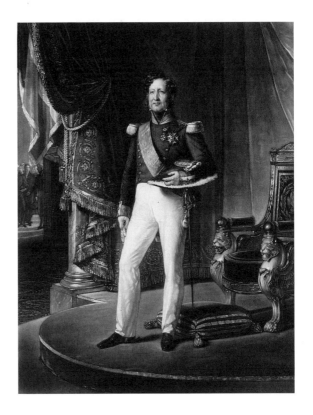

9 François Girard, Aquatint after Louis Hersent's state portrait of Louis Philippe (original exhibited 1831, destroyed 1848). Bibliothèque Nationale de France, Paris.

ion instead of on the king's head and by representing Louis leaning on his sceptre as if it were a walking-stick. In its turn the Rigaud portrait became exemplary. What had been invention turned into convention. Thus a series of French state portraits evoked Rigaud's image of Louis XIV by showing Louis XV, Louis XVI (illus. 8) and Charles X all leaning on their sceptres in the same way, perhaps in order to emphasize dynastic continuity or to suggest that the later rulers were worthy successors of Louis 'the Great'.

On the other hand, after the revolution of 1830 and the replacement of absolute by constitutional monarchy, the new ruler, Louis Philippe, was represented in a deliberately modest way, wearing the uniform of the National Guard instead of coronation robes, and closer to the eye level of the viewer than had been customary, although the king still stands on a dais and the traditional throne and rich curtains remain (illus. 9).[11] The fact that the artists, sitters and a number of viewers would have been aware of the earlier paintings in the series increases the significance of even small divergences from the traditional model.

In the twentieth century, leaving aside deliberate anachronisms like the portrait of Hitler as a medieval knight (illus. 30), the state portrait

was transformed. Fyodor Shurpin's portrait of Stalin, for example, *The Morning of the Motherland* (1946–8), reproduced on the cover of this book, associates the dictator with modernity, symbolized by the tractors and pylons in the background as well as by the sunrise. At the same time, the genre 'state portrait' was overtaken by events in the sense of becoming more and more associated with the past in the age of the signed official photograph and the moving image on the screen.

Reflections on Reflections

Paintings have often been compared to windows and to mirrors, and images are constantly described as 'reflecting' the visible world or the world of society. One might have said that they are like photographs – but as we have seen, even photographs are not pure reflections of reality. So how can images be used as historical evidence? The answer to the question, which will be elaborated in this book, might be summed up in three points.

1. The good news for historians is that art can provide evidence for aspects of social reality which texts pass over, at least in some places and times, as in the case of hunting in ancient Egypt (Introduction).

2. The bad news is that representational art is often less realistic than it seems and distorts social reality rather than reflecting it, so that historians who do not take account of the variety of the intentions of painters or photographers (not to mention their patrons and clients) can be seriously misled.

3. However, returning to the good news, the process of distortion is itself evidence of phenomena that many historians want to study: mentalities, ideologies and identities. The material or literal image is good evidence of the mental or metaphorical 'image' of the self or of others.

The first point is obvious enough, but the second and third points may deserve a little more elaboration. Paradoxically enough, the historian's pictorial turn has come at a time of debate, when common assumptions about the relation between 'reality' and representations (whether literary or visual) have been challenged, a time when the term 'reality' is increasingly placed within inverted commas. In this debate the challengers have made some important points at the expense of the 'realists' or 'positivists'. For example, they have stressed the importance of artistic conventions and have noted that even the artistic style known as 'realism' has its own rhetoric. They have pointed out the importance of 'point of view' in photographs and paintings in both the literal and the metaphorical senses of that

phrase, referring to the physical standpoint and also to what might be called the 'mental standpoint' of the artist.

At one level, then, images are unreliable sources, distorting mirrors. Yet they compensate for this disadvantage by offering good evidence at another level, so that historians can turn a liability into an asset. For example, images are at once an essential and a treacherous source for historians of mentalities, concerned as they are with unspoken assumptions as much as with conscious attitudes. Images are treacherous because art has its own conventions, because it follows a curve of internal development as well as reacting to the outside world. On the other hand, the testimony of images is essential for historians of mentalities, because an image is necessarily explicit on issues that may be evaded more easily in texts. Images can bear witness to what is not put into words. The very distortions to be found in old representations are evidence of past viewpoints or 'gazes' (Chapter 7). For example, medieval world maps, such as the famous Hereford map that shows Jerusalem in the centre of the world, are valuable evidence of medieval world views. Even Jacopo Barbari's famous early-sixteenth-century woodcut of Venice, apparently realistic as it is, may be interpreted, and has been interpreted, as a symbolic image, an example of 'moralized geography'.[12]

Nineteenth-century images of European harems (those painted by Ingres, for example), may tell us little or nothing about the domestic world of Islam, but they have a great deal to say about the fantasy world of the Europeans who created these images, bought them, or viewed them in exhibitions or in books (Chapter 7).[13] Again, images may help posterity tune in to the collective sensibility of a past period. For example the early nineteenth-century European image of the defeated leader symbolized the nobility or the romanticism of failure, which was one of the ways in which the age saw itself, or more exactly one of the ways in which certain prominent groups saw themselves.

As the last remark about groups suggests, it can be extremely misleading to view art as a simple expression of a 'spirit of the age' or *Zeitgeist*. Cultural historians have often been tempted to treat certain images, famous works of art in particular, as representative of the period in which they were produced. Temptations should not always be resisted, but this one has the disadvantage of assuming that historical periods are homogeneous enough to be represented by a single picture in this way. Cultural differences and cultural conflicts are surely to be expected in any period.

It is of course possible to focus on these conflicts, as the Hungarian Marxist Arnold Hauser (1892–1978) did in his *Social History of Art*,

first published in 1951. Hauser viewed paintings as so many reflections or expressions of social conflicts, between the aristocracy and the bourgeoisie, for instance, or between the bourgeoisie and the proletariat. As Ernst Gombrich pointed out in his review of Hauser's book, this approach is still too simple, not to say crudely reductionist. In any case, the approach works better as an explanation of general trends in artistic production than as an interpretation of particular images.[14]

There are, however, alternative ways of discussing the possible relation between images and the culture (or cultures, or sub-cultures) in which they were produced. In the case of the testimony of images – as in so many other cases – the witnesses are least unreliable when they are telling us something they, in this case the artists, do not know they know. In his well-known discussion of the place of animals in early modern English society, Keith Thomas remarked that 'In David Loggan's late-seventeenth-century engravings of Cambridge there are dogs everywhere ... The overall total comes to 35.' What the engraver and the viewers of the time took for granted has become a matter of interest to cultural historians.[15]

Morelli's Ears

This last example illustrates another point relevant to historians and detectives alike, the importance of paying attention to small details. Sherlock Holmes once remarked that he solved his cases by paying attention to small clues, in the same way as a physician diagnoses illness by paying attention to apparently trivial symptoms (reminding readers that Holmes's creator, Arthur Conan Doyle, had been a student of medicine). In a celebrated essay, comparing the approach of Sherlock Holmes to that of Sigmund Freud in his *Psychopathology of Everyday Life*, the Italian historian Carlo Ginzburg has described the pursuit of small clues as an epistemological paradigm, an intuitive alternative to reasoning. Ginzburg's former colleague at the University of Bologna, Umberto Eco, seems to be referring to this essay in his novel *The Name of the Rose* (1980) when he introduces his friar-detective, Brother William of Baskerville, in the act of following the tracks of an animal. The Dutch historian Renier's language of 'traces' (Introduction) expresses a similar idea.[16]

Another observer of significant details, as Ginzburg noted, was the Italian connoisseur Giovanni Morelli (1816–1891). Morelli, who had had a medical training, seems to have been inspired by the work of the palaeontologists who try to reconstruct whole animals from surviving

fragments of bone, making the classical adage *ex ungue leonem* ('from the claw, the lion') come true. In similar fashion, Morelli developed a method, which he called 'experimental', for identifying the author of a particular painting in cases of controversial attributions.

The method, which Morelli described as reading 'the language of forms', was to examine with care small details such as the shapes of hands and ears, which each artist – whether consciously or unconsciously – represents in a distinctive manner, allowing Morelli to identify what he called the 'fundamental form' (*Grundform*) of the ear or the hand in Botticelli, for example, or Bellini. These forms might be described as symptoms of authorship, which Morelli regarded as more reliable evidence than written documents. Conan Doyle probably knew about Morelli's ideas, while the cultural historian Jacob Burckhardt found his method fascinating.

Aby Warburg's famous essay on Botticelli's representation of the movement of hair and drapery does not refer to Morelli, but it may be viewed as an adaptation of his method to the purposes of cultural history, an adaptation that the quotation from Morelli in the epigraph to this chapter suggests he would have approved. This is the model that I shall try to follow, as far as I can, in this book.[17]

Siegfried Kracauer was thinking along similar lines when he claimed that a study of German films, for example, would reveal something about German life that other sources could not. 'The whole dimension of everyday life with its infinitesimal movements and its multitude of transitory actions could be disclosed nowhere but on the screen ... films illuminate the realm of bagatelles, of little events.'[18]

The interpretation of images through an analysis of details has become known as 'iconography'. The achievements and the problems of the iconographical method will be examined in the following chapter.

2 Iconography and Iconology

[An] Australian bushman would be unable to recognise the
subject of a Last Supper; to him, it would only convey the idea
of an excited dinner party.
ERWIN PANOFSKY

Before attempting to read images 'between the lines', and to use them
as historical evidence, it is only prudent to begin with their meanings.
But can the meanings of images be translated into words? The reader
will have noticed that the previous chapter described images as
'telling' us something. In a sense they do: images are designed to
communicate. In another sense they tell us nothing. Images are irre-
deemably mute. As Michel Foucault put it, 'what we see never resides
in what we say'.

Like other forms of evidence, images were not created, for the
most part at any rate, with the future historian in mind. Their makers
had their own concerns, their own messages. The interpretation of
these messages is known as 'iconography' or 'iconology', terms some-
times used as synonyms, but sometimes distinguished, as we shall see.

The Idea of Iconography

The terms 'iconography' and 'iconology' were launched in the art-
historical world in the 1920s and 1930s. To be more exact, they were
relaunched – a famous Renaissance handbook of images, published by
Cesare Ripa in 1593, already bore the title *Iconologia*, while the term
'iconography' was in use in the early nineteenth century. By the 1930s
the use of these terms had become associated with a reaction against a
predominantly formal analysis of paintings in terms of composition
or colour at the expense of the subject matter. The practice of icono-
graphy also implies a critique of the assumption of photographic real-
ism in our 'snapshot culture'. The 'iconographers', as it is convenient

to call these art historians, emphasize the intellectual content of works of art, their implicit philosophy or theology. Some of their most famous and controversial claims concern paintings made in the Netherlands between the fifteenth and eighteenth centuries. It has been argued, for instance, that the celebrated realism of Jan van Eyck, for example, or Pieter de Hooch (illus. 38) is only superficial, hiding a religious or moral message presented through the 'disguised symbolism' of everyday objects.[1]

One might say that for the iconographers, paintings are not simply to be looked at: they are to be 'read'. Today, the idea has become commonplace. A well-known introduction to film studies is entitled *How to Read a Film* (1977), while the critic Roland Barthes (1915–1980) once declared, 'I read texts, images, cities, faces, gestures, scenes, etc.' The idea of reading images actually goes back a long way. Within the Christian tradition it was expressed by the fathers of the church and most famously by Pope Gregory the Great (Chapter 3). The French artist Nicolas Poussin (1594–1665) wrote about his painting of Israelites gathering manna, 'read the story and the painting' (*lisez l'histoire et le tableau*). In similar fashion, the French art historian Emile Mâle (1862–1954) wrote of 'reading' cathedrals.

The Warburg School

The most famous group of iconographers was to be found in Hamburg in the years before Hitler came to power. It included Aby Warburg (1866–1929), Fritz Saxl (1890–1948), Erwin Panofsky (1892–1968) and Edgar Wind (1900–1971), all scholars with a good classical education and wide interests in literature, history and philosophy. The philosopher Ernst Cassirer (1874–1975) was another member of this Hamburg circle, and shared their interest in symbolic forms. After 1933 Panofsky emigrated to the United States, while Saxl, Wind and even Warburg's Institute, as we have seen, all took refuge in England, thus spreading knowledge of the iconographical approach more widely.

The Hamburg group's approach to images was summed up in a famous essay by Panofsky, first published in 1939, distinguishing three levels of interpretation corresponding to three levels of meaning in the work itself.[2] The first of these levels was the pre-iconographical description, concerned with 'natural meaning' and consisting of identifying objects (such as trees, buildings, animals and people) and events (meals, battles, processions and so on). The second level was the iconographical analysis in the strict sense, concerned

with 'conventional meaning' (recognizing a supper as the Last Supper or a battle as the Battle of Waterloo).

The third and ultimate level was that of the iconological interpretation, distinguished from iconography because it was concerned with 'intrinsic meaning', in other words, 'those underlying principles which reveal the basic attitude of a nation, a period, a class, a religious or philosophical persuasion'. It is at this level that images offer useful – indeed, indispensable – evidence for cultural historians. Panofsky was particularly concerned with the iconological level in his essay *Gothic Architecture and Scholasticism* (1951), in which he explored homologies between the philosophical and architectural systems of the twelfth and thirteenth centuries.

These pictorial levels of Panofsky's correspond to the three literary levels distinguished by the classical scholar Friedrich Ast (1778–1841), a pioneer in the art of interpreting texts ('hermeneutics'): the literal or grammatical level, the historical level (concerned with meaning) and the cultural level, concerned with grasping the 'spirit' (*Geist*) of antiquity or other periods. In other words, Panofsky and his colleagues were applying or adapting to images a distinctively German tradition of interpreting texts.

Readers should be warned that later art historians who have taken over the term 'iconology' have sometimes employed it in different ways from Panofsky. For Ernst Gombrich, for instance, the term refers to the reconstruction of a pictorial programme, a significant narrowing of the project linked to Gombrich's suspicion that Panofsky's iconology was simply another name for the attempt to read images as expressions of the *Zeitgeist*. For the Dutch scholar Eddy de Jongh, iconology is 'an attempt to explain representations in their historical context, in relation to other cultural phenomena'.[3]

For his part, Panofsky insisted that images are part of a whole culture and cannot be understood without a knowledge of that culture, so that, to quote his own vivid example, an Australian bushman 'would be unable to recognize the subject of a Last Supper; to him, it would only convey the idea of an excited dinner party'. Most readers are likely to find themselves in a similar situation when confronted with Hindu or Buddhist religious imagery (Chapter 3). To interpret the message it is necessary to be familiar with the cultural codes.

In similar fashion, without a reasonable knowledge of classical culture, we are unable to read many western paintings, to recognize references to incidents from Greek mythology, say, or Roman history. If, for example, we do not know that the young man in sandals and a

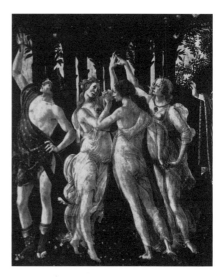

10 Detail showing Mercury and the Graces, from Botticelli's *Primavera*, *c*. 1482, tempera on wood. Galleria degli Uffizi, Florence.

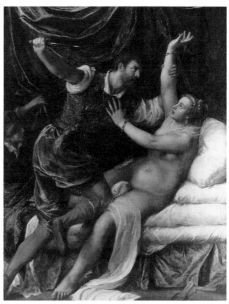

11 Titian, *The Rape of Lucretia*, 1571, oil on canvas. Fitzwilliam Museum, Cambridge.

peaked cap in Botticelli's *Primavera* (illus. 10) represents the god Hermes (or Mercury), or that the three dancing girls are the Three Graces, we are unlikely to be able to work out the meaning of the painting (even with this knowledge, all sorts of problems remain). Again, if we do not realize that the protagonists in the rape scene illustrated by Titian (illus. 11) are King Tarquin and the Roman matron Lucretia, we will miss the point of the story, told by the Roman historian Livy in order to show the virtue of Lucretia (who

wiped out her shame by killing herself), and to explain why the Romans drove out the king and founded a republic.

The Method Exemplified

Some of the most important achievements of the Warburg school concern the interpretation of paintings of the Italian Renaissance. Take the case of Titian's so-called *Sacred and Profane Love* (illus. 12). At the level of pre-iconographic description, we see two women (one naked, the other clothed), an infant and a tomb, which is used as a fountain, all situated in a landscape. Turning to the iconography, for anyone familiar with Renaissance art it is, one might say, child's play to identify the infant as Cupid, whereas decoding the rest of the painting is not so easy. A passage in Plato's dialogue the *Symposium* provides an essential clue to the identity of the two women: the speech of Pausanias about the two Aphrodites, the 'heavenly' and the 'vulgar', interpreted by the humanist Marsilio Ficino as symbols of mind and matter, intellectual love and physical desire.

At the deeper, iconological level, the painting makes an excellent illustration of the enthusiasm for Plato and his followers in the so-called 'Neoplatonic' movement of the Italian Renaissance. In the process, it offers important evidence for the importance of that movement in Titian's milieu in Northern Italy in the early sixteenth century. The painting's reception also has something to tell us about the history of attitudes to the naked body, notably the shift from celebration to suspicion. In early-sixteenth-century Italy (as in Greece in Plato's day), it was natural to link heavenly love with the naked woman, because nudity was viewed in a positive light. In the nineteenth century, changes in assumptions about nudity, especially

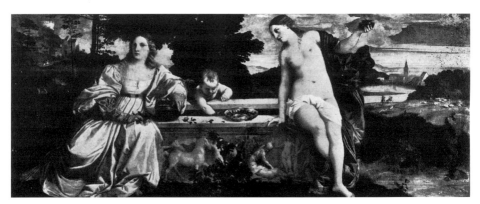

12 Titian, *Sacred and Profane Love*, 1514, oil on canvas. Galleria Borghese, Rome.

38

female nudity, made it seem obvious to viewers – simple common sense, we might say – that the clothed Venus represented sacred love, while the nude was now associated with the profane. The frequency of images of the naked body in Renaissance Italy, compared with their rarity in the Middle Ages, offers another important clue to changes in the way in which bodies were perceived in those centuries.

Standing back from the interpretations and focusing on the method that they exemplify, three points stand out. The first is that in the attempt to reconstruct what is often called the iconographical 'programme', scholars have often joined together images which events had put asunder, paintings which were originally designed to be read together but are now dispersed in museums and galleries in different parts of the world.

The second point is the need for iconographers to have an eye for detail, not only to identify artists, as Morelli argued (Chapter 1) but to identify cultural meanings as well. Morelli was aware of this too and, in a dialogue which he wrote to explain his method, he created the character of a wise old Florentine who tells the hero that people's faces in portraits reveal something of the history of their time, 'if one knows how to read it'. Again, in the case of *Sacred and Profane Love*, Panofsky drew attention to the rabbits in the background and explained them as symbols of fertility, while Wind concentrated on the reliefs decorating the fountain, including a man being whipped and an unbridled horse, interpreting them as references to 'pagan initiatory rites of love'.[4]

The third point is that iconographers generally proceed by juxtaposing texts and other images to the image they wish to interpret. Some of the texts are to be found on images themselves, in the form of labels or inscriptions turning the image into what the art historian Peter Wagner calls an 'iconotext' which may be 'read' by the viewer literally as well as metaphorically. Other texts are selected by the historian in an attempt to clarify the meaning of the image. Warburg, for example, in his approach to the *Primavera*, noted that the Roman philosopher Seneca had associated Mercury with the Graces, that the Renaissance humanist Leonbattista Alberti had recommended painters to represent the Graces holding hands, and that a number of medals showing the Graces were in circulation in Florence in Botticelli's time.[5]

How can we be sure that these juxtapositions are the appropriate ones? Could Renaissance artists have known about classical mythology, for instance? Neither Botticelli nor Titian had much formal schooling and they are unlikely to have read Plato. To meet this objec-

tion, Warburg and Panofsky formulated their hypothesis of the humanist adviser, who drew up the iconographical programme of complex images for artists to execute. Documentary evidence of such programmes is relatively rare. On the other hand, the painters of the Italian Renaissance often had opportunities to talk to humanists, to Marsilio Ficino in Botticelli's case and to Pietro Bembo in that of Titian. Hence it is not implausible to suggest that a variety of allusions to ancient Greek and Roman culture can be found in their work.

The Method Criticized

The iconographical method has often been criticized as too intuitive, too speculative to be trusted. Iconographical programmes are occasionally recorded in surviving documents, but generally speaking they have to be inferred from the images themselves, in which case the sense of the different pieces of a puzzle fitting together, however vivid, is rather subjective. As the unending saga of new interpretations of the *Primavera* illustrates, it is easier to identify the elements of the painting than to work out the logic of their combination. Iconology is still more speculative, and there is a risk of iconologists discovering in images exactly what they already knew to be there, the *Zeitgeist*.

The iconographical approach may also be faulted for its lack of a social dimension, its indifference to social context. The aim of Panofsky, who was notoriously indifferent if not hostile to the social history of art, was to discover 'the' meaning of the image, without asking the question, meaning for whom? Yet the artist, the patron who commissioned the work, and other contemporary viewers may not have viewed a given image in the same way. It cannot be assumed that they were all as interested in ideas as the humanists and the iconographers. King Philip II of Spain, for example, commissioned scenes from classical mythology from Titian (*c.* 1485–1576). It has been plausibly argued that Philip was less interested in Neoplatonic allegories or in representations of specific myths than in pictures of beautiful women. In his letters to the king, Titian himself described his paintings as his 'poems', without any reference to philosophical ideas.[6]

Indeed, it would be unwise to assume that the classical allusions which Panofsky, a humanist himself, so much enjoyed recognizing, were appreciated by the majority of viewers in the fifteenth and sixteenth centuries. Texts sometimes offer us precious evidence of misunderstandings, of one god or goddess being taken for another by contemporary viewers, for instance, or a winged Victory viewed as an

angel by a spectator who knew more about Christianity than about the classical tradition. As missionaries were at times uncomfortably aware, peoples who had been converted to Christianity retained a propensity to view Christian images in terms of their own traditions, to see the Virgin Mary as the Buddhist goddess Kuan Yin, for example, or as the Mexican mother goddess Tonantzin, or to see St George as a version of Ogum, the West African god of war.

Another problem of the iconographical method is that its practitioners have often paid insufficient attention to the variety of images. Panofsky and Wind had sharp eyes for painted allegories, but images are not always allegorical. As we shall see, the question whether the famous seventeenth-century Dutch scenes from everyday life carry a hidden meaning remains controversial (Chapter 5). Whistler issued a challenge to the iconographical approach by calling his portrait of a Liverpool shipowner 'Arrangement in Black', as if his aim was not representational but purely aesthetic. Again, the iconographical method might need to be adapted to deal with surrealist paintings, since painters such as Salvador Dalì (1904–1989) rejected the very idea of a coherent programme and attempted instead to express the associations of the unconscious mind. Artists such as Whistler, Dalì and Monet (below), may be described as resisting iconographical interpretation.

This point about resistance leads on to a final criticism of the method, which is that it is too literary or logocentric, in the sense of assuming that images illustrate ideas and of privileging content over form, the humanist adviser over the actual painter or sculptor. These assumptions are problematic. In the first place, the form is surely part of the message. In the second place, images often arouse emotions as well as communicating messages in the strict sense of the term.

As for iconology, the dangers of assuming that images express the 'spirit of the age' have been pointed out many times, notably by Ernst Gombrich in his criticisms of Arnold Hauser and Johan Huizinga as well as of Erwin Panofsky. It is unwise to assume the cultural homogeneity of an age. In the case of Huizinga, who inferred the existence of a morbid or macabre sensibility in late medieval Flanders from the literature and the paintings of the period, the work of Hans Memling (c. 1435–1494) has been cited as a counter-example, a painter who was 'widely admired' in the fifteenth century yet lacks the 'morbid preoccupation' of his colleagues.[7]

In short, the specific method of interpreting images that was developed in the early twentieth century can be faulted as too precise and too narrow in some ways, too vague in others. To discuss it in general terms risks underestimating the variety of images, let alone

the variety of historical questions which images may help answer. Historians of technology (say), and historians of mentalities come to images with different needs and expectations. Hence the chapters that follow will focus in turn on different domains such as religion, power, social structures and events. If there is a general conclusion to be drawn from this chapter, it might be that historians need iconography but also need to go beyond it. They need to practice iconology in a more systematic way, which may involve making use of psycho-analysis, structuralism and especially reception theory, approaches which will be drawn upon from time to time as well as being discussed more fully and more explicitly in the final chapter of this book.

The Problem of Landscape

Panofsky's second and third levels may well appear to have little relevance to landscape, but for this very reason landscapes allow us to see with particular clarity both the strengths and the weaknesses of the iconographical and iconological approaches. I am using the term 'landscape' with deliberate ambiguity, to refer not only to paintings and drawings but also to the land itself as it has been transformed by 'landscape gardening' and other forms of human intervention.

One of the strengths of the iconographical approach is that it has inspired geographers and art historians alike to read the physical landscape in new ways. The iconography of the land itself is particularly obvious in the case of gardens and parks. There are also the typical or symbolic landscapes that represent nations by means of their characteristic vegetation, from oaks to pines and from palm trees to eucalyptus. One might measure the importance of this symbolism by the indignation aroused when the British Forestry Commission, for example, planted pines where traditional English deciduous trees had grown.[8]

If the physical landscape is an image that can be read, then the painted landscape is the image of an image. In the case of painted landscape, the weaknesses of the iconographical approach may well appear obvious. It seems to be no more than common sense to suggest that landscape painters want to give viewers aesthetic pleasure rather than to communicate a message. Some landscape painters, Claude Monet (1840–1926), for example, rejected meaning and concentrated on visual sensations. When he painted a view of Le Havre in 1872, he called it simply *Impression: Sunrise*. All the same, what appears in a given culture to be 'common sense' needs to be analysed by historians and anthropologists alike as part of a cultural system. In the case of

landscape, trees and fields, rocks and rivers all carry conscious or unconscious associations for viewers.[9] Viewers, it should be emphasized, from particular places in particular periods. In some cultures wild nature is disliked or even feared, while in others it is the object of veneration. Paintings reveal that a variety of values, including innocence, liberty and the transcendental have all been projected onto the land.

For example, the term 'pastoral landscape' has been coined to describe paintings by Giorgione (*c.* 1478–1510), Claude Lorrain (1600–1682) and others, because they express an idealizing vision of rural life, particularly the life of shepherds and shepherdesses, in much the same way as the western tradition of pastoral poetry from Theocritus and Virgil onwards. These painted landscapes appear to have influenced the perception of actual landscapes. In late-eighteenth-century Britain, 'tourists', as the poet Wordsworth was one of the first to call them, guidebooks in hand, viewed the Lake District, for instance, as if it were a series of paintings by Claude Lorrain, describing it as 'picturesque'. The idea of the picturesque illustrates a general point about the influence of images on our perception of the world. Since 1900, tourists in Provence have come to see the local landscape as if it were made by Cézanne. Religious experience too, as we shall see (Chapter 3), is partly shaped by images.

Given these pastoral associations, it is likely that Monet's *The Train* (1872), with its landscape of smoking factory chimneys, must have shocked some of its early viewers, while even the tiny trains to be seen in the distance of some nineteenth-century American landscapes may have raised eyebrows. A more difficult question to answer is whether the artists introduced the trains because they were admirers of progress, like the Mexican mural painter Diego Rivera (1886–1957), whose frescos of 1926 celebrated the tractor and the mechanization of agriculture.[10]

The last point implies that landscape evokes political associations, or even that it expresses an ideology, such as nationalism. Prince Eugen of Sweden was one of a number of artists in the years around 1900 who chose to paint what he called 'Nordic nature, with its clean air, its hard contours and its strong colours'. We might say that Nature was nationalized at this time, turned into a symbol of the mother or fatherland.[11] In twentieth-century Britain, the land has been associated with Englishness, with citizenship, and with the 'organic society' of the village, threatened by modernity, industry and the city.[12]

Again, it has been perceptively observed that eighteenth-century

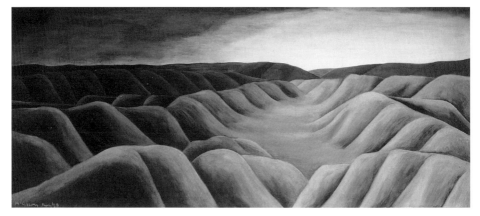

13 Colin McCahon, *Takaka – Night and Day*, 1948, oil on canvas laid on board. Auckland Art Gallery Toi o Tamaki, New Zealand.

English landscape painters disregarded agricultural innovations and ignored recently-enclosed fields, preferring to show the land as it was supposed to have been in the good old days.[13] In similar fashion the landscapes of John Constable (1776–1837), painted during the Industrial Revolution, have been interpreted as an expression of anti-industrial attitudes because they leave out factories. Factories were not of course part of the landscape of Constable's Essex or Wiltshire, but the coincidence in time between the rise of landscape painting and the rise of factories in England remains both intriguing and disturbing.

The same period saw a new enthusiasm for wild nature, marked by the increasing popularity of tours in search of mountains and woods and the publication of a shelf of books on the subject such as the *Observations Relative to Picturesque Beauty* (1786) by the writer William Gilpin (1724–1804). It seems that the destruction of nature, or at least the threat of its destruction, was a necessary condition for its aesthetic appreciation. The English countryside was already taking on the aspect of a paradise lost.[14]

More generally, in the West at least, nature has often symbolized political regimes. The conservative thinker Edmund Burke (1729–1797) described the British aristocracy as 'great oaks', and contrasted the British constitution, which grew naturally like a tree, with the artificial, 'geometrical' constitution of revolutionary France. For liberals, on the other hand, nature represented freedom, defined against the order and constraint associated with absolute monarchy and represented by the symmetrical gardens of Versailles and its many imitations. Forests and the outlaws who live in them, notably Robin Hood, are an ancient symbol of liberty.[15]

The landscapes of empire evoke another theme, the theme of dispossession. The absence of figures in an American landscape, for instance, has been said to carry 'a more loaded meaning than in Europe'. In the case of New Zealand, it has been suggested that 'the evocation of an empty landscape ... cannot be seen as a purely pictorial or aesthetic statement' (illus. 13). Consciously or unconsciously, the artist has erased the aborigines, as if illustrating the idea of 'virgin' soil or the legal doctrine that New Zealand, like Australia and North America, was a 'no-man's-land'. In this way the position of the white settlers has been legitimated. What the painting documents is what might be called the 'colonial gaze' (Chapter 7).[16]

Even in the case of landscape, then, the iconographic and iconological approaches do have a role to play, helping historians to reconstruct past sensibilities. Their function is more obvious in the case of religious images, to be discussed in the following chapter.

3 The Sacred and the Supernatural

Ab re non facimus, si per visibilia invisibilia demonstramus
[We will not err if we show invisible things by means of
visible ones].
GREGORY THE GREAT

Kunst gibt nicht das sichtbar wieder, aber macht sichtbar
[Art does not reproduce the visible but makes visible].
PAUL KLEE

In many religions images play a crucial part in creating the experience
of the sacred.[1] They both express and form (and so also document)
the different views of the supernatural held in different periods and
cultures: views of gods and devils, saints and sinners, heavens and
hells. It is intriguing, to say the least, to learn that images of ghosts
were rare in western culture before the fourteenth century, and
images of the devil before the twelfth century, although a few can be
found from the ninth century onwards. The figure of the devil, hairy,
horned, with claws, tail, wings like a bat and a pitchfork in his hand,
was elaborated over a long period.[2]

A chronological series of images depicting a single theme is a
particularly valuable source for the historian of religion. For example,
in the 1960s the French historian Michel Vovelle and his wife studied
a series of altarpieces from Provence, representing souls in Purgatory,
as a source for the history of mentalities and the history of sensibility
as well as the history of devotion, describing the images as 'one of the
most important records of human attitudes to death as they change
over the long term'.

In this study the Vovelles analysed the chronology, geography and
sociology of these images, noting for example that production
remained more or less constant in the years between 1610 and 1850,
implying that the French Revolution was not a turning-point so far as
Provençal mentalities were concerned. They also made a thematic

analysis of the images, noting the decline of representations of the saints as intercessors, and the shift from an emphasis on the sufferings of the souls in the seventeenth century to a stress on images of deliverance in the eighteenth. The Vovelles also pointed out that changes tended to be initiated by religious orders and to be taken up by religious confraternities before they reached the laity in general. In this way they made a contribution to the local history of the Counter-Reformation.[3]

Images have often been used as a means of indoctrination, as objects of cults, as stimuli to meditation and as weapons in controversies. Hence they are also a means for historians to recover past religious experiences – provided, of course, that they are able to interpret the iconography. In what follows, the four functions just mentioned will be discussed one by one.

Images and Indoctrination

The need for certain kinds of knowledge as a precondition for understanding the meaning of religious images is obvious enough to most westerners in the case of images from other religious traditions. Deciphering the meaning of the hand gestures of the Buddha, for example, such as touching the ground with his right hand to call the earth to witness his enlightenment, requires some knowledge of the Buddhist scriptures. In similar fashion, some knowledge of the doctrines of Hinduism is necessary to identify certain snakes as deities; or to realize that a figure with the head of an elephant is the god Ganesha; or that a blue youth playing with milkmaids is the god Krishna, let alone to interpret the religious significance of the tricks he plays on the girls. In the sixteenth century, Europeans who visited India sometimes perceived the images of Indian gods as devils. The propensity to view non-Christian religions as diabolical was reinforced by the fact that these 'monsters' with many arms or animal heads broke the western rules for representing the divine.

Again, western viewers confronted with the image of the god Shiva dancing, a type known as Shiva 'Lord of the Dance' (*Nataraja*), may not realize that the dance is a cosmic one, symbolizing the act of creating or destroying the universe (although the flames commonly represented around the god provide a clue to the symbolism). They are even less likely to be able to interpret Shiva's gestures or *mudras*, for example the gesture of protection which may be translated as 'Do not be afraid'.[4]

However, the Christian tradition is equally opaque to outsiders, as

Panofsky pointed out in the case of the Last Supper (Chapter 2). Without knowing the conventions of iconography or the legends of the saints it would not be possible to distinguish souls burning in hell from souls burning in purgatory, or the woman carrying her eyes on a plate (St Lucy) from the woman carrying her breasts on a plate (St Agatha).

The iconography mattered at the time because images were a means of 'indoctrination' in the original sense of the term, the communication of religious doctrines. The remarks on this subject by Pope Gregory the Great (*c.* 540–604) were quoted again and again over the centuries. 'Pictures are placed in churches so that those who cannot read in books might 'read' by viewing the walls' (*in parietibus videndo legant quae legere in codicibus non valent*).[5]

The view that pictures were the Bible of the illiterate has been criticized on the grounds that many images on the walls of churches were too complex for ordinary people to understand. However, both the iconography and the doctrines that it illustrated might have been explained orally by the clergy, the image itself acting as a reminder and a reinforcement of the spoken message, rather than as an independent source. Turning to the question of evidence, the discrepancies between the stories told in images and the stories told in the Bible are particularly interesting as clues to the way in which Christianity was seen from below. Thus the brief references in the Gospel of St Matthew to some astrologers and their gifts, and in the Gospel of St Luke to the birth of Christ in a manger, were amplified and made more vivid in innumerable representations of the ox and the ass and of the three wise men Gaspar, Baltasar and Melchior, especially from the fourteenth century onwards.

At an iconological level, changes in the style of sacred images also offer valuable evidence for historians. Pictures that were designed to arouse emotions may surely be used as documents for the history of those emotions. For example, they suggest that there was a particular preoccupation with pain in the later Middle Ages. This was the period when the cult of the instruments of the Passion, the nails, the lance, and so on, reached its height. It was also the time when the suffering Christ, twisted and pathetic, replaced the traditional serene and dignified image of Christ the King on crucifixes, 'reigning from the tree' as people used to say in the Middle Ages. The contrast between the eleventh-century Danish crucifix, known as the 'Aaby Crucifix', and a fourteenth-century German crucifix now in Cologne (illus. 14, 15), is indeed a dramatic one.

In the seventeenth century, on the other hand, there seems to have

14 The 'Aaby Crucifix', second half of
11th century, copper-covered carved wood
reredos. Nationalmuseet, Copenhagen.

15 Crucifix, 1304, wood.
S. Maria im Kapitol, Cologne.

been a greater preoccupation with ecstasy, which achieved its most famous expression in Gian Lorenzo Bernini's sculpture representing the *Ecstasy of St Teresa* (1651).[6]

Cults of Images

Images were much more than a means of spreading religious knowledge. They were themselves agents, to which miracles were attributed, and also the objects of cults. In eastern Christendom, for example, icons had (as they still have) a very special place, whether displayed singly or together on the iconostasis, the screen that hides the altar from the laity during religious services. Icons, following conventions distant from photographic realism, demonstrate the power of the religious image with particular clarity. The pose of Christ, the Virgin or the saints is usually frontal, looking straight at the viewers and so encouraging them to treat the object as a person. Legends of icons that fell into the sea but reached the land by themselves reinforce the impression of these images as autonomous forces.

The cult of images can also be found in western Christendom, from the Virgin of Guadalupe in Mexico to the Black Madonna of Częstochowa in Poland or the image of Santa Maria dell'Impruneta, housed in a church near Florence. An etching of 1620 by the Lorraine artist Jacques Callot (*c.* 1592–1635) shows the fair of Impruneta, an institution which had grown up around the pilgrimages to the image. The Venetian republic was placed under the protection of another image of the Virgin, known as St Luke's Madonna and looted from Constantinople in the thirteenth century. From the later Middle Ages onwards, indulgences, in other words remission of time in purgatory, rewarded people who prayed to particular images, including the 'Veronica' or 'true image' of Christ displayed in St Peter's in Rome.

Worshippers made long pilgrimages to see images, they bowed and knelt before images, they kissed them, and they asked them for favours. The image of Santa Maria dell'Impruneta, for example, was often taken in procession in order to produce rain or to protect the Florentines against political threats.[7] Commissioning images was also a means of expressing thanks for favours received, such as an escape from an accident or a cure from an illness. These 'votive images', many of which may still be seen in some shrines in Italy, for example, or Provence, were made in order to fulfil a vow to a saint (illus. 16). They document the hopes and fears of ordinary people and testify to the close relationship between donor and saint.[8]

Votive images are not uniquely Christian. They may be found in

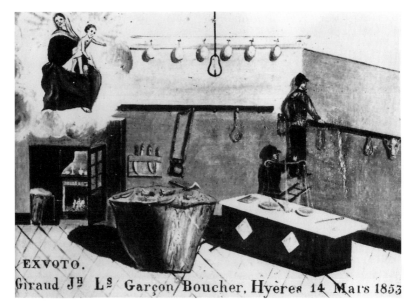

EXVOTO.
Gìraud Jᴮ Lˢ Garçon Boucher, Hyères 14 Mars 1853

16 'Ex-voto' for the son of a butcher, 14 March 1853, oil on canvas. Notre-Dame de Consolation, Hyères.

Japanese shrines, for example, revealing similar preoccupations with illness and shipwreck. They were made in pre-Christian times as well. In Agrigento in Sicily, there is a church filled with ex-votos, silver (or more recently plastic) hands, legs and eyes. Not far away is a museum of classical antiquities containing similar objects in terracotta, dating from before the time of Christ. These images testify to important continuities between paganism and Christianity, which may have left few traces in texts but are of great importance to historians of religion.

Images and Devotion

Images appear to have played an increasingly important part in religious life from the later Middle Ages onwards. A series of pictures illustrating Bible stories circulated in print from the 1460s onwards, while private devotions were increasingly assisted – for those who could afford them – by privately owned paintings. These paintings were different in both form and function from the icons described above. They focused on what has been called the 'dramatic close-up', focusing on a moment in a sacred story.[9] A similar effect was achieved in an even more dramatic way in the scenes from the New Testament enacted by life-size coloured figures in sanctuaries such as the Sacro Monte of Varallo, a holy mountain in northern Italy, much visited by

pilgrims and one which was filled with statues in the late sixteenth century. In the presence of images such as these, it is difficult to resist the sensation that one is really standing in the Holy Land in the time of Christ.[10]

Devotional images also played an important part in the consolation of the sick, the dying, and those about to be executed. In sixteenth-century Rome, for example, it was the duty of the lay brothers of the Archconfraternity of San Giovanni Decollato ('St John the Beheaded') to accompany criminals to the place of execution, showing them little pictures of the Crucifixion or the taking down of Christ from the Cross (illus. 17). The practice has been described 'as a kind of visual narcotic to numb the fear and pain of the condemned criminal during his terrible journey to the scaffold'. It is also worth emphasizing the point that the image encouraged the condemned person to identify with Christ and his sufferings.[11]

The new forms of sacred image have also been linked to the spread of certain practices of religious meditation. The anonymous thirteenth-century *Meditations on the Life of Christ* (attributed to the Franciscan friar St Bonaventure) involved the intense visualization of sacred events by concentrating on small details. In the case of the Nativity, for example, the text encourages readers to imagine the ox and the ass and the Virgin kneeling before her son. In the case of the Last Supper, he explains, 'you must know that the table was close to the ground, and they sat on the ground according to the ancient custom.' The reason for this exercise was explained by a fifteenth-century Italian preacher: 'our feelings are aroused by things seen more than by things heard'.[12]

In similar fashion, three hundred years after Bonaventure, in the devotional handbook the *Spiritual Exercises*, written by St Ignatius Loyola (1491–1556) and published in 1548, readers or listeners were told to see Hell, the Holy Land and other locations in their mind's eye, a practice that Ignatius described as 'composition of place'. They were encouraged to produce 'a vivid portrayal in the imagination of the length, breadth and depth of Hell', the 'enormous fires' and the souls 'with bodies of fire'. Ignatius's text was not originally illustrated, but in one seventeenth-century commentary by another Spanish Jesuit, Sebastiano Izquierdo (1601–1681), engravings were added to the text in order to help readers in the task of visualization.[13]

From conscious meditation on a sacred image to religious visions that apparently come by themselves is not a long step. In any case, religious visions often reflect material images. The trial of Joan of Arc (c. 1412–31) for heresy and sorcery shows that her English interroga-

17 *Deposition*, 16th century, panel. San Giovanni Decollato, Rome.

tors believed her visions of St Michael and other angels to have been inspired by paintings, although Joan denied this. Studies of the late medieval saints Catherine of Siena and Bridget of Sweden have made similar claims.[14] The rich spiritual life of St Teresa of Avila (1515–1582), was also nourished by images – it is known that one particular image of the suffering Christ made a particularly strong impression on her. One is left wondering whether an image inspired the famous mystical experience which was in turn illustrated by Bernini, in which the saint saw an angel who pierced her with an arrow.[15] Again, in Russia, the seventeenth-century patriarch Nikon had visions in which Christ appeared to him looking as he did in icons.[16]

The positive images of the saints in heaven had their negative counterparts in images of hell and of devils, which equally deserve study. Today, the infernal landscapes of Hieronymus Bosch (*c.* 1450–1516), for instance, are probably more alien to most of us than images of the moon or even Mars. It takes an effort to realize that contempo-

raries believed that they might one day see places of the kind Bosch represented, and that the artist drew not only on his own imagination but also on popular vision literature. Emile Mâle once described medieval grotesques as coming 'from the depths of the people's consciousness'. Such images offer historians valuable clues – if they can only interpret them – to the anxieties of individuals and groups in different cultures.[17]

Changing images of hell and the devil, for instance, might help historians construct the history of fear on which a few of them, notably the French scholar Jean Delumeau, have recently been engaged.[18] As we have seen, images of the devil are rare before the twelfth century. Why did they become common at this time? Is the answer to this question to be found in new conventions for what can or should be represented visually, or does the rise of the devil tell us something about changes in religion or even in collective emotions? In the sixteenth and seventeenth centuries, the rise of images of the witches' sabbath (Chapter 7), combining festive themes with what look like scenes from hell, give us clues to the anxieties underlying the rise of witch trials in this period.

Historians are on somewhat safer ground when they analyse not a shift from absence to presence but gradual or rapid changes in the way in which a traditional scene was represented. In the seventeenth century, for instance, illustrations to Loyola's *Spiritual Exercises* show the torments of hell vividly enough, but, like the text they illustrate, they omit the monstrous forms that populate the paintings of Bosch. Is this specific change a clue to a more general one?

Polemical Images

The devotional uses of images did not please everyone. The fear that people might be worshipping the images themselves rather than what they represented has often led to movements of iconoclasm in different places and periods.[19] Gregory the Great's remarks about the reasons for placing pictures in churches, quoted above, were written in reaction to the news of an iconoclastic incident in Marseilles. In Byzantium, there was a major outbreak of iconoclasm in the eighth century. In Western Europe, there were waves of iconoclasm in the 1520s and 1560s. The increasing interest in these movements shown by historians over the last few decades has much to do with the rise of 'history from below'. Collective acts of destruction help us recover the attitudes of ordinary people who left no written evidence of their opinions. This kind of evidence for the responses of viewers will be

discussed in more detail in the final chapter of this book.

An alternative strategy both to the cult and to the destruction of sacred images is to use the visual media as weapons in religious polemic. Protestants made most use of images – especially woodcuts, which were cheap and mobile – in the early years of the German Reformation. They did this in the conscious attempt to reach the majority of the population, who were illiterate or semi-literate. Images were made 'for the sake of children and the simple folk', as Martin Luther put it, 'who are more easily moved to recall sacred history by pictures and images than through mere words or doctrines'.[20] Hence these visual sources record the Reformation from the point of view of ordinary people, offering a perspective which is rarely visible in the printed sources, produced as they were by members of the literate elite. The Protestant printmakers drew on a rich repertoire of traditional popular humour for images that would destroy the Catholic Church by making it a figure of fun. Their work vividly illustrates the theory of the Russian critic Mikhail Bakhtin about the subversive power of laughter.[21]

Luther's friend the artist Lucas Cranach (1472–1553) and his workshop in Wittenberg produced many polemical prints, like the famous *Passional Christi und Antichristi* which contrasted the simple life of Christ with the magnificence and pride of his 'Vicar' the Pope. Thus one pair of woodcuts shows Christ fleeing from the Jews because they are trying to make him their king, while the Pope, on the other hand, defends with the sword his claim to temporal rule over the states of the Church (an obvious reference to the belligerent Pope Julius II, who had died in 1513). Again, Christ was crowned with thorns, the pope with the triple crown or tiara. Christ washed the feet of his disciples, but the Pope presents his foot for Christians to kiss. Christ travels on foot, the Pope is carried, and so on (illus. 18).[22]

Thus the image of the Pope was associated visually with greed for money, with the pride of power, with the devil and so on. Luther, on the other hand, as the late Bob Scribner pointed out, was made into a hero or even a saint, wearing a halo and accompanied by a dove to show that, like the authors of the Gospels, he was inspired by the Holy Spirit (illus. 19).[23] The use of woodcuts to spread their message more widely had some consequences which the reformers had never intended. By the 1520s, the critic of the cult of saints was himself becoming the object of a similar cult. It might not be beside the mark to speak of the 'folklorization' of Protestantism, its assimilation into the imagined world of the illiterate. In a culture of restricted literacy, images offer much richer evidence of this process than texts do.

Paſſional Chꝛiſti vnd

Antichꝛiſti.

Chꝛiſtus.
Als Jheſus iſt ein weytten wegk gangen / iſt er müd woꝛden.
Johan.4. Der mir wil nach volgen / der neñ ſeyn Creutz vff
ſich vnd volge mir. Mathei 16.
Er hatt yhm ſeyn Creutze ſelbſt getragen vnd iſt zu der ſtell die
Caluarie gnant woꝛdt / gangen.19.

Antichꝛiſtus.
Das capittel Si quis ſuadente vñ dergleychen zeygt gnug an
wie ſtarck der Bapſt das creutz der wyder wertigkeyt duldet / ſo
er alle die thenen / die hand an die pfaffen an legt voñ nala deyet
vñ dan tauffd gibt Vnd alſo auch tregt der Bapſt das creutz
das ynnen getauffte Chꝛiſten vff ym achſelen tragen müſſen.

18 Lucas Cranach, Paired woodcuts from *Passional Christi und Antichristi*
(Wittenberg: J. Grunenberg, 1521).

19 Hans Baldung
Grien, 'Luther as a
monk with a halo and
dove', detail from a
woodcut in *Acta et res
gestae ... in comitis
principum Wormaciae*
(Strasbourg: J.
Schott, 1521). British
Library, London.

Some historians, Hans Belting for instance, have suggested that the Reformation was a moment of a 'crisis of the image', a shift from what we might call 'image culture' to 'textual culture'.[24] The rise of iconoclasm in sixteenth-century Europe supports this interpretation. In some places, especially in the Calvinist parts of Europe in the later sixteenth century, there is evidence not only of moments of iconoclasm but also of what has been called 'iconophobia' in the sense of 'the total repudiation of all images'.[25]

However, it would be unwise to extend Belting's thesis to include the whole population of Europe at this time. Iconoclasts and iconophobes were probably a minority. Other scholars, David Freedberg for example, claim that sacred images retained much of their power in Protestant as well as Catholic Europe. This claim is supported by the fact that even after the 1520s, the great decade of German visual polemic, religious images continued to play a part in Lutheran culture. Sixteenth- and seventeenth-century paintings of scenes from the New Testament are still to be seen in churches in Germany and in Scandinavia.

Even more vivid testimony of the survival of the image in the Protestant world comes from visions. In the 1620s, a German Lutheran, Johan Engelbrecht, had visions of hell and heaven, 'the holy angels like a great many flames, and the elect souls like as many bright or light sparks'. A few years later, another Protestant of Polish origin, Kristina Poniatowa, had visions of red and blue lions, a white horse and an eagle with two heads. These heraldic visions suggest that Lutherans were developing their own image culture. A similar impression is given by paintings and prints from the eighteenth and nineteenth centuries.

Catholic image culture also changed, often by accentuating the very features the Protestants had criticized. The Council of Trent (1545–63), which did so much to reshape early modern Catholicism, solemnly reaffirmed the importance of sacred images alongside pilgrimages and the cult of holy relics. The images themselves increasingly reaffirmed doctrines that the Protestants had challenged. The ecstasies and the apotheoses of saints, for example, appear to be designed to overwhelm the viewer and underline the difference between holy people and ordinary mortals. The increasing frequency of representations of St Peter and St Mary Magdalen weeping tears of repentance has been interpreted as a visual answer to the attacks by Protestants on the sacrament of Confession.[26]

The increasingly theatrical style of images in the age of the baroque was surely part of the message. Among other things, this theatrical or rhetorical style expressed an awareness of the need to persuade the viewer, an awareness that was much less acute before Luther, if indeed it existed at all. So, supplementing the classic icono-graphical approach with ideas from psychoanalysis, we may describe these images as responses to the arguments of the Protestants on an emotional, unconscious or, shall we say, a 'subliminal' level. They might also be described as 'propaganda' for the Catholic Church. The idea of propaganda and the political uses of images are the subject of the following chapter.

4 Power and Protest

Ceux qui ont gouverné les peuples dans tous les temps ont toujours fait usage des peintures et statues pour leur mieux inspirer des sentiments qu'ils vouloient leur donner.
THE *CHEVALIER* JAUCOURT.

The religious art discussed in the last chapter developed in the early centuries of Christianity by appropriating elements from Roman imperial art. The frontal pose of emperors and consuls on thrones was adapted to represent Christ or the Virgin 'in Majesty', while the imperial halos were transferred to the saints.[1]

From the Middle Ages to the present, on the other hand, most of the traffic has been in the opposite direction, a long process of 'secularization' in the sense of appropriating and adapting religious forms for worldly purposes. Thus the painting of *Richard II Enthroned* in Westminster Hall is modelled on the image of Christ in Majesty, completing the circular tour from secular to religious uses and back. A still more dramatic example of secularization is a French royalist print, entitled *The New Calvary* (1792), showing the recently-guillotined Louis XVI hanging on the Cross.

Other examples are more subtle. The display of the images of rulers in public, increasingly frequent from the late Middle Ages onwards, appears to have been inspired by the cult of images of saints. Portraits of Elizabeth I as the Virgin Queen, mass-produced with the aid of stencils in the later sixteenth century, replaced portraits of the Virgin Mary and may have performed some of their functions, filling the psychological vacuum created by the Reformation.[2] According to a contemporary guide to etiquette, the portraits of King Louis XIV of France displayed in the palace of Versailles were supposed to be treated with as much respect as if the king himself were in the room in which they hung. Viewers were not allowed to turn their backs on these images.[3]

Studies of visual propaganda are generally concerned either with the French Revolution or with the twentieth century, focusing on Soviet Russia, Nazi Germany, Fascist Italy, or on polemical images of the two world wars.[4] In what follows I shall draw on these studies but try to place them within the history of images in politics over a much longer period, from Augustus to Louis XIV. Some historians doubt the wisdom of using modern concepts such as 'propaganda' to refer to the period before 1789. And yet, whether or not paintings and statues made an important contribution to the maintenance of particular regimes, they were widely believed to do so. It is not only in our own time that rulers have felt the need for a good public 'image'. As the *chevalier* Jaucourt wrote in the article on 'painting' in the *Encyclopédie*, 'At all times, those who have governed have always used paintings and statues, the better to inspire the people with the right sentiments' (see p.144 below). It should be added that both the extent to which governments use images and the ways in which they do this vary considerably in different periods, as this chapter will attempt to show.

As in the case of the sacred, this chapter will distinguish and attempt to read different kinds of image, whether they are focused on ideas or individuals and whether they are designed to maintain or subvert a given political order. Images which tell the story of political events will be left till Chapter 8.

Images of Ideas

One approach to the reading of images is to view 'the artist as a political philosopher', to quote the title of an article by Quentin Skinner reinterpreting a famous fresco by the painter Ambrogio Lorenzetti in the Palazzo Pubblico in Siena. Of course the problem of making abstract concepts visible, of making them concrete, is not a problem for artists alone. Metaphor and symbol have long played an important role in politics itself.[5] The image of Jânio Quadros, newly-elected president of Brazil in 1961, holding a broom to symbolize his wish to sweep away corruption was not only a television opportunity, but a revival of an old tradition.

One traditional metaphor is that of the ship of state, with the ruler or his chief minister as the pilot, a figure of speech made visible in the funeral procession of the emperor Charles V in 1558, for instance, when a life-size ship was drawn through the streets of Brussels. The metaphor was neatly adapted in a *Punch* cartoon of March 1890 by Sir John Tenniel (1820–1914) showing Kaiser Wilhelm dismissing his chancellor Otto von Bismarck, with the caption 'dropping the pilot'.

Another old metaphor for rule is that of horse and rider, a comparison implied by the equestrian statues of rulers discussed below and made even more explicit in the painting by Velázquez of Don Baltasar Carlos, son and heir of Philip IV of Spain, in the riding-school. It may be illuminating to juxtapose this painting with a contemporary Spanish treatise on political thought, the *Idea of a Christian Prince* (1640), by Diego de Saavedra Fajardo, which develops the metaphor, recommending the prince 'to tame the colt of power' by means of 'the bit of will ... the bridle of reason, the reins of policy, the switch of justice, and the spur of courage', and, above all, 'the stirrups of prudence'. At the time of the American Revolution, a British cartoonist gave the old metaphor a new twist by producing an image of 'The Horse America throwing his Master'.

Abstract concepts have been represented through personification from ancient Greek times if not before. The figures of Justice, Victory, Liberty and so on are usually feminine. In a famous Renaissance dictionary of images, Cesare Ripa's *Iconology* (1593), even 'Virility' was represented by a woman. In the western tradition, the number of these personifications has gradually grown. Britannia, for example, like her male equivalent John Bull, dates from the eighteenth century. From the French Revolution onwards, many attempts were made to translate into visual language the ideals of liberty, equality and fraternity. Liberty, for example, was symbolized by the red bonnet, a new version of the Phrygian cap associated in classical times with the freeing of slaves. Equality was shown in revolutionary prints as a woman holding a pair of scales – like the traditional image of Justice but without the blindfold.[6]

Liberty in particular has developed a characteristic iconography, drawing on the classical tradition but transforming it according to changing political circumstances as well as the talents of individual artists. The following three examples illustrate what might be called 'three concepts of liberty', extending the phrase of Sir Isaiah Berlin.

Eugène Delacroix's painting *Liberty Leading the People* (illus. 20) is by far the most famous of the many images of liberty which appeared in paint, plaster and bronze in the aftermath of the Parisian rising of 27–29 July, later known as the Revolution of 1830, which drove out King Charles X. Delacroix shows Liberty half as goddess (modelled on a Greek statue of Victory), half as a woman of the people, the tricolour raised in one hand and a musket in the other, her bare breasts and her Phrygian cap (a classical reference) symbolizing the freedom in the name of which the revolution was made. As for the 'people', the man in the top hat has sometimes been taken to be a bourgeois on

20 Eugène Delacroix, *Liberty Leading the People*, 1830–31, oil on canvas. Musée du Louvre, Paris.

account of his headgear. In fact, top hats were worn by some of the French working class at this time. In any case, a close inspection of his clothing, especially his belt and trousers reveals this figure as a manual worker, yet another example of the importance of small details. The painting offers us a contemporary interpretation of the events of 1830, associating it with the ideals of the revolution of 1789, to which the new 'citizen-king' Louis Philippe paid homage when he revived the use of the tricoloured flag as symbol of France. In 1831, *Liberty Leading the People* was acquired by the French government, as if its interpretation of recent events had been officially accepted. Its later history will be discussed below (Chapter 11).[7]

The Statue of Liberty (illus. 21), designed by the French sculptor Frédéric Auguste Bartholdi (1834–1904) and unveiled in 1886, is even more celebrated, combining the image of a modern Colossus of Rhodes guarding the harbour of New York with an ideological message. All the same, Marina Warner is surely right to contrast this

21 Frédéric Auguste Bartholdi, Statue of Liberty, New York, 1884–6.

'staid and matronly' figure, as she calls her, with the more obviously liberated woman painted by Delacroix. Once again, some of the iconographical details reinforce the statue's message. The broken chains at her feet, a traditional attribute of Liberty, reveal her identity, while the lamp in her hand refers to the sculptor's original conception of 'Liberty enlightening the world'. The political message of the statue is made explicit – for those in a position to read it – by the tablet she holds, which is inscribed '4 July, 1776'. Whatever the private thoughts of the French sculptor may have been, the iconographical clues lead to the conclusion that it is the American Revolution rather than the French that is being publicly celebrated. The halo, replacing the Phrygian bonnet, gives Liberty the air of a saint, so that it is tempting to speculate whether Italian or Polish immigrants approaching Ellis Island – where they were 'processed', prior to entry into the United States – may not have thought that they were viewing an image of the Virgin Mary, the patron of sailors, the 'Star of the Sea'.[8]

Echoing the Statue of Liberty in some respects, but diverging from it in others, the 10-metre-high (or, according to other sources, 8-metre-high) goddess of democracy unveiled on Tian-an-Men Square in Beijing on 30 May 1989 by students from the Central Arts Academy (illus. 22) is a revealing witness to the creativity of reception as well as to the political ideals of the demonstrators. The figure, made of plaster, wire and styrofoam, was variously known at the time as the goddess of democracy, liberty or the nation. Some western observers were quick – perhaps too quick – to assimilate the statue to her American prototype, revealing not only their ethnocentrism but also, once again, the elusiveness of iconography and the need for contextual analysis. The official media in China offered a similar interpretation for opposite reasons, since the analogy with the American statue allowed them to denounce the students' image as foreign, an invasion

of Chinese culture from abroad. Yet the Socialist–Realist style of the statue, following the tradition established in the years of Mao Zedong, goes some way towards undermining this interpretation. We might say that the goddess is alluding to the American cult of liberty without identifying with it.[9]

Nationalism is relatively easy to express in images, whether they caricature foreigners (as in the case of Hogarth's skinny Frenchmen), or celebrate the major events of a nation's history. Yet another way to express national or nationalist sentiments is to evoke the style of the folk art of the region, as in the so-called 'home style' (*Heimatstil*) of early-twentieth-century German and Swiss painters. Yet another is to depict the landscape characteristic of the region, as in the case of the 'Nordic nature' mentioned in an earlier chapter (2).

Socialism too has also been translated into visual form by artists in the USSR and elsewhere, following the model of 'Socialist Realism' and celebrating work in factories and on collective farms (Chapter 6). Again, the murals of Diego Rivera and his colleagues, commissioned by the post-revolutionary Mexican government from the 1920s onwards, were described by the artists themselves as 'a fighting, educative art', an art for the people bearing messages such as the dignity of the

22 A Chinese statue of the Goddess of Democracy, 1989, plaster. Tien-an-Men Square, Beijing (destroyed).

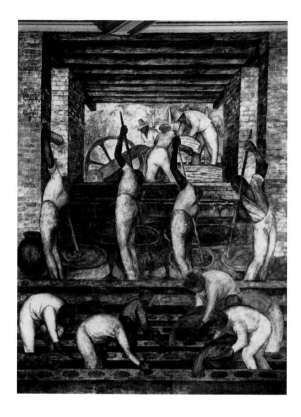

23 Diego Rivera, *The Sugar Refinery* (1923), from the fresco cycle *A Cosmography of Modern Mexico*, 1923–8. Ministry of Education (Court of Labour), Mexico City.

Indians, the evils of capitalism and the importance of labour (illus. 23). As was the case in Russia, the visual messages were sometimes reinforced with didactic or hortatory texts such as 'he who wants to eat must work' (*el que quiera comer, que trabaja*). Once again, an iconotext was considered to be more effective than an image alone.[10]

Images of Individuals

A more common solution to the problem of making the abstract concrete is to show individuals as incarnations of ideas or values. In the western tradition, a set of conventions for the representation of the ruler as heroic, indeed superhuman, was established in classical antiquity. Turning his attention from individual monuments to 'the totality of images that a contemporary would have experienced', the ancient historian Paul Zanker has argued that the rise of the Roman Empire in the time of Augustus (ruled 27 BC–AD 14) required a new, standardized visual language corresponding to its centralizing aims. Augustus, formerly Octavian, was portrayed in idealized fashion from 27 BC onwards, most famously in the more-than-life-size marble

statue now in the Museo Gregoriano Profano (illus. 24).

In this memorable image, Augustus is represented wearing armour, holding a spear or a standard, and raising his arm as if proclaiming victory. The small details of the scene represented on his breastplate reinforce the message – for viewers close enough to see them – by showing the defeated Parthians handing back the Roman standards they had captured earlier. The ruler's bare feet are not a sign of humility, as a modern viewer might think, but a means of assimilating Augustus to a god. During his long reign the official image of Augus-

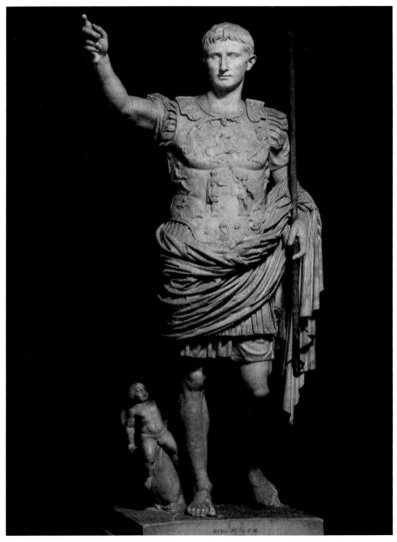

24 Statue of the Emperor Augustus (63 BC—AD 14), stone. Museo Gregoriano Profano, Rome.

tus remained the same, as if the emperor had discovered the secret of eternal youth.[11]

Images of rulers are often triumphalist in style. The classical iconography of triumph, expressed in ritual as well as in sculpture and architecture, included arches, such as the Arch of Constantine in Rome, and also a number of decorative details such as laurel wreaths, trophies, captives, processions, and personifications of victory (a winged woman) and fame (a figure with a trumpet). The size of the statues, sometimes colossal, was part of the statement they made, as in the case of the head of the emperor Constantine which is still to be seen in the Palazzo dei Conservatori in Rome, or the statue of Louis XIV erected on Place Louis-le-Grand in Paris, which was so large that during its erection the workmen were able to take their lunch inside the belly of the horse.[12]

Equestrian statues such as that of the cloaked and curly-headed emperor Marcus Aurelius (ruled AD 161–80) long displayed on the Capitol in Rome – and now replaced by a copy – made visible and palpable the metaphor of ruling as riding (illus. 25). The equestrian monument was revived in Italy at the Renaissance, asserting authority over the piazza in which it stood as the prince did over his domains. From the sixteenth century onwards, these 'bronze horsemen', as Alexander Pushkin called them, spread all over Europe – Grand Duke Cosimo de' Medici on Piazza della Signoria in Florence; Henri IV, Louis XIII and Louis XIV in Paris; Philip III and Philip IV in Madrid; the 'Great Elector' Frederick William of Brandenburg (ruled 1640–88), in Berlin and so on. This revival of the classical tradition was also an allusion to the classical tradition, like the habit of calling even princelings new Alexanders or second Augustuses. Most rulers contented themselves with one such statue, but Louis XIV's advisers organized what has been called a 'statue campaign' in which figures of the king were erected not only in Paris but also in Arles, Caen, Dijon, Grenoble, Lyon and elsewhere.[13] One of the most memorable of the long series of equestrians is the original 'bronze horseman' of Pushkin's phrase, the statue of Peter the Great commissioned by the empress Catherine from the French sculptor Etienne-Maurice Falconet and unveiled in 1782.

Rulers themselves were viewed as images, as icons. Their costume, their posture and the properties surrounding them conveyed a sense of majesty and power, as in the case of their painted and sculpted portraits. The analogy was drawn by some early modern observers such as the English ambassador Christopher Tunstall, who called the emperor Charles V 'as immoveable as an idol', or the Italian political

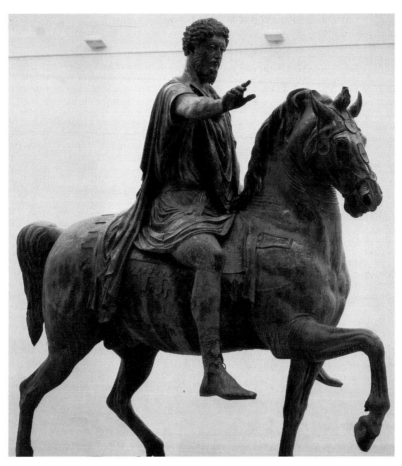

25 Statue of the Emperor Marcus Aurelius (121–180 AD), bronze. Museo Capitolino, Rome.

theorist Traiano Boccalini, who described the Spanish viceroy of Naples as so grave and motionless 'that I should never have known whether he was a man or a figure of wood'.

These phrases give modern viewers their cue. We should look at royal statues or 'state portraits' not as illusionistic images of individuals as they appeared at the time but as theatre, as public representations of an idealized self. The rulers are generally represented not in their ordinary clothes but in ancient Roman costume, or in armour, or in their coronation robes, so as to appear more dignified. The equestrian figure often treads down enemies, foreign or domestic, personifications of rebellion and disorder as well as of rival countries. One famous example is the life-size statue of Charles V by the Italian sculptor Leone Leoni, in which the emperor, spear in hand, stands over a chained figure labelled 'Fury'. Another is the standing figure of

68

Louis XIV, crowned with laurel by a winged figure (representing Victory), treading on a three-headed dog (representing the Triple Alliance of Louis' enemies, the Empire, Britain and the Netherlands), and accompanied by chained captives. This statue was formerly to be seen on the Place des Victoires in Paris. Destroyed in 1792, it is recorded in an engraving of the 1680s (illus. 26).

The examples cited so far have been taken from the age of personal monarchy, of the belief in the 'divine right' of kings to rule, and of 'absolutism', in other words, the theory that the ruler was above the law. What happened to images when this political system changed, especially after 1789? How could the conventions of royal portraiture be adapted to the ideology of progress, modernity, liberty, equality and fraternity? A number of solutions to this problem were proposed in the course of the nineteenth and twentieth centuries. Louis Philippe's costume and gaze (discussed above, Chapter 1) evoke the family nickname of 'Equality' (*Egalité*). A few years earlier, the painting of Napoleon in his study (illus. 27) by Jacques-Louis David (1748–1825), presented a relatively new aspect of power, the ruler as bureaucrat, tied to his desk even in the small hours of the morning (a candle has been lit and the clock shows nearly quarter past four).

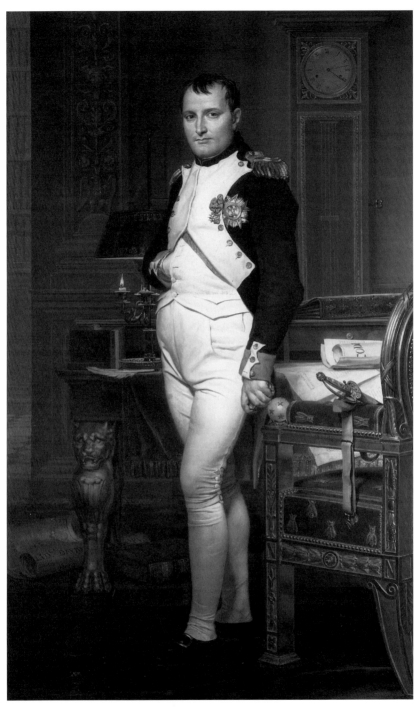

27 Jacques-Louis David, *The Emperor Napoleon in His Study at the Tuileries*, 1812, oil on canvas. National Gallery of Art, Washington, DC.

David's painting became a model for representations of rulers as diverse as Gérard's *Louis XVIII in his Cabinet* (1824) and Reschetnikov's *Stalin in his Office*.

Another form of adaptation to an age of democracy has been to stress the virility, youth and athleticism of the leader. Mussolini, for example, liked to be photographed jogging, whether in military uniform or stripped to the waist (illus. 28). A number of presidents of the USA have been photographed playing golf. Such images form part of what might be called a 'demotic' style of rulership. This style may also be illustrated by photographs of visits to factories in which the head of state speaks to ordinary workers and shakes their hands, or images of 'walkabouts' in which politicians kiss babies, or paintings demonstrating the accessibility of the ruler, as in Vladimir Serov's *Peasant Petitioners Visiting Lenin* (illus. 29), a painting which shows the most powerful man in Russia listening intently to three peasants, two of them seated at his table, and taking careful notes of their needs.

New media have also made their contribution to the myths of rulers. The images of Hitler, Mussolini and Stalin are as inseparable from the many posters that represented them in heroic style as from the radio that amplified their voices. The cinema (Chapter 8) also

28 Mussolini jogging on the beach at Riccione, 1930s, photograph.

29 Vladimir Serov, *Peasant Petitioners Visiting Lenin*, 1950, oil on canvas. State Tretyakov Gallery, Moscow.

made its contribution. Leni Riefenstahl's film *Triumph of the Will* (1935), made with Hitler's personal encouragement, showed the Führer being worshipped by his faithful followers.[14] Today, press photographers and television crews produce images of political leaders which are as influential as they are ephemeral. Their iconography would repay study in detail. For example, photographs of candidates campaigning for the presidency of the United States might be placed in series in order to bring out more clearly changes such as the increasing importance of the candidate's wife, especially in the period running from Jackie Kennedy to Hillary Clinton.

The importance of what might be called 'image management' deserves to be emphasized. In *Triumph of the Will*, Hitler was photo-

graphed from below and shown against the sky to make him appear taller and more heroic. The same device has been adopted in the portrait of Stalin by Fyodor Shurpin, reproduced on the cover of this book. Mussolini, another short dictator, stood on a footstool when reviewing his troops and taking the salute. Again, Nicolae Ceaușescu's portrait photographs had the wrinkles removed before they were allowed to be published in *Scînteia*, the Romanian Communist Party newspaper. Ceaușescu too was a short man and great pains were taken to disguise the fact. According to his English interpreter, 'The pictures of Ceaușescu at airports with foreign dignitaries were always taken from a fore-shortened angle to make sure that he looked as big as or bigger than the other person.'[15] Coming closer to home, a comparison between the photographs of the royal family in British and in foreign newspapers should be sufficient to show the importance of self-censorship.

The continuities between modern states and old regimes are as important as the changes that have taken place since 1789. 'Image management' may be a new phrase but it is not a new idea. Louis XIV, for example, used high heels and was not represented too close to his son because the Dauphin was taller. Napoleon had himself painted three times in his coronation robes (by David, by Ingres and by Gérard), thus placing himself in the series of state portraits described in Chapter 1, although he broke the conventions by wearing a wreath of laurel in place of a royal crown and holding a sceptre the size of a spear. In the twentieth century the great leader was often represented in uniform (the modern equivalent of armour), and sometimes on horseback as well. Mussolini was represented as a helmeted soldier, and Hitler, quite literally, as a knight in shining armour (illus. 30), to suggest that he was engaged in a kind of crusade.

The classical tradition of the colossus, associated with Alexander the Great, was revived in the USSR. There was a plan to top the Palace of the Soviets in Moscow with a statue of Lenin 100 metres high (as in the case of Alexander the Great, the project was never carried out). Although Napoleon was not the first person to be portrayed with his hand in his waistcoat, the gesture has become associated with him (illus. 27). For this reason many later rulers have adopted it, Mussolini and Stalin among them (illus. 31).

Sometimes the leader is represented as saint-like. David, for example, represented the assassinated revolutionary leader Marat as a martyr, indeed as Christ-like, his dead body in the bath in the traditional posture of Christ taken down from the Cross. A few years earlier, Benjamin West had represented the death of General Wolfe in similar fashion. In the twentieth century, Lenin was sometimes shown

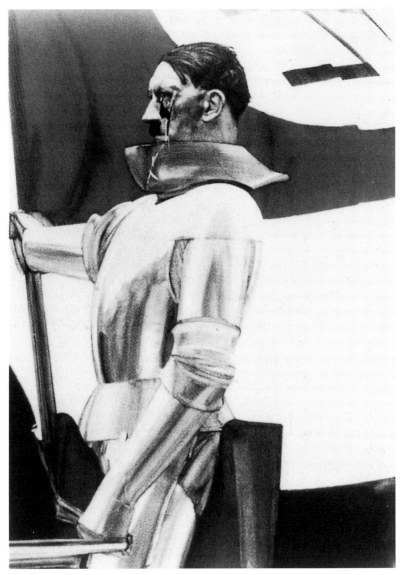

30 Hubert Lanziger, *Hitler as Flag Bearer*, 1930s(?), oil on canvas. US Army Art Collection, Washington, DC.

as a saint, whether making an eloquent gesture against a background of clouds, as in Aleksandr Gerasimov's *Lenin at the Tribune* (1930), or as a statue in a niche in Grigory Stregal's *The Leader, Teacher and Comrade* (1937). Giant portraits of Lenin, Stalin (illus. 31), Hitler, Mussolini, Mao, Ceaușescu and many other leaders have often been carried through the streets during demonstrations like so many icons.

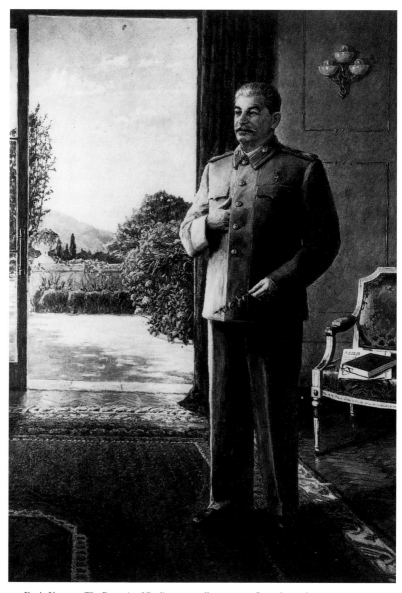

31 Boris Karpov, *The Portrait of Stalin*, 1949, oil on canvas. Location unknown.

These representations have sometimes been described as 'totalitarian art'.[16] The similarities between communist and fascist political images in the middle years of the twentieth century are indeed striking, though it is surely worth adding that, as the image of Augustus (illus. 24) reminds us, neither the adulation nor the idealization was a twentieth-century invention.

Democratic regimes favour portraits of prime ministers, socialist regimes the idealized images of workers. These are usually generalized or typical factory or farm workers but sometimes an exemplary individual will be chosen, Gregor Stakhanov for instance, a coal-miner whose enormous capacity for work made him the original 'Stakhanovite'. His portrait was painted by Leonid Kotlyanov in 1938. Many minor heroes are commemorated by statues in public places, so that a census of the statue population of a given city such as London or Paris, noting the balance between generals, politicians, poets and other social types, might reveal something important about the local political culture (mediated, of course, by the committees which commissioned the sculptors).

For example, in Paris, the 'open-air pantheon', as it has been called, displays intellectuals such as Voltaire, Diderot (on Boulevard St-Germain), and Rousseau. In Antwerp, Rubens has been prominent since his statue was erected in 1840, soon followed by Rembrandt in Amsterdam (1852). In London, on the other hand, one probably thinks first of Nelson on his column in Trafalgar Square (1843), and perhaps of Wellington at Hyde Park Corner (1846), although there are a host of other generals as well. It may tell us something significant about British political culture that radical politicians also have their place in the squares of London, from Charles James Fox (illus. 32) in Bloomsbury (1816), the first statue of a contemporary statesman, to Major Cartwright in Cartwright Gardens (1831) and Oliver Cromwell outside Parliament (a statue erected in 1899, to celebrate the tercentenary of his birth). Heroes of literature and art such as Shakespeare in Leicester Square (1874), and Joshua Reynolds outside the Royal Academy (1931) made a somewhat late appearance and remain rather less visible than soldiers and statesmen. The statue population is of course predominantly male, the most famous exceptions to the rule being Queen Victoria, Florence Nightingale at Waterloo Station (1915) and Edith Cavell in St Martin's Place (1920). The latter two women owe their place in the statue club to the fact that they were nurses who were therefore involved in major wars. Nurse Cavell is commemorated because she was shot by the Germans for helping British soldiers escape from Belgium.[17]

The way in which these figures are represented carries many messages. The survival of the equestrian monument well into the twentieth century, as in the case of Field Marshal Haig in Whitehall (1937), reveals something of the traditional values of English elites, even after the First World War. So does the survival of Roman costume into the nineteenth century. For example, the sculptor

32 Richard
Westmacott,
Charles James Fox,
1810–14, bronze.
Bloomsbury
Square, London.

Richard Westmacott (1775–1856) showed Charles James Fox (illus. 32) in a Roman toga. Like his contemporaries, the artist remained reluctant to represent a statesman wearing trousers (in 1770, the American painter Benjamin West had shocked some viewers by representing the death of General Wolfe in the military uniform he had been wearing when he was killed). Westmacott's image management has also been noted. Fox is represented seated because he was 'too portly to appear dignified standing'. The political message of the monument is revealed by the scroll in Fox's hand representing liberty in the form of Magna Carta. The place in which the monument was erected, near the British Museum, deserves to be emphasized. The statue was erected on 'Whig territory' in Bloomsbury, since by this time, as Nicholas Penny has pointed out, Fox had become the object of a Whig cult.[18]

Iconoclasm is not simply a religious phenomenon. There is also polit-
ical iconoclasm or 'vandalism'. The latter term was coined by the
abbé Henri Grégoire (1750–1831), a supporter of the French Revolu-
tion but an opponent of what he considered its excesses. All the same,
Grégoire recognized the fundamental point made by the iconoclasts,
and made again in this chapter, which is that images propagate values.
He described the monuments of the old regime as 'contaminated by
mythology' and bearing 'the imprint of royalism and feudalism'. He
supported the removal of these monuments, but he wanted them to
be placed in museums rather than destroyed. In fact a number of
monuments were smashed in 1792, among them the two statues of
Louis XIV mentioned earlier, one on Place Louis-le-Grand, the name
of which was changed to Place Vendôme, and the other on Place des
Victoires.[19]

Many other political revolutions have destroyed monuments asso-
ciated with the previous regime. During the Paris Commune of 1871,
the painter Gustave Courbet was responsible for the demolition of
the column in the Place Vendôme and its statue of Napoleon, which
had replaced that of Louis XIV. The Russian Revolution was accom-
panied by the smashing of statues of the tsars, partially recorded on
film at the time, and the Hungarian Revolution of 1956 by the
destruction of the Stalin Monument in Budapest. The fall of the
Berlin Wall was accompanied by the fall of a number of statues from
1989 onwards, including those of the secret police chief Felix
Dzerzhinsky (in Warsaw and Moscow) and of Lenin (in Berlin,
Bucharest, and many other places). In China, on the other hand,
although a few statues of Mao Zedong on university campuses were
toppled in 1988, the best-known act of iconoclasm was conservative
rather than radical. It was the work of the army, which destroyed the
goddess of democracy erected in Tian-an-Men Square in 1989 only a
few days after it had been erected.[20]

Alternatively, the work of subversion may be done by images
themselves. Even a public monument can occasionally be subversive.
Today, tourists who frequent the Campo dei Fiori in Rome may take
the statue of Giordano Bruno in the centre of the square for granted,
if indeed they notice it at all. At the time, though, the erection of the
statue in 1889, after decades of controversy, was a dramatic gesture.
This image of a leading heretic was deliberately placed on the spot
where he had been burned in 1600, and it was erected in defiance of
the Pope at a time when the Italian Prime Minister was a Deist and a

freemason. It was in a sense a monument to anti-clericalism.[21]

More recently, there has been a reaction against monumental forms. The anti-heroic, minimalist style of certain public monuments or 'counter-monuments', both expresses and encourages scepticism concerning heroic views of history and politics. A famous example of the new trend is the Monument against Fascism (1986) in Hamburg, designed by Jochen and Esther Gerz. Its sinking column was deliberately planned to be ephemeral rather than eternal, and to disappear from sight by 1990. It would appear that the age of 'heroes on horseback' has finally come to an end.[22]

In yet another instance of secularization, the arsenal of techniques developed for religious polemic during the Reformation (Chapter 3) was appropriated for political uses. The image campaign against Louis XIV carried on by Dutch artists after the invasion of their country by French troops in 1672 was a continuation of warfare by other means, parodying the official medals and showing the 'sun king' as Phaeton, an incompetent driver whose heavenly chariot crashed.[23]

In England, the rise of political prints in the 1730s has been linked to the emergence of an official opposition to the government. In France, they were linked to the Revolution of 1789, another war of images (Chapter 8), in which over 6,000 prints were produced, thus widening the public sphere and extending the political debate to the illiterate. After 1789 it is no longer anachronistic to speak of 'propaganda'. The revolutionary journalist Camille Desmoulins (1760–1794), for instance, compared 'the propagation of patriotism' with that of Christianity, while the royalists in exile denounced the 'propaganda' of the Revolution. Since 1789, visual propaganda has occupied a large place in modern political history.[24]

All the same, the political uses of images should not be reduced to attempts to manipulate the viewing public. Between the invention of the newspaper and the invention of television, for instance, caricatures and cartoons made a fundamental contribution to political debate, demystifying power and encouraging the involvement of ordinary people with affairs of state. They performed these tasks by presenting controversial issues in a simple, concrete and memorable way and the main actors on the political stage as unheroic fallible mortals. Hence the work of the cartoonist James Gillray (1756–1815), for example, now offers historians precious glimpses of eighteenth-century English politics as viewed from below. Honoré Daumier (1808–1879), a savage critic of King Louis Philippe, offers similar glimpses of nineteenth-century French attitudes, and David Low (1892–1963), the creator of Colonel Blimp, of English ones in the first

half of the twentieth century. The popularity of these caricatures when they were first published suggests that they struck a chord. For this reason they can be used with some confidence to reconstruct vanished political attitudes or mentalities.

5 Material Culture through Images

'I can never bring you to realise the importance of sleeves ...
or the great issues that may hang from a bootlace.'
HOLMES TO WATSON IN ARTHUR CONAN DOYLE'S
A CASE OF IDENTITY

The last two chapters concentrated on what images reveal or imply about ideas, attitudes and mentalities in different periods. Here, in contrast, the emphasis will fall on evidence in a more literal sense of that term, in other words on the uses of images in the process of the reconstruction of the material culture of the past, in museums as well as in history books. Images are particularly valuable in the reconstruction of the everyday culture of ordinary people – their housing for example, sometimes built of materials which were not intended to last. For this purpose John White's painting of an Indian village in Virginia in the 1580s (illus. 3), for example, is indispensable.

The value of images as evidence for the history of clothes is obvious enough. Some items of clothing have survived for millennia, but to move from the isolated item to the ensemble, to see what went with what, it is necessary to turn to paintings and prints, together with some surviving fashion dolls, mainly from the eighteenth century or later. So the French historian Fernand Braudel (1902–1985) drew on paintings as evidence for the spread of Spanish and French fashions in England, Italy and Poland in the seventeenth and eighteenth centuries. Another French historian, Daniel Roche, has used not only inventories but also paintings such as the famous *Peasant Supper* of 1642 (illus. 61) for the history of clothes in France. The rich series of surviving ex-votos from Provence, discussed in an earlier chapter (3), which represent scenes from everyday life, allow the historian to study continuity and change in the clothes of different social groups in that region. One from Hyères in 1853, for instance, shows how butchers dressed for work (illus. 16).[1]

33 Jean-Baptiste Debret, 'Petit Moulin à Sucre portatif' (machine for squeezing juice from sugar-cane), aquatint from *Voyage pittoresque et historique au Brésil* (Paris, 1836-9).

Again, the history of technology would be much impoverished if historians were obliged to rely on texts alone. For example, the chariots used thousands of years before Christ in China, Egypt and Greece can be reconstructed from surviving models and tomb-paintings. The apparatus for viewing the stars constructed for the Danish astronomer Tycho Brahe (1546-1601) in his observatory of Uraniborg was captured in an engraving that has been reproduced many times in histories of science precisely because other sources are lacking. The apparatus used to squeeze juice from a sugar cane on the plantations of Brazil, on the same principle as the mangles which used to be found in sculleries, is clearly illustrated in an aquatint by the French artist Jean-Baptiste Debret, in which two seated men feed the machine while two more supply the energy which keeps the 'engine' turning (illus. 33).

Historians of agriculture, weaving, printing, warfare, mining, sailing and other practical activities – the list is virtually infinite – have long drawn heavily on the testimony of images to reconstruct the ways in which ploughs, looms, presses, bows, guns and so on were used, as well as to chart the gradual or sudden changes in their design. Thus a small detail in the painting of *The Battle of San Romano* by Paolo Uccello (1397-1475) is one testimony among others to the way in which a crossbowman held his instrument while he was reloading it. Eighteenth-century Japanese scroll paintings not only provide the

precise measurements of different kinds of Chinese junk but allow historians to observe their equipment in detail, from anchors to cannon and from lanterns to cooking-stoves.[2] When the National Photographic Record Association was founded in Britain in 1897, to make photographs and lodge them in the British Museum, it was especially of records of buildings and other forms of traditional material culture that the founders were thinking.[3]

A particular advantage of the testimony of images is that they communicate quickly and clearly the details of a complex process, printing for example, which a text takes much longer to describe more vaguely. Hence the many volumes of plates in the famous French *Encyclopédie* (1751–65), a reference book which deliberately placed the knowledge of artisans on a par with that of scholars. One of these plates showed readers how books were printed by picturing a printer's workshop during four different stages of the process (illus. 34).

It is of course dangerous to treat illustrations of this kind as an unproblematic reflection of the state of technology in a particular place and time without engaging in source criticism, identifying the artists (in this case L.-J. Goussier) and, still more important, the artist's sources. In this case it turns out that a number of plates in the *Encyclopédie* were not based on direct observation. They are revised versions of earlier illustrations, from Chambers' *Cyclopedia*, for instance, or from the illustrated *Description des Arts* published by the French Academy of Sciences.[4] As always, source criticism is necessary, but the juxtaposition and comparison of engravings of print-

34 Engraving of the composing room of a printing shop ('Imprimerie'), from the 'Receuil des planches' (1762) of the *Encyclopédie* (Paris, 1751–2).

shops between 1500 and 1800 gives the viewer a vivid impression of technological change.

Two kinds of image, townscapes and views of interiors, will illustrate these points in more detail.

Townscapes

Urban historians have long been concerned with what they sometimes call 'the city as artifact'.[5] Visual evidence is particularly important for this approach to urban history. For example, there are valuable clues to the appearance of Venice in the fifteenth century in the background of paintings in the 'eyewitness style' (see Introduction) such as the *Miracle at the Rialto* by Carpaccio (illus. 35), which shows not only the wooden bridge which preceded the present stone one (erected at the end of the sixteenth century) but also details, such as an unusual form of funnel-shaped chimney, which has disappeared even from surviving palaces of the period but once dominated the Venetian skyline.

In the middle of the seventeenth century, townscapes, like landscapes, became an independent pictorial genre, beginning in the Netherlands with views of Amsterdam, Delft and Haarlem and spreading widely in the eighteenth century.[6] Giovanni Antonio Canaletto (1697–1768), one of the best-known exponents of this genre, known in Italian as 'views' (*vedute*), worked in Venice and for a few years in London. His nephew Bernardo Bellotto (1721–1780) worked in Venice, Dresden, Vienna and Warsaw. Prints of city life were also popular at this time, and so were engravings or aquatints of particular buildings or kinds of building, like the views of Oxford and Cambridge colleges published by the artist David Loggan in 1675 and 1690 and by Rudolph Ackermann (like Loggan, an immigrant from central Europe), in 1816. The rise of these genres at this particular time has itself something to tell us about urban attitudes, civic pride for example.

The fact that the painters of the Dutch Republic were among the first to paint townscapes and domestic interiors – not to mention the still-life – is a valuable clue to the nature of Dutch culture at this period. This culture, dominated by cities and merchants, was one in which the observation of 'microscopic' detail was highly valued. Indeed, it was a Dutchman, Cornelis Drebbel (*c.* 1572–1633), who invented the microscope and another Dutchman, Jan Swammerdam (1637–1680), who first used it to discover and describe a new world of insects. As the American art historian Svetlana Alpers has suggested, seventeenth-century Dutch culture was one which encouraged an 'art of describing'.[7]

35 Vittore
Carpaccio, *Miracle
at the Rialto*,
c. 1496, oil on
canvas. Galleria
dell'Accademia,
Venice.

In the case of townscapes, the details of particular images some-
times have particular value as evidence. The Old Town of Warsaw,
virtually levelled to the ground in 1944, was physically reconstructed
after the Second World War on the basis of the testimony of prints
and also of the paintings of Bernardo Bellotto. Architectural histor-
ians make regular use of images in order to reconstruct the appear-
ance of buildings before their demolition, enlargement or restoration:
old St Paul's Cathedral in London (before 1665), the old town hall in
Amsterdam (before 1648) and so on.

For their part, urban historians not infrequently use paintings,
prints and photographs so as to imagine and to enable their readers to
imagine the former appearance of cities – not only the buildings but
also the pigs, dogs, and horses in the streets, or the trees which lined
one side of one of the grandest canals in seventeenth-century
Amsterdam (illus. 36), the Herengracht, as drawn by Gerrit Berck-
heyde (1638–1698). Old photographs are particularly valuable for the
historical reconstruction of slums that have been swept away, reveal-
ing the importance of alley life in a city such as Washington as well as
specific details such as the location of kitchens.[8]

As one might have expected, the employment of images as evidence
in this way is not without its dangers. Painters and printmakers were
not working with future historians in mind and what interested them,
or their clients, may not have been an exact representation of a city
street. Artists such as Canaletto sometimes painted architectural

36 Gerrit Adriaensz. Berckheyde, *A Bend in the Herengracht, Amsterdam*, before 1685(?), wash and india ink. Gemeentearchief, Amsterdam.

fantasies or *capricci*, magnificent constructions that never went beyond the drawing-board; or they allowed themselves to rearrange a particular city in their imagination, as in the case of a number of composite images bringing together the main sights of Venice.

Even if the buildings are presented with apparent realism, as in the works of Berckheyde, for instance, the cities may have been cleaned up by the artists, the equivalent of the portrait painters who tried to show their sitters at their best. These problems of interpreting the evidence extend to photography. Early photographs of cities often show implausibly deserted streets, to avoid the blurring of the images caused by rapid movement, or they represent people in stock poses, as if the photographers had been inspired by earlier paintings (Chapter 1). According to their political attitudes, the photographers chose to represent the most run-down houses, in order to support the argument for slum clearance, or the best-looking ones, in order to oppose it.

For a vivid example of the importance of replacing images in their original contexts in order not to misinterpret their messages, we may turn to the painting of the port of La Rochelle (illus. 37) by Claude-Joseph Vernet (1714–1789), part of a series of fifteen works devoted to the ports of France, a series which attracted considerable interest, as the high sales of the engraved reproductions testify. This harbour scene with its forest of masts across the river and the men working in the foreground has something of the immediacy of a snapshot. However, the artist has shown the harbour as busy at a time, the mid eighteenth century, when other sources suggest that La Rochelle's trade was actually in decline. What is going on?

37 Claude-Joseph Vernet, *The Port of La Rochelle*, 1763, oil on canvas. Musée du Louvre, Paris.

The question can be answered by replacing the painting in its political context. Like other works in the series, it was painted by Vernet on commission from the marquis de Marigny on behalf of King Louis XV. Even the painter's itinerary was officially planned. Marigny wrote to Vernet criticizing one of the views, that of the port of Cette, because it had achieved beauty at the expense of 'verisimilitude' (*ressemblance*), and reminding the painter that the king's intention was 'to see the ports of the kingdom represented in a realistic manner' (*au naturel*). On the other hand, Vernet could not afford to be too realistic. His paintings were to be exhibited as a form of propaganda for French seapower.[9] If the letters and other documents which illuminate the situation had not survived, economic historians might well have used this painting as a basis for over-optimistic conclusions about the state of French trade.

Interiors and Their Furnishings

In the case of images of the interiors of houses, the 'reality effect' is even stronger than in that of townscapes. I vividly remember my own reaction, as a small boy visiting the National Gallery in London, to paintings by Pieter de Hooch (1629–1684), who specialized in interiors of Dutch houses and courtyards, complete with mothers, servants, children, men drinking and smoking pipes, buckets, barrels, linen chests and so on (illus. 38). In the presence of such paintings the three centuries separat-

ing the viewer from the painter seemed to evaporate for a moment, and the past could almost be felt and touched as well as seen.

The doorway, the frontier between public and private zones, is the centre of interest in a number of seventeenth-century Dutch paintings. One artist, Jacob Ochtervelt (1634–1682), specialized in such scenes: street musicians at the door, or people selling cherries, grapes, fish or poultry (illus. 81). Looking at pictures such as these, it is once again difficult to repress the sense of viewing a snapshot, or even of entering a seventeenth-century house.[10] In similar fashion, well-preserved houses, such as Ham House in Surrey, or the cottages preserved and displayed in open-air museums such as Skansen near Stockholm, filled with furniture from the period in which they were built, give the visitor a sense of direct contact with life in the past.

It takes an effort to remind ourselves that this immediacy is an illusion. We cannot enter a seventeenth-century house. What we see when we visit such a building, whether it is a peasant's cottage or the palace of Versailles, is inevitably a reconstruction in which a team of museum workers have acted like historians. They draw on the evidence of inventories, paintings and prints in order to discover what kind of furnishings might have been appropriate in a house of this kind and how they would have been arranged. When the building was modified in later centuries, as in the case of Versailles, the restorers have to decide whether to sacrifice the seventeenth century to the eighteenth or vice versa. In any case, what we see today is largely a reconstruction. The difference between a fake and an 'authentic' seventeenth-century building in which a substantial part of the wood and stone has been replaced by modern carpenters and masons is surely a difference in degree rather than a difference in kind.[11]

As for paintings of domestic interiors, they should be approached as an artistic genre with its own rules for what should or should not be shown. In fifteenth-century Italy, such interiors appear in the background of religious scenes, as in the case of townscapes. Thus Carlo Crivelli's *Annunciation* (1486), still to be seen in the National Gallery in London, shows the Virgin Mary reading at a wooden desk, with books, candlesticks and bottles on a shelf behind her, while in an upper story we see an oriental rug hung over a parapet.[12]

In the Netherlands in the seventeenth century, images of the interiors of houses turned into a distinct genre with its own conventions. Often taken to be simple celebrations of everyday life, a number of these interiors have been interpreted by a leading Dutch art historian, Eddy de Jongh (Chapter 2) as moral allegories in which what was being celebrated was the virtue of cleanliness or that of hard work.[13]

38 Pieter de Hooch, *Courtyard of a House in Delft*, 1658, oil on canvas. National Gallery, London.

The Disorderly Household by Jan Steen (1626–1679) (illus. 39), for example, with playing cards, oyster-shells, loaves and even a hat artfully scattered on the floor, clearly carries a message about the links between order and virtue, disorder and sin. The painting may also serve to warn twenty-first-century viewers that an artist is not a camera but a communicator with his or her own agenda. Even in the culture of description, people – or at any rate some people – continued to be concerned with what lay beneath the surface, both the surface of images and that of the material world which they represented.[14]

Bearing these problems in mind, however, much can still be learned from the careful study of small details in images of interiors – houses, taverns, cafés, classrooms, shops, churches, libraries, theatres and so on. The rapid sketch of the interior spaces of The Swan Theatre in Southwark during the performance of a play, made by a foreign visitor to London around 1596 (illus. 40), showing a two-storey house set at the back of an open stage and the audience surrounding the performers, is a precious piece of evidence on which historians of the drama in the age of Shakespeare have drawn again and again. They

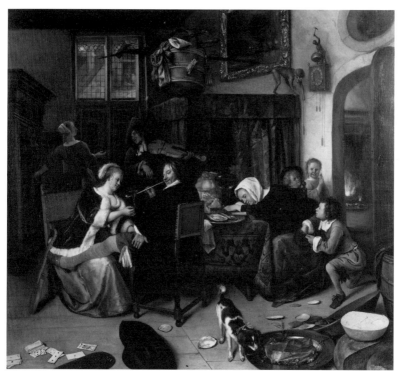

39 Jan Steen, *The Disorderly Household*, 1668, oil on canvas. Apsley House (The Wellington Museum), London.

40 Johannes De Witt, Sketch of the interior of The Swan Theatre, London, *c.* 1596. Utrecht University Library.

are surely right to do so, since a knowledge of the layout of the theatre is essential to the reconstruction of early performances, which is necessary in turn to an understanding of the text. To view the arrangement of objects, scientists and assistants in a laboratory (illus. 41) is to learn something about the organization of science about which texts are silent. Representing gentlemen as wearing top hats in the laboratory challenges assumptions of a 'hands-on' attitude to research.

Again, the Bayeux Tapestry has been described as 'a splendid source for an understanding of the material culture of the eleventh

41 I. P. Hofmann, Engraving showing Justus von Liebig's chemistry laboratory at Giessen, from *Das Chemiche Laboratorium der Ludwigs-Universität zu Giessen* (Heidelberg, 1842).

91

42 Vittore Carpaccio, *St Augustine in his Study*, 1502–8, oil and tempera on canvas. Scuola di S. Giorgio degli Schiavoni, Venice.

century'. The bed with hangings shown in the scene of the death of King Edward the Confessor offers testimony that cannot be matched in any other contemporary document.[15] Even in the case of the better-documented nineteenth century, images capture aspects of material culture which would otherwise be extremely difficult to reconstruct. The heaps of straw and the turf-beds on which some of the inhabitants of Irish cottages slept at this time have long disappeared but they may still be visualized thanks to the watercolours painted by artists of the period, mainly foreign visitors who were impressed – unfavourably for the most part – by conditions which local artists probably took for granted.[16]

Renaissance paintings, sketches and woodcuts of scholars in their studies, especially the scholarly saints or saintly scholars Jerome and Augustine, have been used as evidence for the equipment of the studies of the humanists, their desks, bookshelves and lecterns. In the case of Carpaccio's *St Augustine in his Study* (illus. 42), for instance, the so-called 'revolving chair' has attracted particular attention, though the presence of statuettes, a shell, an astrolabe and a bell (to summon servants) deserve to be noted, as well as the books and writing equipment. Other Italian representations of studies, from Antonello da Messina's *St Jerome* to Lorenzo Lotto's sketch of a young cardinal, confirm the accuracy of some of Carpaccio's details as well as adding new ones.[17]

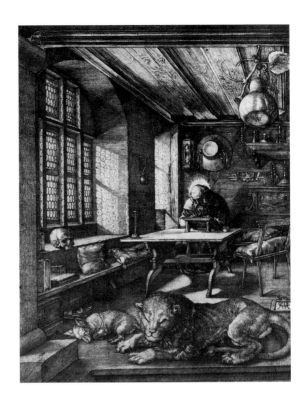

43 Albrecht Dürer,
St Jerome in his Study,
1514, engraving.

It might also be revealing to compare Carpaccio's *Augustine* with images of studies in other cultures or periods. For a distant comparison and contrast we might turn to the studies of Chinese scholars, for example, which are often represented in paintings and woodcuts in a standardized form that presumably represents the cultural ideal. The typical study looked out on a garden. The furnishings included a couch, bookshelves, a desk on which stood the scholar's 'four friends' (his writing brush, brush stand, inkstone and water dropper), and perhaps some ancient bronzes or examples of fine calligraphy as well. The study was more of a status symbol in China than it was in Europe, since it was from the ranks of the so-called 'scholar-gentry' that the rulers of the country were recruited.

For a more neighbourly comparison, we might juxtapose the Carpaccio image to the equally famous woodcut of *St Jerome in his Study* (1514) by Albrecht Dürer (illus. 43), whether what is revealed is a difference between individual painters or a more general contrast between studies in Italy and Germany. Dürer shows a room that may seem rather empty to us but was in some ways luxurious for its period, with soft cushions on the chair and benches, despite Jerome's well-

93

known asceticism. On the other hand, as Panofsky pointed out, the table is bare and 'holds nothing but an inkpot and a crucifix', besides the sloping board on which the saint is writing.[18] Books are few and in the case of a well-known scholar, this absence is surely eloquent. One wonders whether a painter who lived at a time when the printing press was a new and exciting invention was not making a historical point about the poverty of manuscript culture in the age of Jerome. By contrast, a woodcut of Erasmus and his secretary Gilbert Cousin at work together shows a bookcase full of books behind the secretary.

Advertising

The images used in advertising may help historians of the future to reconstruct lost elements of twentieth-century material culture, from motor cars to perfume bottles, but at present, at any rate, they are more useful as sources for the study of past attitudes to commodities. Japan was, appropriately enough, one of the pioneers in this respect, witness the references to branded products, such as sake, in some of the prints of Utamaro (1753–1806). In Europe, the later eighteenth century witnessed the rise of advertising through images such as the new kind of chaise longue illustrated in a German journal specifically devoted to innovations in the world of consumption, the *Journal des Luxus und des Moden* (illus. 44).

A second stage in the history of advertising was reached in the later nineteenth century with the rise of the poster, a large coloured lithograph displayed in the street. Jules Chéret (1836–1932) and Alphonse

44 G. M. Kraus(?), Engraving of a chaise-longue with reading-desk attachment, from *Journal des Luxus und des Moden* (1799).

Mucha (1860–1939), both working in Paris during the *belle époque*, produced a series of posters advertising plays, dance halls, bicycles, soap, perfume, toothpaste, beer, cigarettes, Singer sewing-machines, Moët et Chandon champagne, 'Saxoleine' kerosene for lamps and so on. Beautiful women were shown together with all these products in order to seduce the viewers into buying.

It was in the twentieth century, however, that advertisers turned to 'depth' psychology in order to appeal to the unconscious minds of consumers, making use of so-called 'subliminal' techniques of persuasion by association. In the 1950s, for example, split-second flashes of advertisements for ice cream were shown during the screening of feature films in the USA. The audience did not know that they had seen these images, but the consumption of ice cream increased all the same.

It may be useful to employ the term 'subliminal' in a broader sense to refer to the way in which the mental image of a given product is built up by associating various objects with its visual image. The process is one of conscious manipulation on the part of the advertising agencies, their photographers and their 'motivational analysts', but it is largely unconscious to the viewers. In this manner the sports car, for instance, has long been associated with power, aggression and virility, its qualities symbolized by names such as 'Jaguar'. Cigarette advertisements used to show images of cowboys in order to exploit a similar range of masculine associations. These images testify to the values that are projected on to inanimate objects in our culture of consumption, the equivalent, perhaps, of the values projected on to the landscape in the eighteenth and nineteenth centuries (Chapter 2).

Take the case of advertisements for perfume from the 1960s and 1970s respectively, decades that are perhaps sufficiently distant by now to be regarded with some degree of detachment. The Camay advertisement (illus. 45), for instance, represents the interior of a fashionable auction-room (the name 'Sotheby's' is visible on the catalogue) in which a good-looking and well-dressed man is distracted from the works of art he is viewing by the vision – or is it the perfume? – of the girl who uses the product (Chapter 10).[19] The Camay girl is beautiful but anonymous. In contrast, some advertisements of Chanel No. 5 juxtaposed the perfume to the actress Catherine Deneuve. Her glamour rubs off on the product, encouraging female viewers to identify with her and follow her example. Or perhaps, in a more ambitious formulation, 'What Catherine Deneuve's face means to us in the world of magazines and films, Chanel No. 5

seeks to mean and comes to mean in the world of consumer goods.' As in the case of some advertisements analysed by Roland Barthes, the interpretation of the Camay image by Umberto Eco and of the Chanel image by Judith Williamson follows the lines of a structuralist or semiotic approach (to be discussed in more detail below, Chapter 10), rather than an iconographical one, concentrating on the relation between different elements in the picture and viewing it in terms of binary oppositions.[20]

Problems and Solutions

The examples discussed in the previous two sections raise problems with which the reader will already be familiar, such as the problem of the visual formula. The representations of furniture in the Bayeux Tapestry, for instance, have been described as 'formulaic'. Again, there is the problem of the artist's intentions, whether to represent the visible world faithfully or to idealize or even to allegorize it. A third problem is that of the image which refers to or 'quotes' another

image, the visual equivalent of intertextuality. David Wilkie's *Penny Wedding* (1818), for example, which is full of details of material culture, is doubtless based to some extent on the observation of his native Fife, but it also borrows from or alludes to seventeenth-century Dutch paintings or prints. So to what extent and in what ways can the painting be used by social historians of nineteenth-century Scotland? Yet another problem concerns possible distortion. As was noted earlier, artists may tidy up the rooms and sanitize the streets in their paintings. Other images diverge still further from the everyday. Using the evidence of advertisements, from posters to TV commercials, historians from the year 2500 might be tempted to assume that the standard of living for ordinary people in England in the year 2000 was considerably higher than it actually was. To use the evidence safely, they would need to be familiar with the current televisual convention of representing people in better houses and surrounded by more expensive items than they could in practice have afforded.

On other occasions, the disorder and squalor of rooms may be exaggerated by the artists, whether consciously, like Jan Steen, in order to make a particular rhetorical or moral point, or unconsciously, because they are representing a culture the rules of which they do not know from inside. Cottage interiors in Sweden in the nineteenth century, as in Ireland, were generally sketched by outsiders, who might be foreign and in any case were middle class. A drawing representing a Swedish farmhouse at the beginning of the day, five o'clock in the morning (illus. 46), vividly illustrates the farmers' lack of privacy, with cubicles in the wall instead of bedrooms. More exactly, what it shows is the lack of privacy as perceived by middle-class eyes, including those of the artist, Fritz von Dardel.[21]

Then there is the problem of the *capriccio*, discussed above. View-painters sometimes liked to create architectural fantasies, as Carpaccio did in his famous paintings of the life of St Ursula. In the case of his *Augustine in his Study*, attention has been drawn to 'the strange chair with the reading-stand and the scarcely less curious writing-desk', of which no analogues have survived.[22] Was this a case of fantasy furniture, or can we assume that these objects once existed?

A more complex example of the problems involved in reading images of interiors comes from the series of church interiors painted by the seventeenth-century Dutch artist, Pieter Saenredam (1597–1665). One might have thought that there was no point in representing these churches other than as they were, but careful scrutiny has raised some awkward questions. At the time, these churches were being used for Calvinist worship. However some Catholic images are visible in the

46 Fritz von Dardel, *Morning Reveille in Orsa*, 1893, wash drawing.
Nordiska Museet, Stockholm.

47 Pieter Jansz.
Saenredam, *Interior
of the Church of St
Bavo in Haarlem*,
1648, oil on panel.
National Gallery of
Scotland,
Edinburgh.

paintings and even, on occasion, people engaged in what appears to be a Catholic ritual, such as the baptism represented as taking place in the south aisle of the church of St Bavo in Haarlem (illus. 47). A careful scrutiny of small details shows that the officiant is no Protestant pastor but a Catholic priest dressed in a surplice and stole. It is known that Saenredam was friendly with Catholics in Haarlem (there were many Catholics in the Dutch Republic in the seventeenth century). In the paintings the artist 'restored' the churches to their earlier Catholic state. Saenredam's images offer better evidence of the persistence of Dutch Catholicism than of the contemporary appearance of Dutch churches. They are not simple views but 'laden with historical and religious overtones'.[23]

On the positive side, images often show details of material culture that people at the time would have taken for granted and so failed to mention in texts. The dogs in Dutch churches or libraries or in Loggan prints of Oxford and Cambridge colleges would hardly have been represented if they were not commonly to be found in these places, and so they have been used to support an argument about the omnipresence of animals in everyday life at this time.[24] The testimony of images is all the more valuable because they show not only past artefacts (which have sometimes survived and may be studied directly) but also their organization; the books on the shelves of libraries and bookshops (illus. 48), for instance, or the exotic objects

48 'Interior View of John P. Jewett & Co.'s New and Spacious bookstore, No. 117 Washington Street, Boston', engraving from *Gleason's Pictorial*, 2 December 1854.

49 Giovanni Battista Bertoni, Woodcut of the Museum of Francesco Calzolari, from
Benedetto Cerutti and Andrea Chiocco, *Musaeum Francesci Calceolari Iunioris Veronensis*
(Verona, 1622).

arranged in museums, or 'cabinets of curiosities' as they were
described in the seventeenth century (illus. 49), the stuffed animals
and fish hanging from the ceiling, the ancient vases on the ground, a
statuette on a plinth, smaller objects arranged on the shelves and still
smaller ones in drawers.[25]

Images also reveal how objects were used, as in the case of the cross-
bow in *The Battle of San Romano*, mentioned above, or the lances and
spears represented in the Bayeux Tapestry (illus. 78). In this last case,
the female embroiderers may have lacked the necessary military exper-
tise, but men would presumably have told them how these weapons
were held. An analogous example nearly a thousand years later comes
from films of the First World War, which draw the viewer's attention to
the technical limitations of early tanks by showing them in motion.[26]

For a case study in the uses of images as testimony for the uses of
other objects, we may turn to the history of the book, or as it is now
known, the history of reading. Ancient Roman images show us how to

hold a roll while reading it, an art which was lost after the invention of the codex. Seventeenth-century French engravings show men reading aloud at the fireside or to a group of men and women assembled for the *veillée*, turning evening work into a social activity. Eighteenth- and nineteenth-century images prefer to show reading in the family circle, and the reader is sometimes a woman.

A German historian of literature, Erich Schön, has made considerable use of paintings and prints and even silhouettes to support as well as to illustrate his argument about changes in reading habits in Germany around the year 1800. His point about a 'reading revolution' in the period, the rise of a more 'sentimental' or 'empathetic' form of reading, is supported by the rise of images of people reading in the open air or in more informal poses, reclining on a chaise longue, lying on the ground or – as in Tischbein's sketch of Goethe – balancing on a chair with a book on his lap and his legs off the floor (illus. 50). Another famous image is that of Joseph Wright's painting of Sir

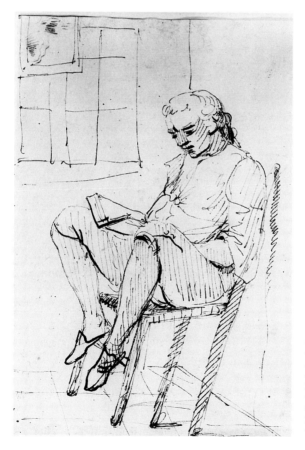

50 J. H. W. Tischbein, Sketch of J. W. von Goethe reading by the window of his Rome lodgings on his first Italian journey, *c*. 1787. Goethe-Nationalmuseum, Weimar.

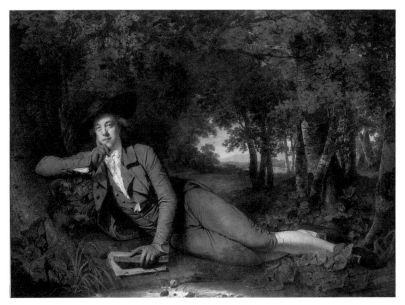

51 Joseph Wright ('of Derby'), *Sir Brooke Boothby Reading Rousseau*, 1781, oil on canvas. Tate Britain, London.

Brooke Boothby, lying in a forest with a book labelled 'Rousseau', the ancestor of so many later images of readers sprawled on the ground (illus. 51).[27] Boothby is implausibly well dressed for his rural surroundings, which suggests that the image (unlike many of its descendants) should be read symbolically rather than literally. It is a translation into vivid visual terms of Rousseau's ideal of following nature.

So far as the history of material culture is concerned, the testimony of images seems to be most reliable in the small details. It is particularly valuable as evidence of the arrangement of objects and of the social uses of objects, not so much the spear or fork or book in itself but the way to hold it. In other words, images allow us to replace old artefacts in their original social context. This work of replacement also requires historians to study the people represented in these images, the main theme in the chapter that follows.

6 Views of Society

... to assure ... that our social and political characteristics as daily and annually exhibited will not be lost in the lapse of time for want of an art record rendering them full justice.

GEORGE BINGHAM ON HIS AIMS AS A PAINTER

The ambition of the German photographer August Sander, whose collection 'Mirror of the Germans' (*Deutschenspiegel*), was published in 1929, was to portray society through photographs of typical individuals. In similar fashion the American photographer Roy Stryker presented what he called 'documentary' photographs to historians as a new means for them to 'capture important but fugitive items in the social scene'. He invited them to examine 'almost any social history, counting the adjectives and the descriptive passages', describing these literary techniques as 'an attempt ... to evoke graphic images that photographs can supply directly and much more accurately'. For similar reasons, George Caleb Bingham, the nineteenth-century American painter of scenes from everyday life, has been described as a 'social historian' of his time.[1]

The comparison can obviously be extended. Many painters might be described as social historians on the grounds that their images record forms of social behaviour, whether everyday or festive: cleaning the house; sitting down to a meal; walking in religious processions; visiting markets and fairs; hunting; skating; relaxing at the seaside; going to the theatre, the racecourse, the concert hall or the opera; taking part in elections, in balls or in games of cricket. Historians of the dance, historians of sport, historians of the theatre and other specialists have all studied the evidence of these images with care and attention to detail. Without them, the reconstruction of the practice of football in Renaissance Florence, for example, would be virtually impossible.[2]

The Dutch artists of the seventeenth century were masters of this

genre. Centuries later, the photographer William Henry Fox Talbot (1800–1877) appealed to their work as a precedent: ... 'we have sufficient authority in the Dutch school of art for taking as subjects of representation scenes of everyday and familiar occurrence'.[3] In similar fashion, Thomas Hardy called his novel *Under the Greenwood Tree* (1872) – an attempt to portray the customs of an earlier generation – 'a rural painting of the Dutch school'.

Why some Dutch artists chose these subjects and painted them in this way we do not know, but George Bingham claimed to produce historical documents, an 'art record', as he called it, of the social and political life of his day, which he saw in pictorial terms as 'exhibited' both daily and annually. Painting, according to Bingham, had the power 'to perpetuate a record of events with a clearness second only to that which springs from actual observation'.[4]

Bingham's own works depicted the life of his own region, Missouri, its fur traders, its flatboatmen, and the life of its small towns, especially during the festivals that accompanied political elections. As in the case of David Wilkie (Chapter 5), Bingham's paintings were based on first-hand observation, but not on observation alone. His election scenes, for example, are reminiscent of some images by Hogarth, which the painter would probably have known through prints. He should be regarded as adapting a pictorial tradition to a local situation, rather than simply recording or reflecting the life of his place and time. August Sander, too, had views about German society in his time and his collection of photographs have been described as providing not so much an archive as 'an imaginary resolution' of the social crisis of the middle class in his time.[5]

To test Bingham's view of the painter as a recording angel – or reporter – it may be useful to examine some images of children and women in more detail, in close-up.

Children

Photographs of children have sometimes been analysed by social historians, one of whom has noted, for example, that street children in Washington were quite well-dressed but appeared to own few toys.[6] However, the use of images of children by historians has been above all to document the history of childhood, in other words of changes in adult views of children.

Philippe Ariès, whose work has already been mentioned in the Introduction, was a pioneer in the history of childhood as well as in the use of images as evidence.[7] This is no accident. Since children did

not loom very large in the documents preserved in archives, to write their history it was necessary to find new sources – diaries, letters, novels, paintings and other images. Ariès was especially impressed by an absence, by the shortage of representations of children in early medieval art, as well as by the fact that medieval images of children show them as miniature adults. From the sixteenth or seventeenth century onwards, however, in France and elsewhere, the rise of child portraits and tombs for children becomes visible, together with the increasing prominence of children in family portraits, the increasing attention given to the signs of what we might call 'childishness' and the increasing separation between the social worlds of children and adults. According to Ariès, all these changes were precious clues for historians, consistent with the literary evidence and suggesting that adults were developing a more acute sense of childhood as a way of life different from their own.

The first edition of the book he published in 1960, known in English as *Centuries of Childhood*, included 26 pictures, including portraits by Hans Holbein and Philippe de Champaigne and genre paintings by Jan Steen and the brothers Le Nain, though many more images were discussed in the text than the publishers felt themselves able to illustrate. Among the arguments which Ariès supported with references to these visual sources is the one about the lack of segregation by age in the old regime, illustrated by a seventeenth-century tavern scene in which children mingle with adults.

A number of paintings of the seventeenth and eighteenth centuries, including some that Ariès does not mention, appear to confirm his arguments. As Simon Schama has noted, the image of *The Sick Child* by the Dutch painter Gabriel Metsu (1629–1669), now in the Rijksmuseum in Amsterdam, shows a concern for children which the viewer is surely expected to share. This painting at least is unlikely to have been made in order to celebrate the history of a family. William Hogarth's portrait of *The Graham Children* (illus. 52), painted in 1742, has been described as 'one of the definitive accounts of eighteenth-century childhood', making a statement about childish playfulness as well as displaying the differences in the characters of the four young sitters, the eldest girl for example being shown as 'self-consciously motherly in her solemn expression'.[8]

All the same, *Centuries of Childhood* has often been criticized in the forty-odd years since its publication. For example, the argument that children used to be viewed as miniature adults, supported by the testimony of images of children wearing miniature versions of adult clothes (an argument which had been put forward before Ariès but

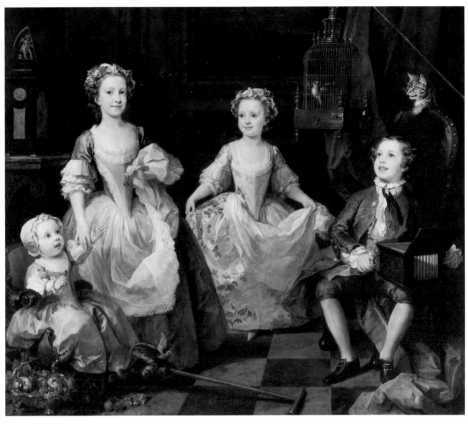

52 William Hogarth, *The Graham Children*, 1742, oil on canvas. National Gallery, London.

one which is central in his work), displays an indifference to context, more precisely a failure to take into account the fact that children and adults alike did not normally wear their everyday clothes when they sat for their portraits.

Two general criticisms of the work of Ariès are particularly serious. In the first place, he stands accused of neglecting the history of changing conventions of representation, a point to be discussed more fully below (Chapter 8). This point is perhaps most obvious in the case of the early Middle Ages. Ariès was impressed by the absence of children from early medieval art, and explained this absence in terms of a general lack of interest in children, or more precisely in childhood. A later and more detailed investigation of the subject, on the other hand, argued that early medieval imagery did show 'a real interest in childhood as such', its innocence and vulnerability, although this interest may have been hidden from viewers unaccustomed to 'the conceptualized and somewhat abstract, linear manner of early

medieval art'. In other words, Ariès failed to read the visual conventions of the early medieval period – an artistic language which is extremely remote from our own – as well as failing to consider what subjects were considered appropriate for visual representation at that time – religious subjects for the most part, into which children, apart from the infant Christ, did not easily fit. At the Renaissance, on the other hand, there was a general expansion in what was considered worthy to be painted, including children (who had in any case been represented in a 'modern' manner in ancient Greek and Roman art), but in no way confined to them.

Ariès has also been criticized for neglecting the functions or the uses of images. Children were generally represented in two ways. In the first place, as part of family groups: even portraits of children by themselves, like *The Graham Children*, were probably intended to be hung together with other family portraits. In that case, these images would testify to the history of a sense of family rather than to a sense of childhood. In the second place, in the seventeenth and eighteenth centuries, children were increasingly regarded as symbols of innocence, and some paintings of children were allegorical or at least quasi-allegorical.[9]

Despite these criticisms, the example given by Ariès has encouraged a mass of research into images of children, by social historians and also by workers in galleries and museums such as the Bethnal Green Museum of Childhood in London.[10] The evidence from portraits and images has not been ruled out of court, but it has been reinterpreted. In the long chapter on children in his *Embarrassment of Riches*, Simon Schama, for instance, drew on the rich visual evidence surviving from the Dutch Republic of the seventeenth century without assuming that the images were realistic. On the contrary, like de Jongh in the case of the Dutch interiors discussed in the previous chapter, he described the images as 'loaded with all kinds of moral preconceptions and prejudices'.[11]

A study of children in American family portraiture between 1670 and 1810 adopted a serial approach (more systematic than that of Ariès), examining 334 portraits representing 476 children, and noting the increase in the representations of toys and other signs of childhood. The author concluded that childhood was coming to be distinguished more sharply from adulthood as well as being shown in a more positive manner.[12] In other words, Hogarth's memorable image of *The Graham Children* forms part of a wider trend. The positive trend went still further in the nineteenth century, so much so that one well-known historian of ideas devoted a book to what he called the 'cult of childhood' at

this time. The cult may be illustrated from images such as *Bubbles* (1886) by Sir John Millais (1829–1896), an image which became still more popular after it was adapted as a poster to advertise Pears Soap.[13]

Women in Everyday Life

It is a commonplace of women's history that – like the history of childhood – it has often had to be written against the grain of the sources, especially the archive sources, created by men and expressing their interests. As in the case of historians of ancient Egypt or the early Middle Ages, the silence of the official documents has encouraged historians of women to turn to images representing activities in which women engaged in different places and times.

A few examples from China, Japan and India may serve to illustrate this point. Street scenes, for instance, show what kinds of people are expected to be visible in public in a given period and culture. Thus a painted scroll representing a street in the city of Kaifeng in China around the year 1100 shows a predominantly male street population, although a woman of substance sitting in a palanquin may be seen passing in the foreground (illus. 53). A historian of Song China concludes that 'Men could be seen everywhere in the business districts of the capital; women were a rare sight.' By contrast, a Japanese print of the 1780s representing a street in Edo (now Tokyo) at night shows women in a crowd of 'actors, playgoers, sightseers and tradesmen'. The print, by Utagawa Toyoharu, has of course to be put into context. The posters on display identify the street as part of the theatre district, and the women, including one in the foreground with an elaborate hairstyle, are probably courtesans.[14]

To see the place of different kinds of women in the life of the city in the West, one might turn to the 132 scenes of Vienna engraved by the German artist Salomon Kleiner between 1724 and 1737. They show many women in the street, most of them on foot, some of them well dressed and represented greeting one another. As an urban historian has observed, 'Ladies with fans engage in polite conversation', while 'passers-by look with interest as two market-women tear each other's hair'.[15] Whatever might have been the case in Mediterranean Europe at this time, the participation in street life of the women of Vienna or Amsterdam or London (as illustrated in Hogarth's prints, for example,) makes a contrast with traditional China and even Japan.

Images offer particularly valuable evidence of the kinds of work which women were expected to do, much of it in the informal economy that often escapes official documentation. A Chinese scroll of the

53 Zhang Zeduan, Detail of a street scene in Kaifeng, from *Spring Festival on the River*, hand scroll, early 12th century, ink and colour on silk. Palace Museum, Beijing.

tenth century, for instance, shows men at a banquet listening to a woman (probably a courtesan) playing a stringed instrument. A thirteenth-century Chinese scroll depicts women reeling silk. An eighteenth-century Japanese print shows a woman standing outside an eating-house, trying to pull a passer-by into her establishment. Another (illus. 54) shows a woman peddling books, a pack of bound volumes on her back and a packet of prints in one hand. Paintings from Mughal India show women working on building sites, whether breaking stones, sifting sand (illus. 55) or climbing to the roof with loads on their heads. Early photographs of the Middle East show women weeding in the fields and threshing wheat, while in urban scenes, by contrast, they are absent from the streets and the coffee houses.[16]

In the case of Europe, social historians can draw on similar testimonies if they wish, subject to the usual precautions. As a reminder of the need for precautions we might take a fourteenth-century English image of three female harvesters, which conflicts with an impression formed on the basis of other kinds of evidence that women did not normally engage in this activity at the time. The presence of women in the illumination has been explained by Michael Camille on the grounds that the text being illustrated is the Psalms, where the harvest is a spiritual one.[17]

There are plenty of street scenes and genre scenes that would repay careful study by eyes attentive to representations of female

54 Torii Kiyomasu, 'Woman book pedlar', c. 1717, woodblock print with hand colouring.

spaces and female roles. The tradition goes back a long way: an ancient Roman marble relief from Ostia some eighteen hundred years ago represents a woman selling vegetables from a stall (illus. 56). Seventeenth-century Dutch paintings have much to tell us about this aspect of everyday life. Emmanuel de Witte specialized in scenes of this kind, such as a poultry stall in which the two prospective buyers and the seller are all female (illus. 57).

Particularly valuable for a social historian are the various series of engravings or etchings which offered pictorial inventories of the occupations practised in the city. The *Cries of London*, for example, or the sixty etchings of *The Itinerant Street Trades of the City of Venice* published by Gaetano Zompini in 1785, seven of which show women workers, selling milk, water, fried food and secondhand clothes, telling fortunes and hiring out servants and seats in the theatre or opera. The increasing popularity of this genre in the eighteenth century suggests that aspects of working-class life were coming to be perceived as 'picturesque' by middle-class eyes.

It is thanks to the rise of this European genre that information about urban occupations in China was recorded in the form of images. Some Chinese paintings and drawings produced in Canton for the European market represent a wide range of urban occupations. They include the hundred gouache paintings of the late eight-0eenth century by Puqua and the 360 ink drawings of the 1830s by Tinqua now in the Peabody Essex Museum in the USA. Among the

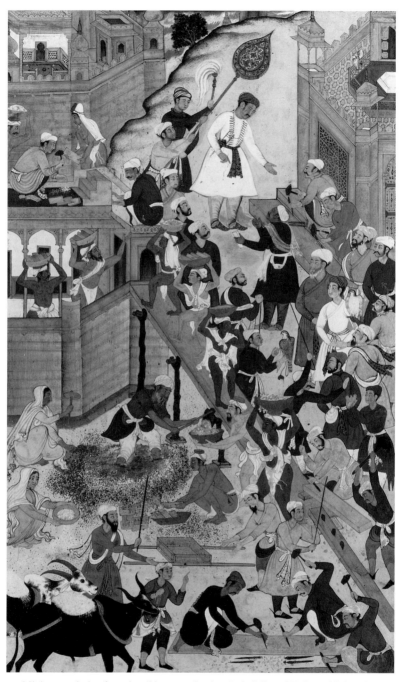

55 Miniature painting from the *Akbarnama* showing the building of Fathpur Sikri, 16th century. Victoria & Albert Museum, London.

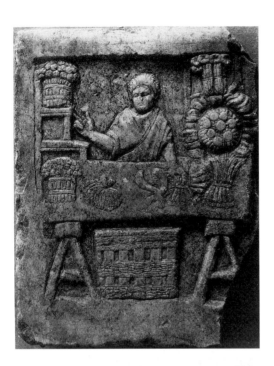

56 Marble relief showing a
woman selling vegetables,
late 2nd/early 3rd century
AD. Museo Ostiense, Rome.

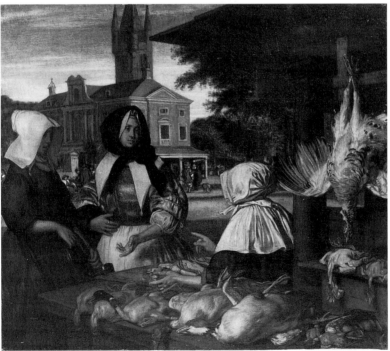

57 Emmanuel de Witte, *Woman Selling Birds on the Amsterdam Market*, oil on panel.
Nationalmuseum, Stockholm.

female occupations shown in these paintings and drawings are weaving, patching cloth, twisting silk, sewing shoes, drawing flowers and carrying pails of night-soil.

Problems remain. The historian cannot afford to forget that these images were produced in a particular context, by local artists working for foreigners. It is quite possible that these local artists were shown European prints in the 'Cries of London' tradition. Even if they did not follow this tradition blindly, they may have included particular images in order to conform to the expectations of a European viewer.[18]

Female literacy as well as women's work may be tracked through the ages thanks to images, from ancient Greece onwards. A Greek vase shows two girls hand in hand, and includes a significant small detail. One of the figures is carrying her writing tablets by a strap, as if it was expected that some girls would learn to write (illus. 58).[19] Some

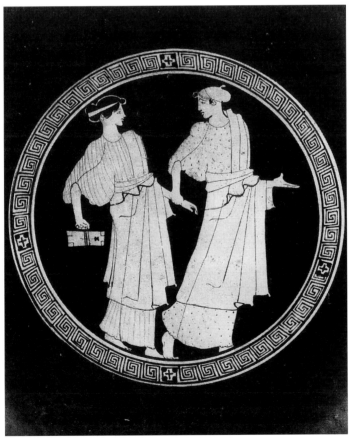

58 Greek red-figure vase painting by the 'Painter of Bologna' showing two girls (*fl.* 480–450 BC). Metropolitan Museum of Art, New York.

59 'Be good, children! Because for an evil-doer the approach of death is terrible!', engraving of a village school, from Nicolas-Edmé Rétif de la Bretonne, *La Vie de mon père* (Neufchâtel and Paris, 1779).

early modern images of schools show segregation by gender, with boys and girls on different sides, as in this engraving of an eighteenth-century French rural school (illus. 59). It should be noted that the boys have a table to write on while the girls sit with their hands in their laps as if they were expected simply to listen, implying that they were learning to read but not to write.

Women readers, on the other hand, are often represented. In the Middle Ages and the Renaissance, a number of images of the Annunciation show the Virgin Mary looking up from a book. The decline of images of the Virgin reading after 1520 appears to have been an early response to what might be called the 'demonization' of reading by the Catholic Church following the Reformation, when the access to books on the part of the laity was blamed for the rise of heresy.[20] On the other hand, images of other women reading gradually became more frequent from this time onwards. Rembrandt painted his mother reading the Bible. The paintings by Jean-Honoré Fragonard (1732–1806) and others of women holding books have been taken as evidence for the spread of reading in eighteenth-century France.[21] The engraving of Jewett's bookstore in nineteenth-century Boston, mentioned in the previous chapter (illus. 48), shows a number of women frequenting the establishment.

As some of the critics of Ariès pointed out, social historians cannot afford to ignore the conventions of particular visual genres any more than of literary ones. If we are considering views of society, the conventions of scenes from everyday life – the visual genre we have come to describe since the end of the eighteenth century as 'genre' – require particular attention.[22] Genre paintings emerged as an independent type of image in the Netherlands in the seventeenth century. The Dutch example was followed by artists in eighteenth-century France (Chardin, for example), nineteenth-century Scotland (Wilkie) and the USA (Bingham). It is not customary to call the French impressionists painters of genre, but the images of the life of leisure in or near Paris in the late nineteenth century in the paintings of Edouard Manet (1832–1883), Claude Monet and Auguste Renoir (1841–1919), all offer new variations on this theme, from the boaters on the river at La Grenouillère to the dancers at the Moulin de la Galette.[23]

Despite Bingham's phrase 'art records', social historians cannot assume that images such as these are impersonal documents. The moralizing approach of Jan Steen in his *Disorderly Household*, for instance, has already been noted (Chapter 5). In the case of some genre paintings by Steen and his contemporaries, the problem is still more complicated. It has been argued that some paintings of Dutch charlatans represent not scenes from urban life but scenes presented on the stage, featuring stock characters from the *commedia dell'arte*. In that case, the charlatans whom we may well have assumed that we were observing directly have passed through not a single but a double filter of moralization. We have returned to the problem of 'apparent realism' (Chapter 5).[24]

An analogous problem is that of the satirical element in some images of marriage. It may be suspected in Pieter Brueghel's *Peasant Wedding* (Chapter 7), in Wilkie's *Penny Wedding* and elsewhere. Satire is particularly obvious in the Hogarth series of paintings and engravings known as *Marriage à la Mode*, in which the first scene represents the meeting of the two families with the lawyers. The two fathers are shown in the centre of the image, at a table, while the pair to be married, with their backs to each other, are located at the right-hand side of the painting, symbolizing their subordinate position in the transaction.[25]

Let us focus for a moment on an image which at first sight, at least, may well appear rather more objective and documentary: the engraving by Abraham Bosse (1602–1676) entitled *Le mariage à la ville*

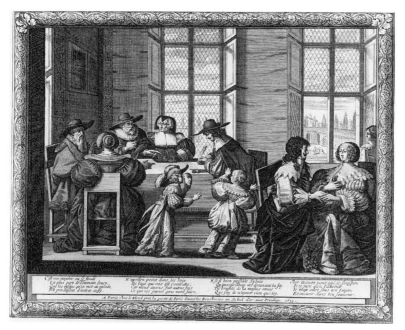

60 Abraham Bosse, *Le Mariage à la Ville*, 1633, engraving. British Museum, London.

('Marriage in Town') (illus. 60). The action in takes place around a
table in which the two pairs of parents negotiate a deal, while the
notary writes it down (the hand gesture of one woman and the sharp
expression of the other suggest that that both are taking as active a
part in the proceedings as the men). In the foreground, but well to
one side, as if they were virtually marginal to what is going on, sit the
couple about to be married, holding hands, a gesture which probably
signifies that their troth has been plighted rather than that they are in
love. Two children, a boy and a girl, presumably the younger brother
and sister of the bride or the groom, are playing near the table, as if
unaware of their future roles in a similar social drama (the boy's mask
brings this theatrical metaphor home to the viewer). The print pays
close attention to details of costume and furnishings and allows us to
locate the scene in the social world of the upper bourgeoisie, whether the
families concerned had made their money from trade or from the law.

We know something about Bosse's life, including the fact that he
belonged to the Protestant minority of the population and also that he
engaged in protracted conflict with the French Royal Academy of
Art, details which increase the possibility that his engraving is meant
as moral and social criticism. The satirical remarks about the buying
and selling of brides in a mid-seventeenth-century romance, Antoine

Furetière's *Roman bourgeois* (1666), make the moralistic interpretation of Bosse's image still more plausible. Furetière prints in his romance what he calls a 'tariff' of dowries, according to which a girl with a hundred thousand *écus* or more is in a position to marry a duke, while a girl with twenty to thirty thousand *livres* has to content herself with a barrister.

Once again, then, a reading of an image of society as a simple reflection or snapshot of society turns out to be misleading. Bosse's engraving is closer to Hogarth's *Marriage à la Mode* than appears at first sight, and may even have inspired it.

The Real and the Ideal

On one side, then, social historians need to be aware of the satirical overtones of images. On the other, they cannot afford to forget the possibility of idealization. For example, a change in representations of old people has been noted in late-eighteenth-century French art. The dignity of old age was coming to be emphasized, rather than its grotesque aspects. As in the case of images of childhood, we have to take into account the possible symbolic uses of the old man or woman. All the same, the long-term modifications in the conventions of representation appear to be significant. It is unlikely that old people were changing in any important way, but attitudes towards them were evolving. In this respect, literary sources confirm the impression given by images.[26]

Again, French images of crowds changed in a quite remarkable fashion after the revolution of 1830. Before this time, individuals in the crowds were generally shown – as in Hogarth's England – as roughs, beggars or drunkards, with expressions verging on the grotesque. After the revolution, on the other hand, they were increasingly represented as clean, well dressed and idealistic, as in the Delacroix image of *Liberty Leading the People* (Chapter 4). It is difficult to believe that a major shift in social attitudes occurred so quickly. It is much more likely that what changed were current notions of what is known today as 'political correctness'. The success of the 1830 revolution required the idealization of 'the people' who were supposed to have made it.[27]

In similar fashion, the image of the village school with its orderly segregation of the sexes (illus. 59) may represent an ideal rather than the messy reality. The image, frequently represented in the eighteenth and nineteenth centuries, of the father reading to his family may also be an idealization, an expression of nostalgia for the days

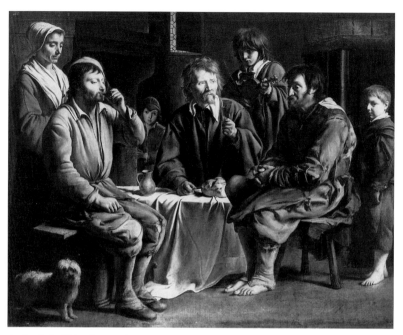

61 Louis Le Nain, *Le repas des paysans*, 1642, oil on canvas. Musée du Louvre, Paris.

when reading was collective rather than individual and the appropriate books were chosen by the paterfamilias. Photographs of rural life made in England around 1900 may well express a certain yearning for the 'organic community' of the traditional village, making their point not only by asking the protagonists to smile but by concentrating on traditional implements at the expense of new machines. This nostalgia has its own history, going back in all probability to well before the Industrial Revolution. For example, the rural images represented in the illuminations of the fourteenth-century English Luttrell Psalter, now in the British Library, were recently described as offering a 'nostalgic vision' of the rural world before the crisis of the feudal system.[28]

A single image studied in close-up may make the process of idealization more visible. A well-known painting by Louis Le Nain, now in the Louvre, *Le repas des paysans*, represents French peasants at table (illus. 61). Pierre Goubert, a historian who devoted his life to the study of the French peasants of the seventeenth century, has drawn attention to the 'white table-cloth, golden loaf, light-red wine and the honest simplicity of dress and furnishings' arguing that 'the cloth and the wine are both out of place, and the bread is far too white'. Goubert believes that the aim of the painter was to provide a popular version of the Last Supper. Other critics see the image as an allusion to the story

recounted in the Gospel of St Luke (24) about the supper of the disciples in the village of Emmaus with a person who turns out to have been Christ. *Le repas des paysans* has become a problem-picture.

By now the need to place the painting in context should be obvious. The Le Nain brothers, who often produced their paintings in collaboration, came from Laon, near the Flemish border, where their family owned land and vineyards. In other words, they knew the life of the peasants from inside. The problem is to discover what kind of image they wanted to make. Unfortunately, we do not know for whom the painting was originally made. One hypothesis is that it was made for a charitable institution, at a time, the early seventeenth century, when there was a rise of organized Christian charity in France.

Another illuminating suggestion is that the image gives visual expression to religious views of the kind expressed a few years later by a French religious writer, Jean-Jacques Olier. In his *La journée chrétienne* (1657), Olier wrote about the sanctification of everyday life and recommended his readers to remember the Last Supper when they sat down to their evening meal. If the image indeed refers to Olier's ideas, this would provide one more example of a genre painting which did not represent everyday life for its own sake, but as a religious or moral symbol, as has been argued in the case of the Dutch paintings discussed earlier. However, a contemporary critic, André Félibien, who came from a higher social group than the Le Nains, commented unfavourably on the 'lack of nobility' of this painting. He seems to have assumed that the painting was not a symbolic one but a genre scene of the kind produced by the Dutch.[29]

The dignified peasants of the painting by Le Nain have parallels in later works by Jean-François Millet, himself of a peasant family from Normandy. For example, *The Sower* (1850), *The Gleaners* (1857) and, best-known of all, *The Angelus* (1857–9) in which a man and a woman stand in the fields praying, all represent rural workers in a monumental style.[30] By this time a positive image of peasants had become more widely acceptable than it had been in the seventeenth century. In Italy, Alessandro Manzoni had made two young peasants the hero and the heroine of his novel *I Promessi Sposi*, 'The Betrothed' (1825–7), although he was criticized at the time for doing this. Middle-class intellectuals had come to see the peasants as the custodians of national tradition. At a time when industrialization and urbanization threatened the traditional rural order the peasants, formerly perceived by the upper classes as grotesque (Chapter 7) were increasingly humanized and even idealized. One is reminded of the history of landscape – appropriately enough, since for urban viewers the peasants were part of the landscape.

62 Mariamna Davydova, *Picnicking in the Woods near Kamenka*, 1920s, watercolour. Location unknown.

Another type of image of the peasant emphasizes the harmony of the social system, for example Petr Zabolotsky's painting *After Harvesting* which shows Russian serfs dancing in the courtyard of the great house while the landowner and his family looks on, their physical position at the top of a flight of steps symbolizing their social superiority. Nostalgia is still more obvious in the watercolours by Mariamna Davydova representing life on a Russian estate from the landowner's point of view, with scenes of a carriage, the priest's visit, a picnic in the woods (illus. 62) and so on, the estate being portrayed as a centre of leisure activities rather than as an enterprise. Painted after 1917, these images evoke the world which Davydova and her class had recently lost.[31] As idyllic as Zablotsky's painting, despite the difference in political context, is the image of life on a collective farm by the Soviet painter Sergei Gerasimov (1885–1964), a reminder that the style known as 'Socialist Realism' – which might be described more accurately as 'Socialist Idealism' – had its parallels in earlier periods.

To juxtapose these last images to the photographs of the rural poor in the United States in the years of depression is to view a stark contrast. The photographs of Margaret Bourke-White and of Dorothea Lange shift their focus from the group to the individual and emphasize personal tragedies by means such as close-ups of a mother and her children (illus. 63). By contrast, looking backwards, even the most

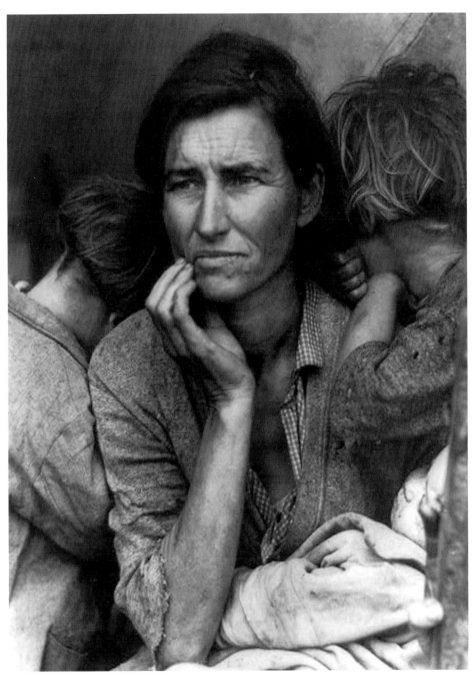

63 Dorothea Lange, *Destitute pea pickers in California. Mother of seven children. Age thirty-two. Nipomo, California. February, 1936.*

sympathetic paintings of the peasantry appear impersonal. Interpreting the difference is not easy. Is it the new medium which makes the difference? Or the fact that these two photographers were women? Or that they came from a culture emphasising individualism? Or that they were working for a government project, for the Farm Security Administration?

This chapter began by posing the awkward question of typicality. Like novelists, painters represent social life by choosing individuals and small groups whom they believe to be typical of a larger whole. The emphasis should fall on the word 'believe'. In other words, as in the case of portraits of individuals, representations of society tell us about a relationship, the relationship between the maker of the representation and the people portrayed. The relationship may be egalitarian but it has often in the past been hierarchical, a point to be developed in the following chapter.

The people portrayed may be viewed with more or less distance, in a respectful, satirical, affectionate, comic or contemptuous light. What we see is a painted opinion, a 'view of society' in an ideological as well as a visual sense. Photographs are no exception to this rule, for as the American critic Alan Trachtenberg argues, 'A photographer has no need to persuade a viewer to adopt his or her point of view, because the reader has no choice; in the picture we see the world from the angle of the camera's partial vision, from the position it had at the moment of the release of the shutter.'[32] Point of view in this literal sense obviously influences – even if it does not determine – point of view in the metaphorical sense.

The importance of social or cultural distance is particularly clear in cases when the artist or photographer is an outsider to the culture being portrayed. At this point we may return to the drawing by Dardel used earlier as evidence of the interior of a Swedish cottage (illus 46). If not exactly a caricature, there is a comic or grotesque element in the sketch, implying a certain distance between a middle-class artist and the people whose material culture and everyday life he was depicting. Images of this kind, images of the 'Other', will be the focus of attention in the following chapter.

7 Stereotypes of Others

> Christians are right and pagans are wrong.
> *THE SONG OF ROLAND*

> East is East and West is West, and never the twain will meet.
> RUDYARD KIPLING

It is only relatively recently that cultural historians have become interested in the idea of the 'Other', with a capital O – or perhaps with a capital A, since it was the French theorists who led the way in discussions of *l'Autre*. It might be more illuminating to think of people different from oneself in the plural rather than turning them into an undifferentiated Other, but since this process of homogenization is so common, cultural historians need to study it. This new interest of theirs runs parallel to the rise of concern with cultural identity and cultural encounters, just one example among many of present preoccupations, such as the debate over multiculturalism, prompting scholars to ask new questions about the past.

In the case of groups confronted with other cultures, two opposite reactions recur. One is to deny or to ignore cultural distance, to assimilate others to ourselves or our neighbours by the use of analogy, whether this device is employed consciously or unconsciously. The other is viewed as the reflection of the self. Thus the Muslim warrior Saladin was perceived by some Crusaders as a knight. The explorer Vasco da Gama, entering an Indian temple for the first time, interpreted a sculpture of Brahma, Vishnu and Shiva as an image of the Holy Trinity (just as the Chinese, a century or so later, would interpret images of the Virgin Mary as representations of the Buddhist goddess Kuan Yin). The Jesuit missionary St Francis Xavier, encountering Japanese culture for the first time in the middle of the sixteenth century, described the emperor (who had high status but little power) as an oriental 'pope'. It is by means of analogy that the exotic is made

intelligible, that it is domesticated.

The second common response is the reverse of the first. It is the conscious or unconscious construction of another culture as the opposite of one's own. In this fashion, fellow-humans are 'othered'. Thus the *Song of Roland* described Islam as a diabolical inversion of Christianity, and presents an image of Muslims as worshipping an infernal Trinity, composed of Apollo, Muhammad and a certain 'Termagant'. The Greek historian Herodotus presented an image of ancient Egyptian culture as the inverse of the Greek, noting that in Egypt people wrote from right to left instead of from left to right, that men carried burdens on their heads rather than their shoulders, that women made water sitting down instead of standing up, and so on. He also described the Persians and the Scythians as in some ways the antithesis of the Greeks.

In the last paragraphs the term 'image' was used in the sense of an image in the mind and the evidence came from texts. To recover or reconstruct these mental images, the testimony of visual images is obviously indispensable, despite all the problems of interpretation that pictures raise. Where writers can hide their attitudes behind an impersonal description, artists are forced by the medium in which they work to take up a clear position, representing individuals from other cultures as either like or unlike themselves.

Two vivid examples of the first process described above, the assimilation of the other, both come from seventeenth-century Dutch engravings. In one, a Brazilian Indian was fitted out with a classical bow and arrows. In this way the Indians were identified with the barbarians of the ancient world, more familiar to the artist and the viewer alike than the peoples of the Americas. In the other engraving, illustrating an account of the Dutch East India Company's embassy to China, a Tibetan lama was represented as a Catholic priest and his prayer beads as a rosary (illus. 64). The accompanying text goes even further in the direction of assimilation, the English version describing the lama's hat as 'much like a cardinal's, with broad brims', while the French version, aimed at a Catholic audience, also compares the lama's wide sleeves to those of a Franciscan friar and his 'rosary' to those of the Dominicans and Franciscans. The hat represented in the engraving, incidentally, differs from the traditional pointed cap of the lamas, which an Italian traveller of the early eighteenth century, in another attempt to assimilate the unknown to the known, compared to a bishop's mitre. Unlike some other images of distant cultures illustrated here (illus. 3, for example), the engraving appears to have been based on the written text rather than on sketches made from life.

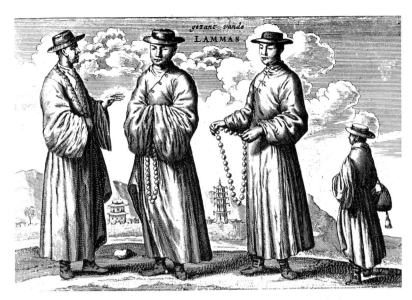

64 Engraving showing a Tibetan ambassador with a 'rosary', from Jan Nieuhof,
L'Ambassade de la Compagnie Orientale des Provinces Unies vers l'Empereur de la Chine…
(Leiden: J. de Meurs, 1665).

In other words, when encounters between cultures take place, each culture's images of the other are likely to be stereotyped. The word 'stereotype' (originally a plate from which an image could be printed), like the word cliché (originally the French term for the same plate), is a vivid reminder of the link between visual and mental images. The stereotype may not be completely false, but it often exaggerates certain features of reality and omits others. The stereotype may be more or less crude, more or less violent. However, it necessarily lacks nuances since the same model is applied to cultural situations which differ considerably from one another. It has been observed, for example, that European pictures of American Indians were often composite ones, combining traits from Indians of different regions to create a simple general image.

In analysing such images, it is difficult to do without the concept of the 'gaze', a new term, borrowed from the French psychoanalyst Jacques Lacan (1901–1981), for what would earlier have been described as 'point of view'. Whether we are thinking about the intentions of artists or about the ways in which different groups of viewers looked at their work, it is useful to think in terms of the western gaze, for example, the scientific gaze, the colonial gaze, the tourist gaze or the male gaze (below, pp. 136ff.).[1] The gaze often expresses attitudes of which the viewer may not be conscious, whether they are hates,

fears or desires projected on to the other. The case for psychoanalytical interpretations of images – an approach to be discussed in more detail in Chapter 10 – receives some of its strongest support from images of aliens, abroad or at home.

Some of these stereotypes are positive, as in the case of the 'noble savage', a phrase used in 1672 by the English poet and playwright John Dryden. The image was a classical one which was revived in the sixteenth century and developed alongside its opposite, the image of the cannibal. Pictures, including the woodcuts in the French Protestant missionary Jean de Léry's *History of a Voyage to Brazil* (1578), illustrated this concept. The high point of the idea of the noble savage was the eighteenth century. It was at this time that the culture of Tahiti, for example, was seen as a survival of the golden age. The inhabitants of Patagonia and Polynesia in particular were viewed by European travellers through the spectacles of the classical tradition as 'modern exemplars of the austere virtuous lives led in classical times by such peoples as the Spartans and the Scythians'.[2]

Unfortunately, most stereotypes of others – the Jews as seen by the Gentiles, the Muslims by the Christians, blacks by whites, peasants by townspeople, soldiers by civilians, women by men, and so on – were and are either hostile, contemptuous or, at the very least, condescending. A psychologist would probably look for the fear underlying the hatred and also for the unconscious projection of undesirable aspects of the self on to the other.

It is perhaps for this reason that the stereotypes often take the form of inversions of the viewer's self-image. The cruder stereotypes are based on the simple assumption that 'We' are human or civilized while 'They' are little different from animals such as the dogs and pigs to whom they are frequently compared, not only in European languages but also in Arabic and Chinese. In this way others are turned into 'the Other'. They are exoticized, distanced from the self. They may even be turned into monsters.

The Monstrous Races

The classic as well as the classical example of this process is that of the so-called 'monstrous races', imagined by the ancient Greeks as existing in faraway places such as India, Ethiopia or Cathay.[3] These races included the dog-headed people, (Cynocephali); those lacking heads (Blemmyae); the one-legged (Sciopods); cannibals (Anthropophagi); Pygmies; the martial, one-breasted race of women (Amazons) and so on. The *Natural History* of the ancient Roman

writer Pliny transmitted these stereotypes to the Middle Ages and beyond. For instance, the reference in *Othello* to the people 'whose heads do grow beneath their shoulders' is clearly to the Blemmyae.

The monstrous races may have been invented to illustrate theories of the influence of climate, the assumption being that people who live in places which are too cold or too hot cannot be fully human.[4] All the same, it may be illuminating to treat these images not as pure invention but as examples of the distorted and stereotyped perception of remote societies. After all, the pygmies still exist and some peoples eat human flesh on certain occasions. As India and Ethiopia became more familiar to Europeans in the fifteenth and sixteenth centuries, and no Blemmyae, Amazons or Sciopods could be found, the stereotypes were relocated in the New World. For example, the Amazon river takes its name from the belief that Amazons lived there. Remote peoples were viewed as morally as well as physically monstrous, as in the case of the cannibals believed to live in Brazil, Central Africa and elsewhere.[5]

For a vivid image of cannibalism, expressing and doubtless also spreading the stereotype, we may turn to a famous woodcut which was circulating in Germany about six years after the Portuguese first landed in Brazil in the year 1500 (illus. 65). In the centre of the print

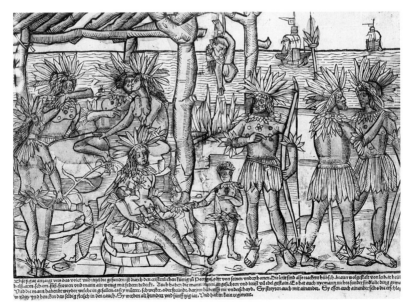

65 'The island and people which were discovered by the Christian king of Portugal or his subjects', German woodcut showing Brazilian cannibals, *c.* 1505. Bayerische Staatsbibliothek Munich.

we see fragments of a mutilated human body hanging from a branch, while the savage at the extreme left tucks into a human arm. This example throws some light on the process of stereotyping. The statement it makes is not exactly false. Some of the Brazilian Indians, the adult males of the Tupinambá for example, whose customs were described in detail by some European travellers later in the sixteenth century, did eat some human flesh, notably that of their enemies, on some ritualized occasions. But the print gives the false impression that human flesh was normal everyday food for all the Indians. It helped to define the inhabitants of a whole continent as 'cannibals'. In this sense it made a contribution to what has been called the 'man-eating myth', to the process in which one culture (not always the western) dehumanizes another by claiming that its members eat people.

Today, readers may find it difficult to take the idea of the monstrous races seriously, to recognize that our ancestors believed in their existence or at least in the possibility of their existence somewhere. Such scepticism is somewhat paradoxical, given the many current images of aliens from outer space, which should perhaps be seen as the ultimate displacement of Pliny's stereotype. Come to that, we continue to view groups culturally distant from ourselves in stereotyped terms. An obvious example is that of the 'terrorist', a term which currently conjures up an image of extreme and mindless violence. If these 'terrorists' – Irish, Palestinian, Kurdish, and so on – are redescribed as 'guerrillas', they recover their human faces together with intelligible motives, not to say ideals. Images of Muslim terrorists in particular have become common in films, especially in the 1990s, following the decline of the Communist 'other' after the fall of the Berlin Wall and the dissolution of the Soviet Union. 'Terrorism' is associated with equally ill-defined pejorative terms such as 'fanaticism', 'extremism' and, more recently, 'fundamentalism'. These hostile images of Islam are linked to what is often described as the 'orientalist' mentality.

Orientalism

In the last twenty years of the twentieth century, the concept of 'orientalism', once a neutral term employed to describe western specialists on the cultures of the Near, Middle and Far East, became a pejorative one.[6] Its change in meaning is largely due to one man, the literary critic Edward Said, and his book *Orientalism*, first published in 1978. Said described his kind of Orientalism as 'the corporate institution for dealing with the Orient' which developed in the west from the late eighteenth century onwards. Alternatively, he referred to it as a 'discourse',

or (quoting the British historian Victor Kiernan) as 'Europe's collective daydream of the Orient', or as 'a western style for dominating … the Orient' against which the Occident defined itself.[7]

Said worked with texts, deciding not to discuss the cultural stereotypes of what he called 'the Oriental genre tableau', but his ideas can be – and have been – used to analyse the paintings of the Middle East by Jean-Auguste-Dominique Ingres (1780–1867), Théodore Géricault (1791–1824), Jean-Léon Gérôme (1824–1904), and Delacroix, as well as by English, German, Italian and Spanish artists.[8] It would not be difficult to assemble a substantial corpus of western paintings of the Middle East which are filled with stereotypes and focus on sex, cruelty, idleness and 'oriental luxury' – harems, baths, odalisques, slaves and so on. The Ingres painting *Odalisque with Slave* (illus. 66) is fairly typical of the genre, giving a western spectator a sense of entering a harem and so of viewing the most intimate secrets of an alien culture.

These visual images illustrate, or at any rate they run parallel to western literary stereotypes of the Orient, such as Montesquieu's *Persian Letters* (1721). Indeed, we know that some artists turned to literature to help with 'local colour', as Ingres turned to the letters from eighteenth-century Istanbul written by Lady Mary Wortley Montagu. Ingres transcribed some of the letters, including the passage in which Lady Mary describes her visit to a Turkish bath, in preparation for painting his *Bain Turc* (1862–3).[9]

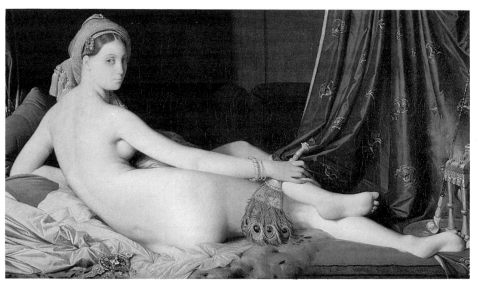

66 Jean-Auguste-Dominique Ingres, *Odalisque with Slave*, 1839/40, oil on canvas mounted on panel. Fogg Art Museum, Cambridge, MA.

Nineteenth- and twentieth-century photographs of scenes from Middle Eastern life taken by Europeans for a European audience perpetuated some of these stereotypes.[10] So did films, notably *The Sheikh* (1921), in which the leading role of Ahmed Ben Hassan was played by the Italian–American actor Rudolph Valentino, as if to American WASP eyes all olive-skinned men were interchangeable. The long life of the stereotypes as well as their multiplication suggests that these examples of collective fantasy or the 'imaginary' responded to the voyeuristic desires of viewers.

The previous paragraphs have tried to show that an analysis of the western images of the Middle East in Said's terms is indeed enlightening. All the same, this approach obscures as well as illuminates. Western attitudes to 'the Orient' were no more monolithic than the Orient itself, but varied with the artist and the genre. Delacroix and Géricault, for instance, both expressed enthusiasm for the cultures of North Africa. Distinctions are in order. To complicate matters still further, it is possible to find what might be called 'oriental orientalists'. The owner of Ingres' *Bain Turc* was the Ottoman diplomat Khalil Bey, while Hamdi Bey (1842–1910), a Turkish artist who had studied in Paris with Gérôme, painted scenes from his own culture in the western style. It would seem that the modernization of the Ottoman Empire required viewing it through western or at any rate westernizing eyes.

Another important distinction to make is between a 'romantic' exoticizing style and what has been called the 'documentary', 'reporting' or 'ethnographic' style, to be found in some nineteenth-century painters of the Middle East as in the earlier work of John White in Virginia (illus. 3) or John Webber (1752–1798) in the Pacific, who was chosen by Captain Cook to accompany him on his third voyage in order 'to preserve, and to bring home' images of 'the most memorable scenes of our transactions'. Examples of this ethnographic style, the equivalent of the 'eyewitness style' discussed above (Introduction) include *Two Seated Women* by Delacroix (illus. 1), the drawing of the Ottoman sultan going to the mosque (illus. 2) by the French artist-reporter Constantin Guys (1802–1892), and the *Street Scene, Damascus* (illus. 67) by Alberto Pasini (1826–1899), including horsemen, street traders, veiled and turbaned figures and an impressive house jutting into the street, the windows covered by latticework so that the women within could see out while themselves remaining invisible.[11]

Even scenes like these, despite their strong 'reality effect', need, like later photographs, to be utilized with care as evidence of social life in the Muslim world in the nineteenth century. Artists often used

67 Alberto Pasini, *Street Scene, Damascus*, oil on canvas. Philadelphia Museum of Art.

Jewish female models because the Muslim women were inaccessible. Sometimes they admitted what they were doing, as in the case of *A Jewish Wedding in Morocco* (another work by Delacroix), but on other occasions they did not. The identity of the women in *Two Seated Women* has often been discussed. They may be Jewish, but the details of their costume suggest that they are indeed Arab Muslims, confirming the tradition that a French acquaintance of the artist's, an engineer working at the port of Algiers, persuaded one of his staff to allow Delacroix to draw his women from life.[12] Another problem of the documentary image is its focus on the typical at the expense of the individual. What is considered to be typical of a given culture may be the result of years of observation, but it may also be the fruit of hurried reading or of pure prejudice.

What Said christened or rechristened 'Orientalism' is a special case of a much wider phenomenon, the stereotyped perception of one culture by another, or of individuals from one culture by individuals from another. Northern European images of the South, especially of Spain and Italy, not all that different – especially when Andalusia or Sicily was the setting – from images of the Orient, might be described as examples of 'Meridionalism'. Images of the far North of Europe, including Lapland and Finland, might be described as 'Borealism'. European images of Africa developed in parallel to images of the Orient. In North and South America, artists represented black slaves in a more or less stereotyped manner.

Among the more sympathetic portrayals of African Americans were a series by Eastman Johnson (1824–1906), a northerner – he was born in Maine – who supported the abolition of slavery. His best-

known treatment of the subject, *Negro Life at the South*, was painted in 1859, on the eve of the American Civil War. This scene of the slaves relaxing after their labours – a man playing a banjo, mothers playing with children, a young man sweet-talking a pretty girl – was described at the time as a pictorial equivalent of *Uncle Tom's Cabin* (Harriet Beecher Stowe's novel had appeared seven years earlier, in 1852). It was praised as an authentic representation of 'the affections, the humor, the patience and serenity which redeem from brutality and ferocity the civilized though subjugated African'. More recently, Johnson's images of African Americans have been described as 'nonstereotypical'. Yet *Negro Life at the South* is composed of stock poses and attributes – the banjo for instance – associated with the slaves. I would prefer to say that the figures are in a relatively gentle and sympathetic manner stereotyped.[13]

Non-European images of Europeans as 'the other' also bear eloquent testimony to cultural stereotyping. The Chinese as well as the Europeans had visions of monstrous races, as some seventeenth-century woodcuts suggest (illus. 68), including one figure uncannily like the classical Blemmyae (a case of cultural diffusion or independent invention?). A sixteenth-century Japanese bottle (illus. 69), like a number of painted screens made a few years later, shows the Portuguese with their breeches blown up like balloons, suggesting that the clothes of the Europeans – like their big noses – were viewed as particularly exotic. African images of the Portuguese made similar points (illus. 70). In this sense we may speak of 'Occidentalism', even

68 Woodcut of a monster, from Wu Renchen, *Shan-Hai-Jing. Guang. Zhu.*

69 Powder flask with a
Japanese image of
Portuguese people,
16th century. Museu
Nacional de Arte
Antiga, Lisboa.

70 Nigerian (Benin)
bronze plaque showing
two 16th-century
Portuguese men.
Private collection.

if it was never what Said calls a 'corporate institution' in the service of political and economic dominance.[14]

Within the west, xenophobia was often expressed by images presenting the people of other nations as monstrous or verging on the monstrous. Hogarth's *Calais Gate* (*c.* 1748), for instance, draws its power from the tradition of English stereotypes of the French. The emaciated Frenchmen remind the viewer that poverty and absolute monarchy were closely associated in British minds, while the jolly fat friar gazing at the meat, his plump hand to his breast, evokes the negative image of popery and what eighteenth-century Protestant

71 John Tenniel, 'Two Forces', cartoon, from *Punch*, 29 October 1881.

intellectuals used to call 'priestcraft'.

Again, in nineteenth-century English and American cartoons, the Irish were often represented as ape-like, or, drawing on the science fiction of the age, as something like a new Frankenstein, a monster, called into existence by the British, which now threatened them. In some ways these images recall the tradition of personifying rebellion or disorder (one of the simian Irishmen drawn by the cartoonist John Tenniel in illustration 71 wears a hat inscribed 'Anarchy'). All the same, their xenophobic thrust is unmistakable.[15]

The Other at Home

A similar process of distinction and distancing operates within a given culture. Men have often defined themselves against their image of women, claiming for instance that 'men don't cry'). The young define themselves against the old, the middle class against the working class, the north (whether in Britain, France or Italy) against the south. These distinctions are embodied in images, so that it may be useful to speak of the 'male gaze', for instance, or the 'urban gaze'. Certain artists specialized in producing images of the Other, like David Teniers the younger, who painted witches, peasants and alchemists, another favourite target for the satirists of the time.[16]

These distinctions are at their most visible in polemical images, religious or political, but there is no sharp line between polemical caricature and unconscious distortions, since the caricaturist both appeals to and reinforces existing prejudices. This point may be illustrated from representations of Jews in paintings and prints in Germany and elsewhere from the Middle Ages onwards (since Jewish culture is anti-iconic, it is not normally possible to compare these representations with self-images of Jews or Jewish images of Gentiles). A recent study by the American historian Ruth Mellinkoff notes how the Jews were 'othered' in medieval art. They were represented in yellow, for instance, wearing peaked or pointed hats and making vulgar gestures, such as sticking out their tongues. They were frequently shown as physically, and so as morally, close to the devil. Their sub-humanity was demonstrated to viewers by associating them with swine in the recurrent image of the *Judensau*.[17]

Some of these associations recur in other contexts. In the cartoons produced during the French Revolution, for instance, King Louis XVI was sometimes portrayed as a pig. Also pig-like are the fat and villainous capitalists in the paintings of Georg Grosz (1893–1959), for instance, or Diego Rivera. Less crude and perhaps less conscious

distortions may be found in many images of women – products of the male gaze – which represent them as alien, whether as seductive or repulsive. Images of prostitutes are the most obvious example of alienating stereotypes. On the seductive side, one thinks immediately of Manet, whose famous *Olympia* clearly evokes the image of the odalisques of the Orient. On the opposite side, one thinks of Edgar Degas (1834–1917), whose images, emphasizing the women's least attractive features have been described as 'brutal and brutalising', or of Grosz, who caricatured the women of the town as rapacious harpies.[18]

A still more extreme case of the male 'othering' of the female is the image of the witch, usually ugly, and often associated with animals such as goats and cats as well as with the devil. A woodcut by the German artist Hans Baldung Grien, for instance, represents a witch as a naked woman flying through the air on the back of a goat. In the sixteenth and seventeenth centuries, witches were coming to be represented more frequently in the act of cooking or eating babies. This accusation recurs in texts of the time but this change in the visual image of the witch may have come about in part as a result of what might be called 'contamination' from the images of cannibals in Brazil and elsewhere discussed above. Literary and visual images sometimes develop independently or semi-independently of one another. The final metamorphosis of the witch, in the eighteenth and nineteenth centuries, was into a crone in a pointed hat with a broomstick (illus. 72), surrounded by small devils, the image which has endured to this day in popular imagination.[19]

As in the case of the accusation of eating babies, levelled against Jews and witches alike, the pointed hat in this woodcut, like the woman's hooked nose, illustrates the migration of stereotypes. The hat may no longer evoke images of Jews, but it once did. The evidence for this assertion includes the law promulgated at Buda in 1421 that anyone arrested for the first time on a charge of witchcraft was obliged to appear in public wearing a so-called 'Jew's hat'. In early modern Spain, heretics arrested by the Inquisition were obliged to wear similar hats. The confusion between witches and Jews is a revealing one, testifying to a general idea of the Other and to what has been called 'a general visual code expressive of sub-humanity'.[20] Dehumanization is surely the point of the association of other groups with animals – apes, pigs, goats, or cats – in images and also in verbal insults.

The Grotesque Peasant

For another case study of images of the other at home we may turn to

72 An early 19th-century woodcut showing a witch.

urban representations of the inhabitants of the countryside. From the
twelfth century onwards, western images of shepherds and peasants
often represented them in a grotesque manner, thus distinguishing
them clearly from the higher-status people who would view these
images. Some vivid examples from fourteenth-century England can
be found in the pages of the famous Luttrell Psalter. The spread of
such negative representations of peasants in the fifteenth and
sixteenth centuries, giving them short fat bodies and vulgar gestures,
suggests that the cultural distance between the town and the country-
side was increasing along with urbanization.[21]

Some of the most memorable of these images occur in the paint-
ings of Pieter Brueghel the Elder, himself a town-dweller and a friend
of humanists, and suggest that they were supposed to be seen as
contributions to a tradition of urban satire.[22] The famous *Peasant
Wedding Banquet* (illus. 73) may at first sight appear to be an example
of the 'art of describing' (Chapter 5), but a number of small details
suggest a comic or satiric intent. There is the child in the foreground,
for instance, wearing a hat too large for him; the man at the end of the
table burying his face in the jug; and perhaps the man carrying the
dishes, with a spoon in his hat (probably a sign of vulgarity in the
sixteenth century, like the pencil behind the ear in Britain a genera-
tion ago). This comic tradition was carried on in the seventeenth
century in the images of peasant fairs and of peasants in inns dancing,

137

73 Pieter Breughel the Elder, *Peasant Wedding Banquet*, *c*. 1566, oil on canvas. Kunsthistorisches Museum, Vienna.

drinking, vomiting and fighting. It would be a mistake to homogenize a tradition which had space for individual variations. As one critic suggests, 'The paintings of Adriaen Brouwer and the later works of Adriaen van Ostade present very different images of the peasantry – the one brutish and uncivilized, the other prosperous and rather stupidly self-satisfied'.[23] All the same, the negative visual tradition was both widespread and powerful.

In the eighteenth and nineteenth centuries, this tradition was gradually replaced by another. The peasant – like the 'savage' – was ennobled or idealized (see above). Alternatively, as in the case of some 'orientalist' painters (above) the gaze of the artist was neither idealizing nor grotesque, but ethnographic, concerned with the faithful reporting of both costumes and customs (the Spanish term to describe this kind of painting or literature was *costumbrista*).[24] The ethnographic gaze can also be discerned in many nineteenth- and twentieth-century photographs of workers, criminals and mad people, although it was generally less objective and less scientific than its practitioners believed. The photographers – the middle class taking photographs of workers, the police taking photographs of criminals and the sane taking photographs of the insane – generally concentrated on traits

which they considered to be typical, reducing individual people to specimens of types to be displayed in albums like butterflies. What they produced were what Sander Gilman calls 'images of difference'.[25] The parallel with westerners producing images of 'the' Bedouin or the Sikh will be obvious enough. The explorer David Livingstone asked his brother Charles, who was taking photographs, to 'secure characteristic specimens of the different tribes'.[26] In some ways the opposite of the vision of the monstrous races, the scientific gaze, attempting objectivity, can be almost equally dehumanizing.

Images of the other, packed with prejudices and stereotypes, appear to undermine the idea that the evidence of pictures is worth taking seriously. But as usual we need to pause and ask ourselves, evidence of what? As evidence of what other cultures or sub-cultures were really like, many of the images discussed in this chapter are not worth very much. What they do document very well, on the other hand, is a cultural encounter, and the responses to that encounter by members of one culture in particular.

At a deeper level, these pictures may have even more to tell us about the West. Many of the images examined here have represented the other as the inversion of the self. If the view of the other is mediated by stereotypes and prejudices, the view of the self implied by these images is still more indirect. Yet it offers precious testimony if we can only learn how to read it. Ruth Mellinkoff's remark about Northern Europe in the late Middle Ages surely has a much wider application. 'One way of penetrating the core of this society and its mentality is to ask how and where it established the borders of who was in and who was out.' What people in a given place and time view as 'sub-human' tells us a good deal about the way in which they see the human condition.[27]

8 Visual Narratives

Every picture tells a story.

So far this book has had little to say about historical events. Images have evidence to offer about the organization and the setting of events great and small: battles; sieges; surrenders; peace treaties; strikes; revolutions; church councils; assassinations; coronations; the entries of rulers or ambassadors into cities; executions and other public punishments and so on. One thinks, for example, of Titian's painting of the Council of Trent in session in the cathedral, of the surrender of Breda as painted by Velázquez, of the coronation of Napoleon according to David, of the firing squads painted by Goya and Manet, of the punishment of heretics in an auto da fé in Madrid in 1680, as viewed by the painter Francisco Rizi.

The age of the daguerrotype produced memorable images such as the Chartist meeting on Kennington Common in 1848 (illus.74), which records the orderly appearance of what the middle class viewed as a subversive occasion. In the age of photography, the memory of particular events became more and more closely associated with their visual images. In 1901, a leading Brazilian journalist, Olavo Bilac, predicted that his profession was doomed because the photograph would soon replace the description in writing of any recent occur-rence. In the age of television, the perception of current events is virtually inseparable from their images on the screen. The number of these images and the speed with which they are transmitted are novelties, but the televisual revolution in everyday life should not lead us to forget the importance of images of events in earlier periods.

In the age of film, it became possible for viewers to imagine that they were watching the rise of Hitler. Before the camera, woodcuts and engravings were already performing similar functions.

140

74 William Edward Kilburn, *The Great Chartist Meeting on Kennington Common*, 10 April 1848, daguerrotype. Windsor Castle, Berks.

Images of Current Events

Early in this book (Introduction), it was suggested that one of the most important consequences of printing images was to make it possible to produce pictures of current events and to sell them while the memory of those events was still fresh, making these images the pictorial equivalent of the newspaper or news-sheet, an invention of the early seventeenth century. Some images of this kind can be found earlier, images of Luther at the Diet of Worms, for example, or the coronation of Charles V at Bologna. However, production increased sharply during the Thirty Years' War (1618–48), in which so many Europeans were involved at all levels of society. Engravings illustrated the news-sheets recounting the major events of the war as they happened, or were sold separately, like the images of the burning of the town of Oppenheim in 1621, or the assassination of General Albrecht von Wallenstein in 1634, both engraved by one of the leading graphic artists of the time, Matthäus Merian (1593–1650).[1]

Some paintings too were commissioned precisely in order to commemorate current events. The revolt of Naples in 1647, for

141

instance, led by the fisherman Masaniello, was recorded in a painting by Michelangelo Cerquozzi (1602–1660), made for a sympathizer with the revolt, the anti-Spanish cardinal Spada. A whole cluster of paintings was commissioned by Dutch patrons to commemorate the Congress of Westphalia and the Peace of Münster, which finally brought an end to the Thirty Years' War, including Bartholomeus van der Helst, *Officers Celebrating the Peace of Münster*; Cornelis Beelt, *The Proclamation of the Peace of Münster in Haarlem*; and Gerard Ter Borch, *The Swearing of the Oath of the Ratification of the Peace of Münster* (illus. 75). It will be seen that Ter Borch has been careful to show as many as possible of the participants at the same level, an important as well as a difficult task, given the conflicts over precedence which bedevilled peace conferences in the seventeenth and early eighteenth centuries. The prominence given to the documents themselves is also worth noting.

Again, the American painter John Trumbull (1756–1843), encouraged by Thomas Jefferson, made it his life's work to represent the major events of the struggle for independence. His painting of *The Declaration of Independence*, for example, made use of information provided by Jefferson, who had participated in the event.

Of another of Trumbull's history paintings it has been argued that

75 Gerard Ter Borch, *The Swearing of the Oath of the Ratification of the Peace of Münster on 15 May 1648*, 1648, oil on copper. National Gallery, London.

it 'is not, nor was it meant to be, an eyewitness account', since the painter accepted the conventions of the grand style of narrative painting, which meant omitting anything that might detract from the dignity of the scene, in this case a battle.[2] The same point might be made about the literary conventions associated with the doctrine of the 'dignity of history', which for many centuries excluded references to ordinary people.

Ter Borch, on the other hand, definitely painted in the eyewitness style (illus. 75). The artist spent three years in the city of Münster during the peace conference, in the entourage of the Dutch and later the Spanish envoy. His *Ratification* offers a sober description of a special occasion. The contemporary engraving of the picture is described in the inscription as 'a most exact image' (*icon exactissima*).[3] The eyewitness style has its own rhetoric, as we have seen (Introduction), and Ter Borch may well have arranged the scene to look more orderly, as group photographers do today, but he allowed himself less latitude than Trumbull did. In any case, peace conferences offer fewer opportunities for breaches of decorum than battles do.

Reading Narratives

Narrative paintings pose problems of their own both for the painters and for the readers – the metaphor of 'reading' images is especially appropriate in this case. For example, there is the problem of representing a dynamic sequence in the form of a static scene, in other words of using space to replace or to represent time. The artist has to condense successive actions into a single image, generally a moment of climax, and the viewer has to be aware of that condensation. The problem is to represent a process while avoiding the impression of simultaneity.[4]

The reduction of sequence to scene faces viewers with a number of interpretative problems such as the problem of distinguishing between arrivals and departures, or – as in the case of Watteau's famous painting of an art-dealer's shop – between the act of placing the portrait of Louis XIV in a box or that of taking it out. Sometimes the context provides the answer, as in Watteau's case, since the work was painted after the king's death in the very different atmosphere of the Regency. Packing Louis XIV away in the cellar makes sense in this political context, while taking him out does not.

In many cases, anticipating difficulties such as these, the painter provides explanations in the form of inscriptions, legends or 'subtitles' (formerly known as *tituli*), making the image into what the art

historian Peter Wagner calls an 'iconotext' (Chapter 2). Thus the first scene of Hogarth's *Marriage à la Mode*, discussed in the previous chapter, includes a paper in the hand of the girl's father bearing the words 'Marriage Settlement of the Rt Honourable Lord Viscount Squanderfield', not only allowing viewers to identify the scene but also alerting them, via the term 'squander', to the presence of satire.

Readers of images who inhabit a culture or a period different from that in which the images were made face more acute problems than contemporaries. Among these problems is that of identifying the narrative conventions or 'discourse' – whether leading figures may be represented more than once in the same scene, for instance (below, p. 153), or whether the story is told from left to right or vice versa, or even, as in the case of a sixth-century Greek manuscript known as the Vienna Genesis, alternately from left to right and from right to left. Narrative conventions also include stereotyped elements which might be described, following the model of a classic analysis of oral narratives, Albert Lord's *The Singer of Tales* (1960), as 'formulae' and 'themes'.

By 'formulae' I mean small-scale schemata, such as a figure in a particular pose, a 'stock' figure in the sense that it was part of an artist's repertoire which could be brought out when needed and adapted to different commissions. A well-known example is that of the figure of Christ taken down from the Cross, adapted by eighteenth-century painters, as we have seen (Chapter 4) to the cases of Wolfe and Marat. Themes, by contrast, are large-scale schemata, 'stock' scenes such as battles, councils, meetings, departures, banquets, processions and dreams, recurrent elements in long narratives such as the Bayeux Tapestry, which will be discussed in some detail below. Hollywood films have often been criticized as formulaic, and this characteristic has sometimes been explained in terms of mass-production. However, it is only reasonable to recognize that most if not all narratives rely on formulae of some kind, even stories which try to disrupt the expectations of their readers. This point is relevant not only for narrative sequences but also for attempts to freeze the action, to capture a story in a single image.

Single Images

In ancient Rome coins often alluded to contemporary events and their testimony of these events is sometimes all that remains (especially in the mid third century AD, when surviving literary sources are sparse).[5] Both the choice of events to commemorate and the way in which they are presented testify to the nature of the regime in which

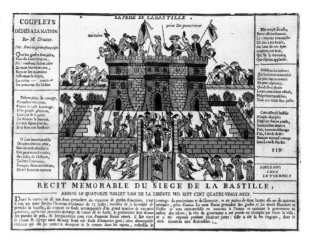

76 'Récit Memorable
du Siège de la
Bastille', colour
woodcut, Paris.
Bibliothèque
Nationale de France.

they were produced, while the analyses of a whole series of ancient coins over the long term reveals unconscious or at least semi-conscious changes in the perception of events.

In sixteenth- and seventeenth-century Europe, it is possible to discern a rise in the number of images of public life. A new genre, the political medal, modelled on ancient coins, was specifically designed to commemorate important public events. Medals were distributed by governments to ambassadors and other important people. Their inscriptions effectively gave contemporary viewers instructions on how to read the images, just as they now give historians access to the way in which the regime which produced the medal viewed itself. Although the term had not yet been coined, the medals produced in increasing numbers for rulers such as Emperor Charles V and King Louis XIV may reasonably be described as making 'propaganda', since they offered official interpretations of specific events as well as the vaguer praises of rulers which had been customary before that time.[6] The triumphalism of the medals struck to commemorate events such as the victory of Charles V over the Protestant princes at Mühlberg (1547) or Louis XIV's crossing of the Rhine (1672), is obvious enough. In similar fashion the destruction of the Spanish Armada was celebrated and interpreted in the Netherlands and in England by a medal that proclaimed that 'God blew and they were scattered' (*Flavit et dissipati sunt*).

Images of this kind were in a sense historical agents, since they not only recorded events but also influenced the way in which those events were viewed at the time. The role of image as agent is still more obvious in the case of revolutions. Revolutions have often been cele-brated in imagery, provided that they have been successful, as in the

cases of 1688, 1776, 1789, 1830, 1848 and so on.[7] However, the function of images is arguably even more important while the revolution is still in progress. They have often helped to make ordinary people politically conscious, especially – but not exclusively – in societies of restricted literacy.

A famous example of the image in action concerns the taking of the Bastille, which was almost immediately represented in prints that circulated widely – they were cheap, and those who could not afford to buy them could look at them in the windows of print-shops. One such image was already on sale on 28 July 1789, in other words, only two weeks after the event it represented. The image was surrounded by texts justifying the attack on the fortress. In a later woodcut, the accompanying text placed greater stress on the themes of liberty and the people, thus contributing to the creation of what might be called the 'myth' of the taking of the Bastille, now presented as a symbol of a repressive old regime. Less realistic and more schematic, a 'split representation' (to use the phrase of Lévi-Strauss) in which the right-hand side mirrors the left in reverse, this second woodcut (illus. 76) has been aptly described as 'a political devotional image'. It is indeed very much in the style of French woodcuts of the saints, known as 'images of Épinal', still being produced in large numbers at this period and indeed well into the nineteenth century. Portraying actual events less exactly than the first, it was more vivid and doubtless more effective as an illustration of the myth.[8]

The Battle-Piece

Among portrayals of events, the battle-piece deserves pride of place. Partly because the tradition goes back such a long way, at least as far as the battle of Til-Tuba represented on an Assyrian relief of the seventh century BC. And also because, for centuries, especially from 1494 to 1914, so many European artists created images of battles, usually on land, but sometimes at sea, from Lepanto to Trafalgar. These images were requested by rulers, by governments and finally by journals as well. If oil paintings of battles were seen by relatively few people, even in the age of public exhibitions of art in the nineteenth century, many of these images circulated widely in the form of engraved copies.

Representing such scenes raised awkward problems, expressed in epigrammatic form by the British historian John Hale: 'Battles sprawled. Art condensed.' One possible solution to the problem of sprawl was to concentrate attention on the actions of a few indi-

viduals, fragmenting the grand narrative into small ones. The painter Horace Vernet was criticized by the poet Baudelaire for producing battle-scenes which 'consisted merely of a host of interesting little anecdotes'.[9]

As a point about Vernet in particular the comment is less than fair, but it does highlight a recurrent problem of the genre. The difficulty of observing combat at close quarters and the desire to produce heroic images encouraged the use of stock figures, formulae taken from classical sculpture (the battles represented on Trajan's Column and the Arch of Constantine, for instance), and also from earlier paintings, 'genre plums', as Hale calls them, which artists could 'pull out of the pie of visual clichés almost automatically'.[10]

For an example of the formula, at once literary and visual, one might turn to the *Lives of the Artists* first published in 1550 by Giorgio Vasari (1511–1574), and note his description of Leonardo da Vinci's lost fresco of the battle of Anghiari, including the detail of two horses 'with their forelegs interlocked ... battling with their teeth no less fiercely than their riders are struggling for the standard'. Writing only a few years earlier, the Florentine historian Francesco Guicciardini (1483–1540) had included in his account of another Italian battle, at Fornovo, a vivid vignette of 'the horses fighting with kicks, bites and blows, no less than the men'. Later in the century the poet Torquato Tasso, in his epic poem *Jerusalem Delivered*, described the opening of a battle with the words 'every horse also prepares to fight'. The use of such formulae suggests that the aim of painters, poets and historians alike at this time was to represent fighting as dramatically as possible rather than to look for what was specific to a particular battle.

Images of combat are a vivid form of propaganda, offering the opportunity of portraying the commander in a heroic manner. Renaissance images of battle tend to show the leaders as themselves engaged in the fray. Later images, corresponding to changes in the organization of warfare, show the commander viewing the battlefield after the victory, as in the case of Napoleon in *The Battle of Eylau* by Antoine-Jean Gros (1771–1835).[11]

Alternatively, as in a number of scenes from the wars of Louis XIV, commissioned by the king, the commander is represented observing the progress of the battle from a hill, receiving news of the fighting and giving his orders accordingly. He is literally as well as metaphorically above the battle. Narrative has been replaced by the portrait of a man of power against a military background or panorama.[12]

As a pictorial genre, the panorama, made to be displayed in a circular

building, emerged at the end of the eighteenth century. Battle-scenes quickly took their place among the most popular panoramas, the *Battle of Aboukir* (1799), for example, by Robert Barker (1739–1806), or the *Battle of Waterloo*, by his son Henry Aston Barker (1774–1856). At last a means had been found of conveying to the viewer some sense of the complexity of a battle, if not of its confusion.[13]

Any discussion of the evidential value of images of battle needs to draw distinctions. Some artists tried only to represent a generalized battle. Others, like Horace Vernet (1789–1863) – son of Joseph Vernet (discussed in an earlier chapter) – took the trouble to speak to participants in the battle of Valmy about their impressions of the fighting, before painting his battle-scene. Henry Barker did the same in his research on the battle of Waterloo.

Again, some artists lacked personal experience of fighting, but others, like Swiss Niklaus Manuel (*c.* 1484–1530), had served as soldiers themselves. A few were sent to the front precisely in order to witness and record what happened. The Flemish painter Jan Vermeyen (*c.* 1500–59) was ordered to accompany the emperor Charles V on his expedition to North Africa for this reason, while another Fleming, Adam van der Meulen (1632–1690), accompanied Louis XIV on campaign. In the nineteenth and twentieth centuries the war artist, like the war photographer, became an institution.

For example, Louis-François Le Jeune was an eyewitness of the battle of Marengo in northern Italy 1800, where Napoleon defeated the Austrians, and recorded his impressions in sketches made on the spot.[14] The photographer Mathew Brady witnessed the American Civil War and made a collection of photographs which he described as 'a complete Pictorial History of our National Struggle'. Brady was praised at the time for these pictures, 'which will do more than the most elaborate descriptions', as a contemporary predicted, 'to perpetuate the scenes of that brief campaign'; Another contemporary verdict on Brady was that 'He is to the campaigns of the republic what Vandermeulen was to the wars of Louis XIV.'[15]

Again, the Crimean war (1853–6) was 'reported' visually by the French painter Constantin Guys and also by a virtual platoon of British artists, sent by newspapers, art dealers and publishers and including Edward Armitage, Joseph Crowe, Edward Goodall and William Simpson.[16] The photographer Roger Fenton was also in attendance. From that time onwards, no major war has been without its corps of photographers or, more recently, its television crews.

Looking back over western images of battle from the sixteenth century to the twentieth, two major changes stand out. The first,

beginning in the sixteenth century but becoming more obvious in the seventeenth, was a shift from representing 'a' battle, any battle, to a concern with a unique event, the battle of the White Mountain (say), or the battle of Waterloo, with its particular strategy and tactics. This shift was in part the result of an increasing interest in visual record, exemplified by a wide range of images, from drawings of plants to sketches of everyday life in other cultures.

The change also corresponded to modifications in the art of warfare, the so-called 'military revolution'. Following the invention of drill, battles were becoming less like an agglomeration of single combats and more like collective actions in which groups of soldiers marched, charged or fired as one man. The new pictorial trend, in step with military developments, was to show a scene which could be read like a diagram – and was indeed influenced by the diagrams printed in books on the art of war.[17] Another way of describing the shift in style is to say that 'hot' images, which were supposed to involve the spectator emotionally, were being replaced – or at any rate, supplemented – by 'cool' images, which were intended to inform.

The gain in legibility attained by the new style of battle-piece should not be equated with a gain in realism. Indeed, it may have been achieved at the expense of realism, by a deliberate refusal to take account of the confusion or 'sprawl' of actual warfare. The change in the conventions of visual narrative allowed more information of one kind to be communicated, at the price of making another kind of information less visible than before, privileging what was supposed to have happened over what actually happened. Once again, historians have to be on their guard not to take idealizing images for the reality they claim to represent.

The second major change in western images of battle was the shift from a heroic to a 'factual' or an anti-heroic style. This shift should not be dated too precisely, to the Crimean War for example, since alternative styles coexisted in different milieux over the centuries. The 'battle-scene without a hero', for instance, was already being produced in Naples in the mid-seventeenth century. At most we can speak of a gradual revulsion against what the American writer Stephen Crane (1871–1900), most famous for his unheroic account of war in *The Red Badge of Courage*, but a photographer as well as a writer, called 'the romantic distortions of generations of battle paintings'.[18]

The horrors of war – sometimes emphasized by artists on the losing side in a kind of visual counter-offensive – were displayed in vivid detail in the etchings of Jacques Callot (*c.* 1592–1635), and Francisco de Goya (1746–1828). In the series of etchings which

Callot published in 1633, *Les misères et les malheurs de la guerre*, the artist shows scenes such as the destruction of a convent, the plundering of a farmhouse and the burning of a village, together with the punishment of indisciplined soldiers by hanging, by firing-squad, at the stake and on the wheel.

After 1800, these horrors invaded the scene of battle itself, as in the famous close-up of the dying Prussian grenadier in *The Battle of Eylau*, or the famous photograph of the battle of Gettysburg in the American Civil War, *A Harvest of Death* (illus. 5), or some of the images of the Crimean War by British artists who had observed its conditions for themselves. A few artists and photographers remained within the bounds of the heroic style, but others represented ordinary soldiers, invalids or generals caught in unheroic attitudes.[19]

The heroic style survived the Second World War in certain locales, in paintings commissioned by British officers' messes, for example, or by the government of the USSR. By this time, however, the majority of twentieth-century artists and photographers of war were expressing the values of civilian, democratic or populist cultures in their choice of alternative styles. Battles were increasingly viewed from below. John Sargent's *Gassed* (1919), like Robert Capa's famous photograph of a Spanish Republican infantryman (Chapter 1; illus. 4), represents the tragedy of the ordinary soldier, while Hung Cong Ut's equally celebrated photograph, *Napalm*

77 Hung Cong Ut, *Napalm Attack*, 1972, photograph.

Attack, showing Vietnamese children, one of them completely naked, running down a road screaming (illus. 77), displayed the consequences of war for civilians.[20]

Historians using these images as evidence face the usual battery of problems. The problem of fabricated photographs, for example, discussed earlier in this book (Chapter 1) on the basis of military and other examples. In the case of the heroic battle painting, the pressures of the patrons – often princes or generals – have to be remembered, while in the case of the anti-heroic photograph, the historian cannot afford to forget the pressures of newspaper editors and television stations, concerned with 'human interest' stories. All the same, images often reveal significant details which verbal reports omit. They give viewers distant in space or time some sense of the experience of battle in different periods. They also testify in vivid fashion to changing attitudes to war.

The Series

Some of the problems arising from the attempt to turn a story into a scene can be avoided by displaying two or more images of the same event. The antithesis, so effectively employed by Cranach (Chapter 3) – or by Hogarth in his contrasts between Beer Street and Gin Lane or between the industrious and idle apprentices – can be adapted to a narrative of 'before' and 'after'. Later commonplace in the history of advertising, the technique was already in use in 1789 to illustrate the consequences of the French Revolution. In the first of a pair of anonymous prints, a peasant staggers under the weight of a priest and a nobleman. In the second, he is riding on their backs and announcing that he always knew that one day it would be his turn (as in the case of medals, the use of a text as a guide to the reading of political prints is worth noting). Pairs of images of this kind cry out for structural analysis in terms of binary oppositions, although it might equally well be argued that the existence of these prints implies that structuralism is not really new (Chapter 10).

The political graphics representing incidents in the revolt of the Netherlands (1568–1609) and the Wars of Religion in France (1562–89) were a little more complex. For example, the illustration of the 'cruel and barbarous' assassinations of the powerful family of the Guises by order of King Henri III of France divided the story into eight scenes, including two close-ups of the bodies of the Guise brothers pierced by daggers and halberds. A print of this kind sensitizes the historian-viewer to the attempt to appeal to the emotions of

ordinary people at the time, the 'rhetoric of hate' also revealed in the language of the pamphlets of the time, and thus reveals an important aspect of the conflict.[21]

For still more complex narratives we may turn to a series of images illustrating different episodes in a war or a reign. Callot, for example, devoted six etchings, published in 1628, to the Spanish siege of Breda in the Netherlands, and six more, published in 1631, to the siege of the French Protestant city of La Rochelle by the troops of King Louis XIII.

Images made for the purposes of propaganda often employed the device of the series. Jan Vermeyen, for instance, represented the emperor Charles V's campaign in North Africa in designs for tapestries representing incidents such as the emperor gathering his forces in Barcelona; the fall of the fortress of La Goleta; the attack on Tunis and the release of 20,000 Christian captives. In similar fashion a series of tapestries was made to celebrate the victories of Louis XIV, a series known at the time as 'the story of the king' (*L'Histoire du roi*). (Louis' enemies the British and the Dutch commissioned a rival series of tapestries depicting the victories of the Duke of Marlborough). Engravings of the three hundred-odd medals issued to glorify the events of the reign of Louis XIV were gathered into a book entitled the 'medallic' (or 'metallic') history of the reign. They are vivid testimonies to the 'official version' of the history of France under Louis, the way in which the regime wanted events to be perceived and remembered.[22]

Narrative Strips

From a series of discrete images it is only a step to a continuous strip, like the Assyrian reliefs at Nineveh, the procession on the frieze of the Parthenon, or Trajan's Column in Rome, where the reliefs, spiralling around the column, tell the story of the Roman campaigns against the Dacians (AD 101–106). From the Renaissance onwards, the sculptures on Trajan's Column have been used as sources not only for the history of the campaign but also for that of the clothing and equipment of the Roman army. In the sixteenth century, the importance of processions in political as well as religious life, together with the development of the art of engraving, encouraged the production of a number of printed strips illustrating such events as the arrival of Charles V at Bologna for his coronation (1530) and the procession of the doge of Venice through the streets of the city on the occasion of major festivals. In the case of the imperial entry into Bologna, there

was even an equivalent of a soundtrack, a reference in the accompanying text to the shouts of 'Cesare' on the part of the bystanders.

Images of this kind, whether engraved or painted, as in the case of the Great Tournament Roll of 1511, are extremely useful in the reconstruction of what happened, though it cannot be assumed that they are complete records rather than summaries of what occurred. They are even more useful for the reconstruction of what should have happened, since rituals do not always go according to plan. Here as elsewhere, the element of idealization in the pictorial record should not be forgotten. The element of propaganda should not be forgotten either, since the engravings of Charles's coronation, for instance, were commissioned by his aunt Margaret of Austria. Bologna was a papal city, and the relative prominence of the imperial and papal retinues was a matter for delicate negotiations at the time. The engravings give the impression that the emperor dominated proceedings, but to trust their testimony on such a controversial matter would be, to say the least, somewhat rash.[23]

The Bayeux Tapestry

An exceptionally important strip-narrative, about 70 metres long, is the Bayeux Tapestry, and its testimony has often been used by historians concerned with the Norman Conquest of England and the events leading up to it. Modern accounts of the battle of Hastings, for example, generally describe the death of King Harold as the result of an arrow entering his eye. This detail derives in the first instance not from a literary source but from a scene in the Bayeux Tapestry (illus.

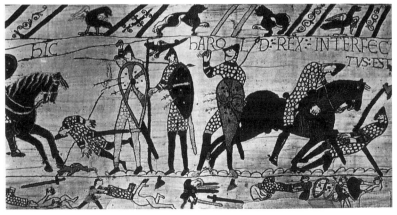

78 Detail of the death of King Harold during the Battle of Hastings, from the Bayeux Tapestry, c. 1100. Musée de la Tapisserie, Bayeux.

78) in which we see a warrior trying to pull an arrow out of his eye under an inscription declaring that 'here King Harold was killed' (HIC HAROLD REX INTERFECTUS EST). The story first appears in writing about the year 1100 but the written version may well have been inspired by a reading of the image, a memorable one in which even the inscription, as a recent commentator remarked, 'is aggressively penetrated by the thrusts of Norman lances and arrows'. Despite the inscription, the meaning of the scene is not completely clear. Some scholars have argued that the image does not represent Harold at all, and that the dying king is actually the figure on the ground to the right of the warrior. Alternatively, both figures may represent Harold, since the deaths of his brothers Leofwine and Gyrth are also shown twice. Double images of this kind are a common narrative device to represent the passing of time, the two 'shots' representing two different moments of the same story.

The testimony of the Tapestry cannot of course be accepted at face value. For one thing, as we have seen, telling the story in images would be impossible without the use of visual formulae. Their function is to ease the task of the viewer as well as that of the narrator, making certain actions more recognizable at the price of eliminating some of their specificity. It is also necessary to place the narrative in context. In other words, historians have – as usual – to ask who was telling the story to whom in this way, and what their intentions may have been in so doing.

The Bayeux Tapestry was woven in England, but the instructions probably came from Normandy. According to tradition, the Tapestry was commissioned by William the Conqueror's brother, Bishop Odo of Bayeux, and the prominence given to Odo in the narrative supports this story. The scenes which represent Harold's mission to William, culminating in his famous oath of fealty sworn on holy relics, have been described as 'deliberately framed' to display William's power and Harold's obligations to him. What we see is a story with a moral, 'the story of just retribution for Harold's perjury'. In other words, although the hanging appears to have been embroidered by English needles, it is a spectacular example of history written by the victors.[24]

Film as Evidence

For a more fluid narrative and a still greater 'reality effect' or 'illusion of actuality', we may turn to the cinema, to the contemporary films of the Boer War and the First World War, for example, and to the weekly newsreels which flourished from about 1910 to the 1950s, when tele-

vision took over their function on a daily basis. The potential of film as a historical source, like that of still photography, has long been realized. For example, in 1920, the Dutch Academy asked Johan Huizinga to advise them on the value of a project for an archive of documentary films. Huizinga, despite his visual approach to history (Introduction) advised against the project on the grounds that film made no serious contribution to historical knowledge, since what these images showed was either unimportant or already known.[25]

The best way to refute Huizinga's objection is to offer concrete examples. An archivist at the Imperial War Museum commented on a film about the Easter Rising in Dublin in April 1916 that 'one can see the extent of the damage, the demeanour and equipment of the troops involved and even the attitude of the Dublin populace'. British newsreels have been used as a source for the history of the Spanish Civil War, and a film taken by the British army at Belsen in April 1945 was used as evidence at the Nuremberg trials. At a time when the Holocaust is being denied in some quarters, the testimony of film is worth remembering.

Again, if tape-recorded oral history is taken seriously as a source, it would be odd to take videotapes any less seriously, like the testimonies about collaboration and resistance in Clermont-Ferrand during the Second World War collected by Marcel Ophuls in the 1960s, some of which were used in his film *Le chagrin et la pitié* (1971). As for social history, the example of the anthropological film shows how the new medium was used from the early twentieth century onwards to make a record of social customs. Franz Boas, for example, recorded the dances of the Kwakiutl people on film in 1930, while Gregory Bateson and Margaret Mead filmed the Balinese a few years later. A leading maker of ethnographic films, Robert Gardner, claimed that they offered evidence 'of a direct and unambiguous kind, being reality instantaneously captured and suffering no distortion due to faults of sight, memory or semantic interpretation'.[26]

The problem, once again, is to evaluate this form of evidence, to develop a kind of source criticism that takes account of the specific features of the medium, the language of the moving picture. As in the case of other kinds of document, the historian has to face the problem of authenticity. Has a certain film, or a scene from a film, been shot from life, or has it been fabricated in the studio using actors or models (of burning buildings, for instance)? Even film shot on location may not be completely reliable as a record. For technical reasons Franz Boas, for example, was forced to film the night dances of the Kwakiutl by day, so what we now see is the record not of a typical dance but of a special 'command performance'.

In the case of film, the problem of detecting interpolations is a particularly acute one, given the practice of montage and the relative ease with which images of different places or events can be introduced into the sequence. This may be done in order to mislead the viewers, giving the impression, for example, that the owner of the Krupp firm of arms manufacturers was a friend of the Kaiser's. On the other hand, interpolation may be done in good faith. Robert Gardner's films of ritual warfare among the Dani of New Guinea give the impression of recording specific fights, but – despite his proud remark about 'reality instantaneously captured' – they are actually made up of shots of different fights combined into a composite battle. Even if the film is authentic, in the sense of being composed from photographs taken on location, problems remain. For example, rapid movement was difficult to photograph in the early twentieth century, so the British War Office Film of the Battle of the Somme used 'before' and 'after' scenes to replace the action itself.[27]

In the case of war films, the exact location is crucial. Is it the front or an area behind the lines that is being shown to the viewer? Were there restrictions on the movements of the camera crew? As for the images themselves, the focus, the lighting and the framing are so many means for emphasizing some features of the subject at the expense of others.

Another process of selection and elaboration takes place in the studio. Like journalists – and historians – the directors of films edit their 'text', choosing some images and omitting others. As in the case of the Bayeux Tapestry, formulaic elements may be chosen because they make it easier for viewers to follow the story. The director may also be subject to external pressures, whether they take the form of the political pressures of the censor or the economic pressures of the box-office.

In a way, the medium itself is biased in the sense of being well suited to the representation of the surface of events, rather than the process of decision-making that underlies them. In any case, film-makers have their own view of events. Take the case of *Triumph of the Will* (1935), for instance, Leni Riefenstahl's film of the Nuremberg Rally of 1934. Riefenstahl claimed to have made a documentary, but the rhetoric of the film is obvious enough. The director, herself an admirer of Hitler, made use of various visual techniques (described above, Chapter 4) to present the leader in a heroic light. The following chapter will explore somewhat further the idea of image-makers as interpreters of the past.

9 From Witness to Historian

> The task I am trying to achieve is above all to make you see.
> D. W. GRIFFITH

> Film should be a means like any other, perhaps more valuable
> than any other, of writing history.
> ROBERTO ROSSELLINI

In the last chapter we considered the use of visual narratives as historical evidence, as a source or resource for historians when they write their books. Some visual narratives may also be regarded as histories themselves (as the director Roberto Rossellini suggested in the interview quoted above), recreating the past through images and interpreting it in different ways. In what follows I shall consider two genres from this point of view: the historical painting and the historical film.

The Painter as Historian

Although the tradition of representing historical events in images is a long one, as we have seen the interest of painters in the accurate reconstruction of scenes from the past was particularly strong in the West between the French Revolution and the First World War.[1] The rise of the historical painting in this relatively strict sense coincided with the rise of the historical novel in the manner of Sir Walter Scott (1771–1832) and Alessandro Manzoni (1785–1873), a literary genre in which the author not only told a story set in the past, recent or remote, but also attempted to evoke and describe the way of life and the mentality of the people who lived in that period.

This type of historical painting required considerable research, as a number of artists recognized. For example, the Pre-Raphaelite painter William Holman Hunt (1827–1910) went to Palestine in the

1850s in order to give his scenes from the Bible the appropriate 'local colour'. Painters who chose military subjects, so popular in the nineteenth century, sometimes carried out careful research into the uniforms and equipment of the soldiers they were painting, like the Frenchman Ernest Meissonier (1815–91) who specialized in the Napoleonic era, the German Adolph Menzel (1815–1905), who concentrated on the age of Frederick the Great or Franz Roubaud (1856–1928), who painted panoramas of the battle of Sebastopol and the battle of Borodino.[2]

These painters may be regarded as historians in their own right. They learned from the work of the professional historians who were to be found in ever-increasing numbers in nineteenth-century universities, but they also made their own contribution to the interpretation of the past. The history they usually represented was national history, driven by nationalism. Meissonier painted French victories (or more rarely, noble defeats), while Menzel painted German ones. The Swedish painters Gustaf Cederström (1845–1933) and Carl Hellqvist (1851–1890) represented scenes of the life and death of two of the most famous Swedish monarchs, Charles XII and Gustav Adolf. The Polish painter Jan Matejko (1838–1893) represented some of the most famous scenes from Polish history, including a famous image of the sixteenth-century court jester Stanczyk, which seems to go as far as a painting possibly can in the direction of interpreting history rather than simply displaying scenes from the past. While the rest of the court rejoices at the news of the war against Muscovy, a war which would lead to the defeat of Poland, Stanczyk, to whom Matejko gave his own features, sits melancholy in a corner, because he and he only can foresee the consequences which the war would bring in its train.

Two features of these painted interpretations of the past deserve emphasis. In the first place, implicit parallels between past and present. For example, in the Paris Salon of 1831, the French painter Paul Delaroche (1797–1856) exhibited a painting of Cromwell with the body of Charles I, obliquely referring to the history of France, with Louis XVI as the obvious parallel to Charles. Cromwell is more of a puzzle, given the divergences between French and English history. Is he to be identified with Napoleon, as some contemporaries thought? Or is he, as Francis Haskell once argued, the post-revolutionary king Louis Philippe?[3] A second feature of nineteenth-century historical paintings was a gradual shift towards social history, or to the social aspects of politics. Thus, in one of his best-known paintings, David Wilkie chose to represent not the battle of Waterloo but the Chelsea Pensioners rejoicing at the news of the battle. The painting

has been described as showing 'the assimilation of history painting into the popular mode of genre', thus making it more accessible to a wider public.[4]

Film as Interpretation

As early as 1916 a book was published in England under the title *The Camera as Historian*.[5] Given the importance of the hand that holds the camera, and the eye and the brain that direct it, it might be better to speak of the film-maker as historian. Or better still, to speak of 'film-makers' in the plural, since a film is the result of a collaborative enterprise in which the actors and camera crew play their parts alongside the director, not to mention the writer of the screenplay and the novel from which the film is so often adapted – so that historical events reach the viewer only after passing through a double filter, literary as well as cinematographic. In addition, films are iconotexts displaying printed messages to aid or influence the viewer's interpretation of the images. Among these iconotexts one of the most important is the film's title, which influences the expectations of viewers before they see a single image. A striking example is *Birth of a Nation* (1915), the famous film about the American Civil War. A sentence that appears on the screen during the performance reinforces the title with the words 'The agony which the South endured that a nation might be born.'

The power of film is that it gives the viewer a sense of witnessing events. This is also the danger of the medium – as in the case of the snapshot – because this sense of witnessing is an illusory one. The director shapes the experience while remaining invisible. And the director is concerned not only with what actually happened but also with telling a story which has an artistic shape and will appeal to many viewers. The hybrid term 'docudrama' is a vivid reminder of the tension between the idea of the drama and the idea of the document, between the anticlimaxes and inconclusiveness of the past and the director's need, like the writer's or the painter's, for form.[6]

The essential point is that a filmed history, like a painted history or a written history, is an act of interpretation. To juxtapose *Birth of a Nation*, directed by D. W. Griffith (1875–1948) with *Gone with the Wind* (1939), for instance, is to see the American Civil War and the ensuing Age of Reconstruction in two rather different ways, even if both films present events from the viewpoint of white southerners (Griffith came from Kentucky, and his film is based on a novel, *The Clansman* by a southern Protestant clergyman, Thomas Dixon, who

viewed himself as a crusader against the 'black peril').[7]

Again, the glorious image of the French Revolution projected by *La Révolution française* (1989), directed by Robert Enrico and Richard Heffron and forming part of the bicentenary celebrations, is in sharp contrast to the view underlying Andrzej Wajda's *Danton* (1982), with its pessimistic reflections on what Carlyle called the Revolution 'eating its own children' and the sacrifice of ideals to the lust for power. His decision to begin with the Terror, rather than with the more positive early phase of the Revolution, makes the thrust of his interpretation clear enough.

Paraphrasing E. H. Carr (Introduction) it might be argued that before studying the film, you should study the director. Wajda is a Pole with a long history of films that commented on the events of his time, from *Ashes and Diamonds* (1958), set in 1945, to *Man of Marble* (1977), which deals with a Stakhanovite worker in postwar Poland. His historical films, like the historical paintings of Delaroche and other artists discussed above, may be interpreted as oblique commentaries on the present. In his *Danton*, the role of the secret police, the purges, and the show trials make his allegorical intentions clear enough. There is even a reference to the rewriting of history for political reasons, in the scene where the painter David is shown in the act of removing Fabre, a revolutionary who is becoming a non-person, from his fresco painting commemorating the Revolution.

A historical film is an interpretation of history, whether it is made by a professional director, as is usually the case, or by a professional historian like Anthony Aldgate, who directed a film about the Spanish Civil War for Edinburgh University, or the team from Leeds university, including John Grenville and Nicholas Pronay, who made *The Munich Crisis* (1968).[8] As in the case of Plato's philosopher-kings, the ideal maker of a historical film needs to be equally at ease in two virtually incompatible roles. Despite this problem, filmed history offers an attractive solution to the problem of turning image into words, which we encountered earlier in this book (p. 34). What the American critic Hayden White calls 'historiophoty', defined as 'the representation of history and our thought about it in visual images and filmic discourse', is complementary to 'historiography'.[9]

Of course, as we have seen, many historians have treated images as ancillary to texts, where they have not ignored them altogether. Will their testimony be taken more seriously now that historians have the opportunity to use images themselves? There are certainly signs suggesting that this is the case, including reviews of films in historical journals as well as a debate on history and film published in the *Amer-*

ican Historical Review in 1988, contributions to which have already been cited. For example, in 1998 the *Journal of American History* included assessments of two of Stephen Spielberg's films, *Amistad* and *Saving Private Ryan*, under their regular rubric 'Movie Reviews'. Both reviewers were impressed by the power of Spielberg's images, but both drew attention to misrepresentations, in one case of historical individuals, in the other of the American troops, represented as 'undisciplined' and 'cowering'.[10]

The potential of film for making the past appear to be present and for summoning up the spirit of a past age through surfaces and spaces is obvious enough. The problem, as in the case of the historical novel, is whether the potential has been exploited and with what success. In this connexion it may be illuminating to compare and contrast films set in relatively remote periods – the equivalent of Sir Walter Scott's *Ivanhoe* – with films of recent periods, the equivalent of his *Waverley*. Films set in the relatively recent past are generally more accurate as history, especially in the matter of period style. The material culture of the upper classes in the nineteenth century is evoked in dazzling fashion in the scenes of fashionable Palermo in Luchino Visconti's *The Leopard* (1963), for instance, or the scenes of fashionable New York in Martin Scorsese's *The Age of Innocence* (1993), that of the provincial gentry in the BBC's *Pride and Prejudice* (1995), and that of the working class in the 1930s in the restaurant scene in Federico Fellini's *Roma* (1972).

On the other hand, it is relatively difficult to find a film concerned with a period before the eighteenth century which makes a serious attempt to evoke a past age, to show the past as a foreign country with a material culture, social organization and mentality (or mentalities) very different from our own. In my own experience it is difficult indeed for a historian to watch a film set in a period before 1700 without becoming uncomfortably aware of anachronisms in settings and gestures as well as in language or ideas.

Some of these anachronisms may be necessary, as a way of making the past immediately intelligible to the present. Others may be deliberate, a noting of parallels between older and more recent events in the manner of the historical painters discussed above, as in the case of Sergei Eisenstein's *Ivan the Terrible* Part II (made in 1946, but not released until 1958 and the age of destalinization). All the same, some anachronisms to be found in even the best historical films appear to be the result either of carelessness or of a failure to realize how much attitudes and values have changed over the long term.

A few films set centuries ago are more or less exempt from these

criticisms. Kevin Brownlow's *Winstanley* (1975), for instance, evoking the world of the Diggers in England during the Civil War. Brownlow based his plot on the novel *Comrade Jacob* by the historian David Caute but he wanted to make a film 'that depends on the facts', as he put it, so he read the pamphlets of the time as well as consulting Christopher Hill on historical points and borrowing armour from the Tower of London.[11]

A number of films by the Japanese director Akira Kurosawa, set in Japan before its modernization in the later nineteenth century, also offer a serious interpretation of the past. Kurosawa's 'intense feelings for premodern Japan' have been noted by a critic, his 'special bond to the samurai world' – he studied traditional swordsmanship when he was young. Most samurai films deal with the Tokugawa period (1600–1868), a period of peace when the function of the samurai was more bureaucratic than military, but Kurosawa preferred action. 'I think I'm the only one', he claimed, 'who has ever made films about the sixteenth-century civil wars.'

In *Seven Samurai* (1954) and *Hidden Fortress* (1958), for example, Kurosawa communicates a vivid sense of the insecurity and confusion of the period before Japan was reunified by the Tokugawa dynasty. He presents a vivid, sympathetic picture of both the skills and the ethos of the ideal samurai, whose calm concentration owes a good deal to the tradition of Zen Buddhism. However, Kurosawa also shows how the new technology of gunpowder spelled the end of the traditional warrior class and assisted the passage from feudalism to modernity. Here, as throughout his work, he was offering his viewers a conscious interpretation of Japanese history.[12]

Rossellini's Louis XIV

Another serious attempt to evoke the feel of a remote age is Roberto Rossellini's *Louis XIV Takes Power* (*La prise de pouvoir de Louis XIV*, 1966). As the basis for his film Rossellini used the biography of Louis published by the French historian Philippe Erlanger in 1965, and he employed Erlanger as a historical adviser. He also drew on texts from the period, such the maxims of La Rochefoucauld, which Louis is shown reading, and the memoirs of the Duke of Saint-Simon, describing the court rituals that the film so vividly displays. *Louis XIV* is made in what might be called an 'eyewitness style', rejecting montage for example, and giving the leading role to an amateur actor. It also makes effective use of the evidence of seventeenth-century images, notably contemporary portraits of the protagonists, although

the director appears to have based the scene of the deathbed of Cardinal Mazarin on a nineteenth-century painting by Paul Delaroche.[13]

At this point in his career, Rossellini had recently decided to make historical films as a form of popular education, in order to help people understand the present through the past. He had already made *The Age of Iron*, and was to go on to make films about Descartes, Pascal, Socrates, the Apostles, Augustine, and *The Age of Cosimo de' Medici*. In the case of his *Louis XIV*, the director's didactic intention is particularly apparent in his use of the traditional device of a stranger to the court asking questions about the meaning of what he observed and being told, for example, that the queen clapped her hands in the royal bedchamber to signify that the king had performed his conjugal duties.

As history, his *Louis XIV* is particularly remarkable for two reasons. In the first place, its concern with everyday life at a time, the sixties, when the 'history of the everyday' was not yet taken seriously by professional historians. It illustrates neatly the point made by Siegfried Kracauer that 'The whole dimension of everyday life with its infinitesimal movements and its multitude of transitory actions could be disclosed nowhere but on the screen ... films illuminate the realm of bagatelles, of little events'.[14]

For example, the film begins with an invented scene of ordinary people on the banks of the river discussing political events. It regularly shows work being done, Versailles under construction, for example, as well as the finished product. We not only see the grand royal meals but also glimpse the kitchen in which they are being prepared. Boatmen, cooks, masons and servants have their role in the film and in history as well as kings and courtiers. So do animals, especially dogs, in both the indoor and the outdoor scenes (compare the remark quoted earlier in this book, Chapter 1, about the presence of dogs in Oxford and Cambridge colleges in the seventeenth century). Material objects such as a chamber pot or a covered dish become the focus of attention on occasion.

In the second place, the director concentrated on the way in which Louis was able to take power and hold it, focusing on the theatre of the court at Versailles and how the king used it in order to tame the nobility. A brief remark by the Venetian ambassador about cloaks for courtiers designed by the king, quoted in Erlanger's biography, formed the basis of the famous scene in the film between Louis and his tailor, giving him instructions about the expensive and showy clothes which courtiers are to wear henceforth. The final scene of the film, perhaps inspired by a famous drawing of Louis XIV by the

novelist William Thackeray, shows Louis in his study taking off his grand clothes and his wig and in the process turning into an ordinary human being contemplating his mortality. In other words, Rossellini used spectacle as a means of analysing spectacle, its political uses and effects.[15]

Yet another serious history film is Daniel Vigne's *Martin Guerre* (1982), telling a true story set in the south of France in the sixteenth century, in which a peasant abandoned his wife and farm in order to become a soldier. Years later, a man returned, claiming to be Martin and was initially accepted by Martin's wife Bertrande as her husband, but his story did not convince everyone in the family. Later still, another claimant arrived, and the first man was unmasked as a certain Arnaud du Tilh and executed. While the film was being shot, the American historian Natalie Davis acted as historical adviser to the director. In return she learned from the opportunity to observe the film-making process. Some of the actors read books about the period and asked her questions about the characters they were playing. 'I can't imagine why Bertrande waited so long before turning against the impostor at the trial,' said one of them. 'Why should a peasant woman take such chances?' To which the historian replied, 'The real Bertrande didn't wait so long.'

Although Davis was troubled by some of the film's departures from 'the historical record', she has recorded that 'Watching Gérard Depardieu feel his way into the role of the false Martin Guerre gave me new ways to think about the accomplishment of the real impostor, Arnaud du Tilh,' and so made a contribution to her own study in book form, *The Return of Martin Guerre* (1983).[16] As a simple spectator I should like to pay similar tribute to Depardieu and confess that watching him play Danton in Andrzej Wajda's film of that name, discussed above, helped me enter into the character of the great revolutionary – his generosity, his warmth, his greed and his egotism – and so understand better the role he played in French history.

Contemporary History

The majority of good historical films deal with the relatively recent past. In what follows, then, I shall concentrate on twentieth-century history and the role of cinema directors in helping their contemporaries to interpret events they have all lived through; 1917, 1933, 1945, 1956 and so on, focusing on two films directed respectively by Gillo Pontecorvo and Miklós Jancsó.

Gillo Pontecorvo's *The Battle of Algiers* appeared in 1966, soon

79 A still from Gillo Pontecorvo's film
The Battle of Algiers (1966).

after the events it chronicled. The film does not use any newsreel
footage, and yet it gives the impression of a newsreel – in other words,
an eyewitness account – thanks to the style of photography as well as
the use of many non-professional actors (illus. 79). The scenes of the
French torturing and killing suspected terrorists were based on
research in the police archives made possible by the cooperation of
the Algerian government. Like the same director's *Queimada* (1969),
which was set in the Caribbean in the early nineteenth century, *The
Battle of Algiers* offers a powerful image of a Marxist interpretation of
the historical process as a struggle between oppressors and oppressed
in which the latter are destined to be victorious. At the same time,
Pontecorvo avoided the temptation to present all the rebels as good
and all the supporters of the colonial regime as evil. The screen
clearly displays the atrocities committed by both sides in the struggle.

Pontecorvo made his story more complex by giving a major role to
a sympathetic figure on the 'wrong' side, Colonel Mathieu, a brave
man and a fine soldier (a character based in part on a real historical
figure, General Massu). Another of the director's devices was his
choice of ending, ambiguous rather than triumphant. At the close of
the film, the viewers learn that at the moment of their victory over the
French, the rebels are fragmenting into rival groups, each intent on
taking power from the others.[17]

Like *The Battle of Algiers*, the Hungarian director Miklós Jancsó's
The Red and the White (1967, originally entitled 'Stars and Soldiers',
Csillagosok katonák), manages to avoid presenting the Russian Civil
War in a simple one-sided way, despite the fact that the film was
commissioned by the Soviet government for the fiftieth anniversary of

165

the Russian Revolution. The technique this time is to choose a local viewpoint, a village which is taken and retaken by the Reds (including a group of Hungarian volunteers) and the opposing Whites. In these successive waves of ebb and flow, the place itself – the village, the surrounding woodlands, and a local monastery and field hospital – provides the only fixed point. Viewed from this centre, the atrocities of the two sides appear to be equally terrible, although their styles differ in significant details – the violence of the Whites, for example, who were generally professional soldiers, seems less spontaneous and more disciplined than that of the Reds, who were not.

As in Jancsó's earlier film *The Round-Up* (1965, original title 'Poor Young Men', *Szegénylegények*), which was concerned with the suppression of a band of outlaws who had taken part in the revolution of 1848 (thus making an oblique reference to the Hungarian rising of 1956, still much on people's minds), the wide screen and the long shots prominent in *The Red and the White* make individuals seem relatively unimportant and so encourage the viewers to focus their attention on the historical process. Yet thanks to its location in or near a village, the film also makes a contribution to 'microhistory' – a term current among historians from the 1970s onwards, but already used in the 1960s by the film historian and critic Siegfried Kracauer.

Another microhistory was offered in Bo Widerberg's *Ådalen 31* (1969), a film about a strike in a paper mill in a small Swedish town in 1931 which lasted for twenty-five weeks and ended tragically when the troops moved in to protect the factory, firing on a peaceful demonstration and shooting five strikers in the process. Widerberg designed his film to reveal the general by means of a sharp focus on the particular, embodying the links as well as the conflicts between the two sides in the dispute in individuals such as Kjell, a worker who has an affair with Anna, the mill manager's daughter. Local viewpoints are also central to Edgar Reitz's *Heimat* (1984), a long film (made for German television), set in a village in the Rhineland. *Heimat* devotes a good deal of time to the age of Hitler and the way in which the Nazi regime and the Second World War were perceived at the time at local level. Spanning the period 1919–82, the film also offers both an impression and an interpretation of social change, of the coming of modernization and the loss of community which it brought with it.[18]

As in written history, so in films, the sharp focus on the local brings losses in understanding as well as gains. In both genres, one might argue, a bridge between the microlevel and the macrolevel is to be desired. Such a bridge is offered in Bernardo Bertolucci's *Novecento* (1976), a film whose very title reveals something of the director's

ambition to interpret history. Like Rossellini, Bertolucci signed a manifesto of Italian directors in 1965 declaring their ambition to make films that would show humanity the fundamental trends of its history. *Novecento* combines a study of the relations between landowners and agricultural workers on a single estate in Bertolucci's native region of Emilia, concentrated into a conflict between two families, with a progressively wider sweep over the history of Italy in the first half of the twentieth century.

In their different ways, all these films illustrate the importance of viewpoint in visual narrative. They achieve many of their most vivid and memorable effects by alternating close-ups with long shots, views from below with views from above, images which are associated with what a particular character is thinking and images which are not. If there is one lesson that all the films teach, it is the difference between the ways in which different individuals or groups view the same events. In a non-fiction film about the Yanomamo people, *The Ax Fight* (1971), the director, Timothy Asch, made this point by discussing alternative interpretations of the event within the film itself. The lesson is sometimes described as the 'Rashomon effect', a tribute to Akira Kurosawa's film *Rashomon* (1950), which translated into hauntingly visual terms two short stories by Ryunosuke Akutagawa in which a narrative about the death of a samurai and the rape of his wife is retold by different participants from several divergent points of view.[19]

A similar point about the variety of possible perspectives on the past was made within the context of the recent history of Argentina in Luis Puenzo's film *La historia oficial* (1984), whose protagonist is Alicia, a middle-class history teacher in a school in Buenos Aires, who presents to her pupils, some of whom express scepticism, the official version of the glorious history of the nation. The story told by Puenzo is one of the teacher's gradual awareness of the tortures and the murders perpetrated by the regime and by implication of an unofficial version of the history of Argentina. In this way the film itself encourages viewers to become more aware of alternative histories, and in the process demonstrates the power of the cinema to demystify and to raise consciousness.

There remains the problem of demystifying the film, of resisting the 'reality effect' which is even more intense in films than in snapshots or realistic paintings. The playwright Brian Friel once observed that what shapes the present and the future is not so much the past itself as 'images of the past embodied in language'. Images embodied in film are more powerful still. One mode of liberation from this

power might be to encourage students of history to take control and to make their own films as a way of understanding the past. In the 1970s, for example, some students at Portsmouth Polytechnic were encouraged by their history teacher, Bob Scribner, to make films about the German Reformation. Critical reviews of films in historical journals, a practice which is gradually becoming more common, are a step in the same direction. A collaboration on equal terms between a historian and a director, along the lines of the collaboration of anthropologists and directors in some ethnographic films, might be another way to use the cinema to stimulate thought about the past.

Despite Panofsky's interest in the cinema, exemplified by an article on 'Style and Medium in the Moving Pictures' (1937) the problems of interpreting film seem to have taken us a long way from the iconographical method associated with him, the method which was discussed in Chapter 2. The extent to which it is necessary for historians using images as evidence to go beyond iconography – and in what direction – will be the theme of the final chapters of this book.

10 Beyond Iconography?

> I read texts, images, cities, faces, gestures, scenes etc.
> ROLAND BARTHES

After examining different kinds of image in turn – images of the sacred, images of power, images of society, images of events, and so on – it is time to return to the problems of method originally raised in the chapter on iconography. Erwin Panofsky published a famous essay on the iconography of 'Hercules at the Cross-Roads', confronted with the decision which would determine his later career. A recent symposium adapted his title to a discussion of 'Iconography at the Cross-roads', the problem whether or not historians of images should continue to follow Panofsky's path.[1]

Some criticisms of the Panofsky method have already been mentioned (Chapter 2). The question to be discussed here and in Chapter 11 is whether there is any alternative to iconography and iconology. There are three obvious possibilities; the approach from psychoanalysis, the approach from structuralism or semiotics and the approach (more exactly, approaches in the plural) from the social history of art. All these approaches have made their appearance more than once in earlier chapters and all of them have parallels in the history of literary criticism. I call them 'approaches' rather than 'methods' on the grounds that they represent not so much new proce-dures of investigation as new interests and new perspectives.

Psychoanalysis

The psychoanalytical approach to images focuses not on conscious meanings, privileged by Panofsky, but on unconscious symbols and unconscious associations of the kind which Freud identified in his *Interpretation of Dreams* (1899). This approach is indeed a tempting one. It is difficult to deny that the unconscious plays a part in the

creation of images or texts. Freud did not often provide interpretations of specific images – apart from his celebrated and controversial essay on Leonardo da Vinci – but his concern with small details, especially in the *Psychopathology of Everyday Life*, resembles that of Giovanni Morelli (Chapter 1), as Carlo Ginzburg has noted.[2] Some of Freud's remarks on dreams offer clues to the interpretation of paintings. For example, the concepts of 'displacement' and 'condensation', which Freud developed in the course of analysing the 'dream work', are also relevant to visual narratives.[3] The idea of the phallic symbol has obvious relevance to some images. It has been argued by Eddy de Jongh, for example, that the birds, parsnips and carrots which make such a frequent appearance in Flemish and Dutch genre paintings of the sixteenth and seventeenth centuries should all be interpreted in this way.[4]

Faced with the examples discussed in Chapter 7 in particular, a psychoanalyst might well suggest that some stereotyped images, such as the harem, are visualizations of sexual fantasies, while others – images of cannibals, for example, or of witches – are projections onto the 'other' of the self's repressed desires. It is hardly necessary to be a committed Freudian to approach images in this manner. As we have seen (Chapter 2), attitudes and values are sometimes projected onto landscapes (either the land itself or its painted image), just as they are projected onto the blots of the famous Rorschach test. The discussion of sacred imagery also raised the questions of unconscious fantasies and unconscious persuasion. Again, the discussion of advertising in the chapter on material culture noted the 'subliminal' approach, in other words the attempt to create associations between products and the viewer's more or less unconscious dreams of sex and power.

All the same, even if we leave on one side the controversies over the scientific status of psychoanalysis and the conflicts between different schools of analysis, from Carl Gustav Jung to Jacques Lacan, serious obstacles remain in the way of historians who wish to follow this approach to images. On what criteria does one decide whether an object is a phallic symbol? Can the phallus not be used in its turn as a symbol of something else? The nineteenth-century Swiss philologist Johann Jakob Bachofen regarded it as an image of the sacred, at least in classical art.

There are two obstacles in particular to this kind of historical psychoanalysis, problems which are not confined to images but exemplify the general difficulties of practising what has become known as 'psychohistory'. In the first place, psychoanalysts work with living individuals, while historians cannot place dead artists on the couch

and listen to their free associations. We may, like the Spanish director Luis Buñuel, view Bernini's *St Teresa* (Chapter 3) as an interpretation of religious ecstasy in sexual terms, but all the evidence we have is contained within the marble itself. The sources which de Jongh used in his famous article on sexual symbolism in the art of the Netherlands came principally from proverbs and poems, in other words from consciously-expressed attitudes. However different his conclusions may have been, he did not diverge from Panofsky in his methods.

In the second place, historians are primarily concerned with cultures and societies, with collective desires rather than individual ones, while from Freud onwards, psychoanalysts and other psychologists have been less successful, or at any rate more speculative, in this domain. Freud, for example, devoted his essay on Leonardo to the relation between the artist's 'mother fixation' and his paintings of smiling women, without taking into account the nature of fifteenth-century culture. For example, he based conclusions about Leonardo's personality on his representation of St Anne, the mother of the Virgin Mary, as more or less the same age as her daughter, without realising that this was a cultural convention of the period. Hollywood was described as a 'dream factory' by an anthropologist, Hortense Powdermaker, in 1950, but the processes of production and reception of these fantasies still await analysis. Relatively little has been written on the history of images as expressions of collective desires or fears, although, as we have seen (Chapter 3) it might be illuminating to examine changing images of heaven and hell from this perspective.[5]

The conclusion seems to be that so far as historians using images are concerned, the psychoanalytic approach is both necessary and impossible. It is necessary because people do project their unconscious fantasies onto images, but it is impossible to justify this approach to the past according to normal scholarly criteria because the crucial evidence has been lost. Interpreting images from this point of view is inevitably speculative. There is of course an irreducibly speculative element in all attempts at iconological analysis – and in much of iconographical analysis as well – but the element of speculation is even greater when the unconscious meanings of images are under discussion. The best thing to do is probably to go ahead and speculate, but to try to remember that this is all that we are doing.

Structuralist and Post-structuralist Approaches

The approach with the best claim to be regarded as a 'method' in a reasonably strict sense of the term, is structuralism, otherwise known

as 'semiology' or 'semiotics'. These last terms were coined to describe the general 'science of signs' of which some linguists dreamed at the beginning of the twentieth century. The structuralist movement became more widely known in the 1950s and 1960s, thanks in particular to the anthropologist Claude Lévi-Strauss and the critic Roland Barthes, both of whom were extremely interested in images. Lévi-Strauss, for instance, wrote about the art of Amerindian peoples such as the Tsimshian of Canada, especially on the phenomenon of 'doubling' in which one side of the picture of an animal, say, is a mirror image of the other.

As for Barthes, the essays collected in his *Mythologies* (1957) comment on a wide range of images, including films about ancient Rome, advertisements for soap powders, photographs of shocking events and the illustrations in contemporary magazines, including what he called the 'visual myth' of the black soldier saluting the tricolour on the cover of an issue of *Paris-Match* (25 June–2 July 1955). 'I am at the barber's', Barthes tells us, 'and a copy of *Paris-Match* is offered to me' (presumably a self-respecting French intellectual of the period would not have allowed himself to be seen buying a copy of this popular paper). 'On the cover, a young Negro in a French uniform is saluting, with his eyes uplifted, probably fixed on a fold of the tricolour.' Barthes read the image – which he did not reproduce – as signifying 'that France is a great Empire, that all her sons, without any colour discrimination, faithfully serve under her flag'.[6]

From the point of view of this chapter, two of the structuralists' claims or theses are particularly important. In the first place, a text or an image may be regarded, to use their favourite phrase, as a 'system of signs', emphasizing what the American art historian Meyer Schapiro calls the 'non-mimetic elements'.[7] Such a concern diverts attention from the relation of the work in question to the external reality it may appear to represent and also from its social context, as well as from the elements which iconographers claim to decode or interpret. On the positive side, regarding an image or a text in this way means focusing attention on the work's internal organization, more especially on the binary oppositions between its parts or the various ways in which its elements may echo or invert one another.

In the second place, that system of signs is viewed as a sub-system of a larger whole. That whole, described by linguists as 'langue' (language), is the repertoire from which individual speakers make their selection ('parole'). Thus the Russian folklorist Vladimir Propp (1895–1970) analysed Russian folktales as permutations and combinations of 31 basic elements such as 'The Hero acquires the use of a

magical agent'. Structurally, according to Propp, it is the same function (no. 14), whether the princess gives the hero a ring or the king gives him a horse.

What are the consequences of approaching images as 'figurative texts' or 'systems of signs'? Among other things, the structuralist approach encourages sensitivity to oppositions or inversions. Images of 'the other', for instance, may often be read as inversions of the observer or the painter's self-image. The binary oppositions between pairs of images, as in the case of Cranach's 'antitheses' between Christ and the pope (illus. 18), or within a single image, as in the case of Hogarth's *Calais Gate* as noted earlier (p. 134), or Pieter Brueghel's *Carnival and Lent*, take on a new importance when one is wearing structuralist spectacles.

It is particularly illuminating to analyse visual narratives in structuralist terms, whether they are tapestries, engravings or films. To return to Bertolucci's *Novecento* (Chapter 9; illus. 80), its depiction of two families, one of landowners and the other of agricultural workers, is a complex combination of similarities and oppositions. The protagonists, Alfredo and Olmo, were born the same day, grew up together and are deeply attached to each other, yet destined for conflict. Their relationship is in some ways a replay, but in others the exact opposite, of the relationship between their grandfathers, Alfredo senior and Leone.

A structuralist approach is also concerned with the associations between one sign and another, a car and a beautiful girl, for instance, created in the mind of the viewer by means of frequent juxtapositions of the two elements. As for the structuralist emphasis on system, advertisements have been analysed, as we have seen (Chapter 5), to show how each new example refers back to earlier ones and in turn

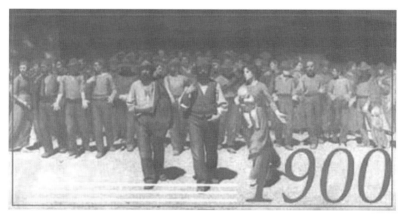

80 Poster for the Bernardo Bertolucci film 1900 (*Novecento*) (1976).

adds something to the common treasury. A similar point might be made about other ensembles of images. For example, the paintings, sculptures, engravings, medals and other images produced in the seventeenth century in order to glorify Louis XIV formed a self-referential system. A medal was struck to commemorate the erection of a statue to the king, an image of the medal was published in a book of engravings, and so on.[8]

As a single concrete example, we might take Umberto Eco's structuralist analysis of the Camay advertisement already discussed in Chapter 5 (illus. 45). Eco describes the woman as beautiful ('according to current codes'), nordic ('a sign of status', since this is an Italian advertisement), rich and cultivated (since she goes to Sotheby's); 'if she is not English she must be a high-class tourist'. The man is virile and self-confident but 'does not have an English appearance'. He is an international traveller, rich, cultivated, and a man of taste. He finds her fascinating, and the legend suggests that the brand of soap advertised is the source of the fascination.[9]

Michel Foucault was also a kind of structuralist, though not along the lines laid down by Lévi-Strauss. He was interested in systems of 'representation' just as he was interested in systems of thought. By a 'representation', Foucault meant a verbal or pictorial image of some object, made according to a certain set of conventions, which interested him more than the greater or lesser fidelity with which the object was described or depicted. His famous analysis of a painting by Velázquez, *Las Meninas*, followed these lines, describing it as 'the representation … of classical representation', at a time when the traditional links between signs and the objects they signify had been broken. In the wake of Foucault's work in the sixties and seventies, the idea of representation was taken up by art historians, literary critics, philosophers, sociologists, anthropologists and historians. The success of the term doubtless contributed to the success of the interdisciplinary journal *Representations* (founded in 1983), and vice versa.[10]

Another aspect of the structuralist approach deserves to be noted here. The concern with the act of selection from a repertoire not only underlines the importance of visual formulae and themes (Chapter 8), but also focuses attention on what is not chosen, what is excluded – a theme which was particularly dear to Foucault. In the course of this study we have already had occasion to note the importance of such blind spots, the equivalent of silences in oral discourse; the absence of children from medieval imagery, for instance (Chapter 6), that of the indigenous inhabitants of New Zealand from McCahon's landscape (Chapter 2), and the lack of the traditional royal attributes of crown

and sceptre in the portrait of Louis Philippe (Chapter 1). These blind spots should be distinguished from the 'blanks' which the image-maker consciously leaves the viewer to fill in, like the absent tricolour which the viewer infers from the salute in the case of the cover of *Paris-Match* analysed by Barthes. Interpreters of images need to be sensitive to more than one variety of absence.[11]

Problems remain, as some of the most distinguished practitioners of the structuralist approach themselves admit. Is the idea of the 'language' of images, or of paintings as 'texts' anything more than a vivid metaphor? Are there 'disanalogies' as well as analogies between art and language? Is there one language or 'code' for images, or are there a number of different ones, the equivalent of English (say), Arabic or Chinese? Is the code conscious or unconscious? If unconscious, is it so in the strict Freudian sense of what is repressed, or in the ordinary-language sense of what is taken for granted? To some critics the structural approach appears to be intolerably reductionist, with no place for ambiguities or for human agency. In one of the best-known and most forceful of these criticisms, the American anthropologist Clifford Geertz concluded that 'To be of effective use in the study of art, semiotics must move beyond the consideration of signs as means of communication, code to be deciphered, to a consideration of them as modes of thought, idioms to be interpreted.'[12]

My own view on this controversial issue is that the practice of the structural analysis of images as if it were an alternative method to iconography is indeed open to the criticisms summarized above, but that the structuralists have made an important contribution to the common treasury of interpretation by their emphasis on formal parallels and oppositions. A point which brings us to the question of the novelty claimed for this approach. Structural analysis is surely more innovative – and more shocking – in the case of literary narrative than it is in the case of images. Literature, as the German critic Gottfried Ephraim Lessing explained in his *Laokoön* (1766), is an art of time, but the structuralists deliberately ignore this point and read narratives against the grain, as in the case of Lévi-Strauss's analysis of the Oedipus myth, which reduces it to a single point repeated over and over again.

In the case of painting, on the other hand, an art of space, a concern with internal relations, with what artists and critics call 'composition', is traditional, a reading with the grain rather than against it. If the structure lies beneath the surface in literary works, which we read or hear word by word, it lies on the surface of images, at least if they are seen from a distance. A concern with internal rela-

tions was indeed the 'formal' or 'formalist' analysis in vogue around the year 1900, the approach against which Panofsky reacted by stressing meaning (he entitled a collection of his essays 'Meaning in the Visual Arts'). Like the formalists, the structuralists differ from Panofsky in the sense of showing less interest in the decoding of specific elements of the image than in the relation between them. They emphasize what the critic Hayden White has called 'the content of the form'.

In any case, insofar as they do analyse specific elements of images, Lévi-Strauss, Barthes and Eco might all be described as doing iconography rather than breaking with it. Bernardette Bucher's structural analysis of a series of engravings of the New World was inspired by Lévi-Strauss and Panofsky alike. For his part, Lévi-Strauss once described Panofsky as 'a great structuralist'. Again, imagine what Panofsky might have said about the Camay advertisement. How different would his iconography and iconology have been from the semiology of Eco? Barthes's idea of reading culture, brilliantly exemplified in *Mythologies* in his celebrated essay on wrestling as a performance of suffering and justice, has its parallel within the hermeneutic tradition in Clifford Geertz's at least equally celebrated reading of the Balinese cockfight. Both interpreters treat sporting occasions as texts and compare them to drama, yet one of them is supposed to be employing a structuralist approach, the other a hermeneutic one.[13]

As we have seen, the structuralists have been criticized for a lack of interest in specific images (which they reduce to simple patterns), and also for lack of concern with change. In reaction against their approach there has developed a movement known as 'post-structuralist'. If iconographers stress the conscious production of meaning, and the structuralists, like the Freudians, emphasize unconscious meanings, the focus of the post-structuralists falls on indeterminacy, 'polysemy' or what Jacques Derrida has called the 'infinite play of significations'. They are concerned with the instability or multiplicity of meanings and the attempts by image-makers to control this multiplicity, by means, for example, of labels and other 'iconotexts' (discussed above, Chapter 2).[14]

Like despotism and anarchy, the structuralist and post-structuralist approaches might be said to have opposite strengths and weaknesses. The weakness of the structuralist approach is the propensity to assume that images have 'a' meaning, that there are no ambiguities, that the puzzle has a single solution, that there is one code to be broken. The weakness of the post-structuralist approach

is the inverse, the assumption that any meaning attributed to an image is as valid as any other.

Another question to ask about the emphasis on ambiguity in the post-structuralist approach is whether it is really new, or more precisely, to what extent and in what ways it differs from earlier movements. Some at least of the practitioners of the 'classic' icono-graphical approach have long been aware of the problem of polysemy or 'multivocality'.[15] So indeed was Roland Barthes, despite the fact that accepting polysemy undermines the structuralist decoding of images, or at the very least the grander claims made for this approach. Again, studies of propaganda have long paid some attention to the use of inscriptions – on Roman coins or Renaissance medals, for example – as a means of leading viewers to 'read' the image in the correct way.

What is new in our day is essentially the emphasis on indeterminacy and the claim that makers of images cannot fix or control their meaning, however hard they try to do so, whether by inscriptions or other means. This emphasis fits in well with the post-modernist movement in general and in particular with the analysis of the 'reception' of images, an approach that will be discussed in the following chapter.

11 The Cultural History of Images

> The analysis of the images diffused by television ... should be
> complemented by the study of what the cultural consumer
> constructs with those images.
> MICHEL DE CERTEAU

The discussion of the meaning of images has had little to say so far
about a fundamental question: meaning for whom? Erwin Panofsky,
as we have seen, had little time for the social history of art, practised
in his day by Marxists such as Frederick Antal and Arnold Hauser
and focusing on the conditions of production and consumption from
the workshop to the art market. Yet it might reasonably be argued,
against classical iconographers and post-structuralists alike, that the
meaning of images depends on their 'social context'. I am using this
phrase in a broad sense, to include the general cultural and political
'background' as well as the precise circumstances in which the image
was commissioned and also its material context, in other words the
physical location in which it was originally intended to be seen. In this
survey of more or less new approaches to images, there is a place for
social or cultural history.

Social Histories of Art

The phrase 'the social history of art' is actually something like an
umbrella erected over a variety of competing or complementary
approaches. Some scholars, Arnold Hauser for example, viewed art as
the reflection of a whole society. Others, such as Francis Haskell,
concentrated their attention on the little world of art, more especially
the relation between artists and patrons. Two more recent approaches
to images, inspired by feminist theory and reception theory, may also
be included under this umbrella.

By the 'feminist approach', I mean the analysis of the social history

178

of art in terms not of social class but of gender, whether the focus is on the gender of the artist, the patron, the characters represented in the work itself or that of the intended or actual viewers. Pioneering figures in this expanding field include Linda Nochlin and Griselda Pollock. Like other social historians of the 'imaginary' and of fantasy, they ask 'Whose imaginary?' or 'Whose fantasy?' In answering these questions they have dedicated themselves to exposing and undermining the aggressive or 'mastering' male gaze, which they associate with a 'phallocentric culture'.

Like the structuralists, the feminists have added to the common treasury of interpretation in the sense that it has become virtually unthinkable to ignore the topic of gender when analysing images, just as it was once difficult to ignore the question of class. The approach or series of approaches to images in terms of gender has already been illustrated by earlier discussions of representations of women readers, for instance, of women's work, of witches and of harems (Chapters 6 and 7).[1]

A second recent approach to the social history of art focuses on the history of responses to images or the reception of works of art, running parallel to the movements in literary studies known as 'reception theory' and 'reader-response'. Response is the main theme of David Freedberg's *The Power of Images* (1989), for example. In this form of the social history of art, Marx is in a sense turned on his head. The study of the effects of images on society has virtually taken the place of analyses of the influence of society on the image. The history of the physical relationship between spectator and image has also been studied, notably by Michael Fried in his *Absorbtion and Theatricality* (1981).

Some historians and critics in this group or school concern themselves with the artist's image of the viewer, a visual parallel to what literary critics call the 'implicit reader'. They examine what Barthes described as 'the rhetoric of the image', the ways in which it operates to persuade or coerce spectators into making a particular interpretation, encouraging them to identify with a victor or a victim, for example, or alternatively (as has been argued in the case of some nineteenth-century historical paintings), placing the viewer in the position of an eyewitness of the event represented.[2]

Others, like Freedberg himself, investigate actual rather than predicted responses to images by studying texts: devotional handbooks, for example, or the journals of travellers, or descriptions of the behaviour of pilgrims or of groups viewing films or political cartoons. It is this approach which, in my view, promises to be the most valuable

in the next few years. It might be described as the 'cultural history of images', or even the 'historical anthropology of images', since it is concerned to reconstruct the rules or conventions, conscious or unconscious, governing the perception and interpretation of images within a given culture. The essential point is to reconstruct what the British art historian Michael Baxandall calls 'the period eye'. In his own studies of fifteenth-century Italian paintings and sixteenth-century German sculptures, he has explored the effect on the perception of images of contemporary cultural practices such as gauging barrels, dancing, and calligraphy.[3]

The practices studied by Baxandall are practices that condition perceptions of the form of images. Other cultural practices had more influence on the way in which spectators viewed the content of images, their messages. Let us take an example close to the central theme of this book, that of the cultural practice of self-conscious eyewitnessing. John Bargrave (1610–1680), canon of Christ Church Canterbury, was a scholar, a traveller and a collector. In Innsbruck in 1655, he witnessed the reception of Queen Christina of Sweden into the Catholic Church and recorded her appearance in a drawing which he had engraved. In Rome in 1660, he bought a series of engravings of Pope Alexander VII and his cardinals, and pasted them into a book, adding his own annotations, usually to the effect that 'this picture is very like him', 'extraordinarily like the persons', and so on. A reference to the revolt of Naples in 1647 prompted him to write that 'of this last passage at Naples I that wrote this was an eye witness'. Bargrave's interest in the events of his time and his interest in collecting engravings were closely linked. He took these images seriously as testimonies about the recent past.[4]

Negative responses to images offer evidence just as valuable as positive ones. As we have seen, Eisenstein's *Ivan the Terrible* Part II was kept from the public by the government until the death of Stalin. Goya's famous painting of the execution of 3 May 1808 was kept for years in the cellars of the Prado for political reasons. Again, the contemporary fate of the Delacroix painting of *Liberty Leading the People* (Chapter 4), for instance, was a kind of thermometer, measuring the political temperature. In 1831 the painting was bought by the government, in 1833 it was hidden in a cellar, in 1849 it made a brief reappearance, only to be banished again after Louis Napoleon was firmly in power. The point was that for some contemporary viewers the image evoked the republic installed in 1792 after the execution of King Louis XVI, thus making it an embarrassment for monarchical regimes. The trial of Daumier in 1832 and his imprisonment for six

months for making a caricature of King Louis Philippe also illuminates the moral and political attitudes of the time, like the trial of Flaubert for publishing *Madame Bovary* (1857).[5]

The history of the cinema offers some analogous examples of contemporary responses that clarify the ways in which certain films were originally perceived. The banning of *Birth of a Nation* from some states in the USA helps posterity understand how Griffith's images were interpreted at the time. So does the protest by the National Association for the Advancement of Coloured People against what it regarded as 'racist' scenes in *Gone with the Wind*.[6]

On occasion these texts reveal that the meaning of a given image was 'misunderstood'. The history of the reception of images, like that of texts, undermines the common-sense notion of misunderstanding by showing that different interpretations of the same object, or indeed the same event, are normal rather than aberrant, and that it is difficult to find good reasons for describing one interpretation as 'right' and the others as 'wrong'. All the same, the concept of misunderstanding may still have its uses as a way of describing the differences, at times acute, between intentions and effects, between the message as it is broadcast (by governments, missionaries, painters, and so on), and the message as it is received by different groups of viewers, readers or listeners. In that sense Vasco da Gama, for instance, 'mistook' an Indian temple for a Christian church (Chapter 7).

As we have seen (Chapter 2), chroniclers and ambassadors who viewed public spectacles such as royal entries into cities did not always interpret them in the way in which those who devised the spectacle had intended. They missed allusions or took one classical goddess for another. The problem is still with us. As was noted above (Chapter 4; illus. 22), the famous 'Goddess of Democracy' on Tian-an-Men Square was interpreted in a number of different ways in 1989, officially and unofficially, by foreigners and by Chinese.

The evidence of responses to images is not only literary but pictorial as well. The pictures represented in pictures, whether paintings in drawing rooms or engravings on tavern walls, tell us something about the uses of images and about the social history of taste. Erasures also have stories to tell. A notorious example of such a story is that of a painting by Velázquez of the heir to the throne, Prince Baltasar Carlos, in the riding-school. In the first version of the painting the first minister, the Count-Duke of Olivares, can be seen to the right of the painting in the middle distance, but after his disgrace and banishment in 1643, Olivares turned into a 'non-person' and he was removed. To be more exact, he was simply left out of the later version

of the painting, which is now to be seen in the Wallace Collection. Again, David had to repaint his *Coronation of Napoleon* because 'it was judged prudent not to show Napoleon crowning himself'. After the Bourbon restoration in 1815, the image of Napoleon on the cupola of the Pantheon was replaced by that of King Louis XVIII. In the course of the revolution of 1848, Hersent's *State Portrait of Louis Philippe* was destroyed (illus. 9).[7]

Testimonies to the responses of viewers also include iconoclasm or vandalism of various kinds, actions that encourage posterity to think about the characteristics of the images which provoked such violent responses. There is pious vandalism, for instance, as in the case of the anonymous spectators who gouged out the eyes of Judas in medieval representations of the Last Supper. There is the theological vandalism of the Byzantines or the Protestants who smashed religious images on the grounds that they were obstacles rather than means to communication between Christians and their God (Chapter 3). There is political vandalism, whether directed against the public statues of Louis XIV, for example, in 1792, or against Stalin, whose statue in Prague was destroyed in the 1960s, or against Nelson, whose statue atop a pillar in Dublin was blown up by the IRA in 1966, treating the admiral as a symbol of British hegemony.

There is also feminist iconoclasm, exemplified in the notorious attack on the so-called 'Rokeby Venus' of Velázquez in the National Gallery in London in 1914, the work of a suffragette who wished to draw attention to the cause, and aesthetic iconoclasm, as in the case of some attacks on modern sculpture, from Rodin's *Thinker* to Reg Butler's *Unknown Political Prisoner*. Alternatively, in a mild version of iconoclasm, statues have been removed from public squares and displayed in a museum or a statue park. This is what has happened to images of communist heroes in Budapest after the change of regime in Hungary in 1989 (the statue park in Budapest was opened in 1993), and what had already happened to statues of Queen Victoria after India became independent in 1947.[8]

Like graffiti, these acts of iconoclasm provide a rich vein of evidence for the history of responses to images. After erecting their 'anti-monument' in Hamburg (Chapter 4) the sculptors invited the public to respond by writing on the column, expecting signatures of solidarity but in practice evoking a much wider range of response, from 'Fascism never Again' to 'Foreigners Out' and 'I love every girl'.[9]

No wonder, then, that image-makers try to control the interpretations given to their artefacts by the public by giving them cues of different kinds. Some of these attempts at control are pictorial, fram-

ing devices for example, or the emphasis given to one person rather than another by differences in size or colouring. Another device is the image within the image, like the juxtaposition of the preacher Sacheverell and the highwayman MacHeath in the same Hogarth print, inviting viewers to make a comparison between them.

Alternatively, the responses of the viewers can be influenced or manipulated by textual means, from the legends on medals to the captions on photographs. A number of iconotexts of this kind have already been discussed in this book, from the inscriptions on the Bayeux Tapestry which allow viewers to identify the warrior with an arrow in his eye as King Harold, to those on murals by Diego Rivera which make it clear that the frescos of scenes of manual labour were intended to encourage viewers to work. In the case of medals, with tiny images that are difficult for viewers to 'read' with the naked eye, inscriptions are particularly important. In a book on the official images of Louis XIV, I suggested that the inscriptions on the medals commemorating events of the reign might be compared to newspaper headlines in form as well as function. Examples include 'Twenty Towns on the Rhine Taken by the Dauphin in a Single Month' (1686), and 'Algiers struck by Lightning' (*Algeria Fulminata*), referring to the French bombardment of the city in 1683 and presenting the actions of the French as a force of nature.[10]

The last few pages have suggested that scholars since Panofsky have not only pointed out the weaknesses in his iconographical and iconological approaches, but also made some constructive suggestions in their turn. Whether their positive recommendations should be treated as an alternative method or methods is a difficult question, to which my own answer would be 'no', on the grounds that it is possible to make a synthesis between elements of the iconographical approach and elements of the alternatives to it. The standpoint from which I have written this study is that images are neither a reflection of social reality nor a system of signs without relation to social reality, but occupy a variety of positions in between these extremes. They testify to the stereotyped yet gradually changing ways in which individuals or groups view the social world, including the world of their imagination.

It is time to sum up the message of the book about images as evidence. As we have seen, their testimony has often been ignored and has sometimes been denied. The critic Stephen Bann, voicing a more general scepticism, recently wrote that 'the visual image proves noth-

ing – or whatever it does prove is too trivial to count as a component in the historical analysis'.[11] The testimony of images is sometimes dismissed on the grounds that all they show are the conventions for representation current in a given culture. There is a continuing conflict between 'positivists', who believe that images convey reliable information about the external world, and the sceptics or structuralists who assert that they do not. The latter group focus attention on the picture itself, its internal organization, the relations between its parts and between this picture and others in the same genre, while the positivists attempt to peer through the picture to glimpse the reality beyond it.

There are times when this debate sounds to me like a dialogue of the deaf, or to employ a more visual image, it resembles the so-called 'duck-rabbit', the drawing which can equally well be seen as a rabbit or as a duck, but not at the same time. Nevertheless, I believe that a 'third way' is open to anyone who cares to take it. To take this third way does not mean walking in the middle of the road, but making careful distinctions, as I have tried to do throughout this book, avoiding simple alternatives, taking on board the most penetrating criticisms of traditional historical practice and reformulating the rules of historical method to take account of this critique.

Instead of describing images as reliable or unreliable, followers of the third way are concerned with degrees or modes of reliability and with reliability for different purposes. They reject the simple opposition between the view of the image as 'mirror' or 'snapshot', on the one hand, and nothing but a system of signs or conventions on the other. They claim that in the case of images – as in that of texts – the conventions filter information about the outside world but do not exclude it. It is only rarely, as in the case of the 'monstrous races' (Chapter 7) that stereotypes are so crude as to exclude information altogether.

Reading a western traveller or a historian of the nineteenth century, for example, or looking at the work of a painter of the same period, we may well be acutely aware of the individual or collective conventions according to which all three represent an alien culture, the Chinese Empire for example, but this does not prevent many details about that empire being communicated to us as well as information about nineteenth-century attitudes, values and prejudices.

In other words, the testimonies about the past offered by images are of real value, supplementing as well as supporting the evidence of written documents. It is true that, especially in the case of the history of events, they often tell historians who are familiar with the docu-

ments essentially what they know already. Even in these cases, however, images have something to add. They offer access to aspects of the past that other sources do not reach. Their testimony is particularly valuable in cases where texts are few and thin, the case of the informal economy, for instance, or of the view from below, or of changes in sensibility. The paintings and engravings of coronations or peace treaties convey something of the solemnity of the occasion and how the ceremony was supposed to be perceived, while the emphasis on ritual events, or ritualized events, in seventeenth-century imagery for example, reminds us of the importance of ritual in the eyes of contemporaries.

In the case of economic and social history, images offer particularly valuable evidence of practices such as street trading which were rarely recorded because of their relatively unofficial nature, thus supplementing the testimonies of guild records. Images of other cultures may be inaccurate and prejudiced, as we have seen again and again, but as evidence of prejudice itself they cannot be bettered. Not the least advantage of using the evidence of images, as the American historian Peter Paret has pointed out, is the fact that this evidence 'may be examined by reader and author together'. Documentary evidence is often available only to someone prepared to visit the archive in which it is stored, and may take many hours to read, while a painting or a photograph is often easily accessible, especially in reproduction, and its message may be scanned with relative rapidity.[12]

Of course, as in the case of texts, anyone who wishes to use images as evidence needs to be constantly aware of the point – obvious enough, yet sometimes forgotten – that most of them were not produced for this purpose. Some of them were, as we have seen, but most were made in order to perform a variety of functions, religious, aesthetic, political and so on. They have often played their part in the 'cultural construction' of society. For these very reasons, images are testimonies of past social arrangements and above all of past ways of seeing and thinking.

There remains the problem of how to read these testimonies. I hope that readers of this book did not come to it expecting a 'how-to-do-it' treatise on decoding images as if they were puzzles with single definitive solutions. On the contrary, what this book has tried to show is that images are often ambiguous or polysemic. It has proved a good deal easier to generalize about how not to read images, and the pitfalls awaiting our approaches. Variety has been a recurrent theme, both the variety of images and the variety of uses to which their testimony can be put by historians with different concerns – historians of science, of

gender, of warfare, of political thought and so on.

Even cultural historians differ among themselves in their use of visual evidence. Burckhardt for example, in his *Age of Constantine* as well as in his *Civilisation of the Renaissance*, used the testimony of style and iconography to help him characterize the spirit of the age, interpreting increasingly rich ornamentation as a sign of decadence, or the rise of the portrait as a symptom of individualism. Other historians examine images for clues to the small details of social life rather than to a whole age.

Take, for instance, the series of paintings of doorways and entrance halls by the seventeenth-century Dutch artist Jacob Ochtervelt. For a historian of music, the picture of street musicians is valuable evidence of the place of music in Dutch life at this time (illus. 81). For an economic historian, the goods the hawkers are offering at the door are of interest. They are mainly perishables such as fish and fruit (grapes and cherries). The paintings testify to the practice of door-to-door sales of these items, which other kinds of document do not record. To a social historian, the identities of the hawkers are of particular interest, since the men selling fish and poultry and the women selling fruit

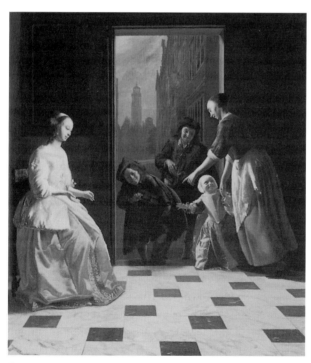

81 Jacob Ochtervelt, *Street Musicians at the the Doorway of a House*, 1665, oil on canvas. The Art Museum, St. Louis Art Museum.

suggest a division of labour based on gender. Simon Schama, as we have seen (Chapter 5), interprets these paintings in his *Embarrassment of Riches* as signs of the frontiers dividing insiders from outsiders, private and public, house and street. His point about frontiers is linked to one of the main themes of his book, the construction of Dutch identity in the seventeenth century.[13]

However, Schama is careful not to jump straight from individual paintings to generalizations about 'Dutchness'. The strength of his analysis lies in its close reading of specific images. By contrast, the same author's *Landscape and Memory*, a fascinating inventory of the historical associations which have accrued to forests, rivers and rocks, tends to cite images simply to illustrate generalizations, as Burckhardt did, although these generalizations concern human memory rather than specific periods.

Despite contrasts in both the analytical techniques and the purposes of different historians, a few general points have emerged from the analysis of the specific examples in earlier chapters, and with due caution they might be reformulated here, not as universal principles but simply as summaries of problems of interpretation which regularly recur in different contexts.[14] The problems are not, of course, confined to the testimony of images, although 'context', for example, takes on a somewhat different meaning when images rather than texts are under examination.

1. Images give access not to the social world directly but rather to contemporary views of that world, the male view of women, the middle-class view of peasants, the civilian view of war, and so on. Historians cannot afford to forget the opposite tendencies of image-makers to idealize and to satirize the world which they represent. They face the problem of distinguishing between representations of the typical and images of the eccentric.

2. The testimony of images needs to be placed in 'context', or better, in a series of contexts in the plural (cultural, political, material and so on), including the artistic conventions for representing children (say) at a particular place and time, as well as the interests of the artist and the original patron or client, and the intended function of the image.

3. A series of images offers testimony more reliable than that of individual images, whether the historian focuses on all the surviving images which viewers would have seen in particular places and times (in Zanker's phrase, 'the totality of images that a contemporary would have experienced'), or observes changes in images of purgatory (say) over the long term. What the French call 'serial history' turns out to

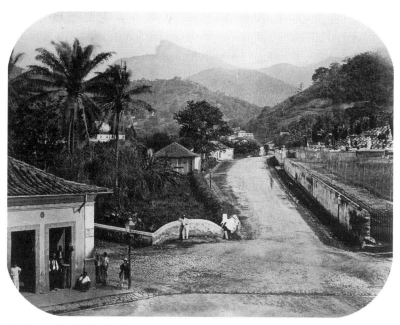

82 Augusto Stahl, *Rua da Floresta, Rio de Janeiro*, *c.* 1865, albumen print. Private collection.

be extremely useful on occasion.[15]

4. In the case of images, as in that of texts, the historian needs to read between the lines, noting the small but significant details – including significant absences – and using them as clues to information which the image-makers did not know they knew, or to assumptions they were not aware of holding. Morelli's identification of the authors of particular paintings by studying the shapes of the ears or hands depicted (Chapter 1) has important implications for historians.

For example, a picture of a street in Rio de Janeiro, taken by the photographer Augusto Stahl around 1865, shows a group of people inside and outside a shop (illus. 82). Since the shop occupies only a minor part of the picture, towards the left-hand margin of the photograph, it is unlikely that the photographer took the trouble to tell this group of people how to stand or what to wear (as was sometimes the case in nineteenth-century social photography, as we have seen). Hence the fact that one of the men in the group wears a hat but no shoes may be taken as evidence for the dress conventions of his social class at this particular place and time.

These conventions may well seem somewhat odd to a European today, for whom a hat may appear superfluous and shoes a necessity. In nineteenth-century Brazil, however, the reverse was the case, for a mixture of climatic and social reasons. A straw hat was cheap, but

leather shoes were relatively expensive. We read of African-Brazilians who bought shoes as a status symbol but preferred not to wear them, walking through the streets carrying the shoes in their hands. The photograph thus offers a final example of a recurrent theme in this study. As Erwin Panofsky used to say (quoting Flaubert and Warburg), *Le bon Dieu est dans le détail.*

References

Introduction

1　Gordon Fyfe and John Law, 'On the Invisibility of the Visual', in Fyfe and Law, eds, *Picturing Power* (London, 1988), pp. 1–14; Roy Porter, 'Seeing the Past', *Past and Present*, CXVIII (1988), pp. 186–205; Hans Belting, *Likeness and Presence* (1990: English trans. London, 1994), p. 3; Ivan Gaskell, 'Visual History', in Peter Burke, ed., *New Perspectives on Historical Writing*, (1991: second edn Cambridge, 2000), pp. 187–217; Paul Binski, *Medieval Death: Ritual and Representation* (London, 1996), p. 7.

2　Raphael Samuel, 'The Eye of History', in his *Theatres of Memory*, vol. I (London, 1994), pp. 315–36.

3　David C. Douglas and G. W. Greenaway, eds, *English Historical Documents, 1042–1189* (London, 1953), p. 247.

4　Francis Haskell, *History and its Images* (New Haven, 1993), pp. 123–4, 138–44; the critic is quoted in Léon Lagrange, *Les Vernet et la peinture au 18e siècle* (second edn Paris, 1864), p. 77.

5　Haskell, *History*, pp. 9, 309, 335–46, 475, 482–94; Burckhardt quoted in Lionel Gossman, *Basel in the Age of Burckhardt* (Chicago, 2000), pp. 361–2; on Huizinga, cf. Christoph Strupp, *Johan Huizinga: Geschichtswissenschaft als Kulturgeschichte* (Göttingen, 1999), especially pp. 67–74, 116, 226.

6　Frances A. Yates, *Shakespeare's Last Plays* (London, 1975), p. 4; cf. *idem*, *Ideas and Ideals in the North European Renaissance* (London, 1984), pp. 312–5, 321.

7　Robert M. Levine, *Images of History: 19th and Early 20th Century Latin American Photographs as Documents* (Durham, NC, 1989).

8　Philippe Ariès, *Un historien de dimanche* (Paris, 1980), p. 122; cf. Michel Vovelle, ed., *Iconographie et histoire des mentalités* (Aix, 1979); Maurice Agulhon, *Marianne into Battle: Republican Imagery and Symbolism in France, 1789–1880* (1979: English trans. Cambridge, 1981).

9　William J.T. Mitchell, ed., *Art and the Public Sphere* (Chicago, 1992), introduction.

10　Robert I. Rotberg and Theodore K. Rabb, eds, *Art and History: Images and their Meanings* (Cambridge, 1988).

11　Gustaaf J. Renier, *History, its Purpose and Method* (London, 1950).

12　Haskell, *History*, p. 7; Stephen Bann, 'Face-to-Face with History', *New Literary History* XXIX (1998), pp. 235–46.

13　John Tagg, *The Burden of Representation: Essays on Photographies and Histories* (Amherst, 1988), pp. 66–102; Alan Trachtenberg, *Reading American Photographs: Images as History, Mathew Brady to Walker Evans* (New York, 1989), pp. 28–9.

14　Erwin Panofsky, *Early Netherlandish Painting* (2 vols, Cambridge, MA, 1953); cf Linda Seidel, *Jan van Eyck's Arnolfini Portrait: Stories of an Icon* (Cambridge,

1993); Ernst H. Gombrich, *The Image and the Eye* (London, 1982), p. 253.

15 Patricia F. Brown, *Venetian Narrative Painting in the Age of Carpaccio* (New Haven, 1988), pp. 5, 125.

16 On texts, Marshall McLuhan, *The Gutenberg Galaxy* (Toronto, 1962); cf. Elizabeth Eisenstein, *The Printing Press as an Agent of Change* (2 vols, Cambridge, 1979). On images, William H. Ivins, jr, *Prints and Visual Communication* (Cambridge, MA, 1953); cf. David Landau and Peter Parshall, *The Renaissance Print 1470–1550* (New Haven, 1994), p. 239.

17 Walter Benjamin, 'The Work of Art in the Age of Mechanical Reproduction' (1936: English trans. in *Illuminations* [London, 1968], pp. 219–44; cf. Michael Camille, 'The *Très Riches Heures*: An Illuminated Manuscript in the Age of Mechanical Reproduction', *Critical Inquiry* XVII (1990–1), pp. 72–107.

18 Edward H. Carr. *What is History?* (Cambridge, 1961), p. 17.

1 *Photographs and Portraits*

1 Francis quoted in James Borchert, *Alley Life in Washington: Family, Community, Religion and Folklife in an American City* (Urbana, 1980), p. 271; Roland Barthes, 'The Reality Effect' (1968: English trans. in *The Rustle of Language*, Oxford, 1986, pp. 141–8).

2 Roy E. Stryker and Paul H. Johnstone, 'Documentary Photographs', in Caroline Ware, ed., *The Cultural Approach to History* (New York, 1940), pp. 324–30; F. J. Hurley, *Portrait of a Decade: Roy Stryker and the Development of Documentary Photography* (London, 1972); Maren Stange, *Symbols of Social Life: Social Documentary Photography in America, 1890–1950* (Cambridge, 1989); Alan Trachtenberg, *Reading American Photographs: Images as History, Mathew Brady to Walker Evans* (New York, 1989), pp. 190–2.

3 John Tagg, *The Burden of Representation: Essays on Photographies and Histories* (Amherst, 1988), pp. 117–52; Stange, *Symbols*, pp. 2, 10, 14–15, 18–19; Sarah Graham-Brown, *Palestinians and their Society, 1880–1946: A Photographic Essay* (London, 1980), p. 2.

4 Siegfried Kracauer, *History: The Last Things before the Last* (New York, 1969), pp. 51–2; cf. Dagmar Barnouw, *Critical Realism: History, Photography and the Work of Siegfried Kracauer* (Baltimore, 1994); Stryker and Johnstone, 'Photographs'.

5 Raphael Samuel, 'The Eye of History', in his *Theatres of Memory*, vol. I (London, 1994), pp. 315–36, at p. 319.

6 Trachtenberg, *Reading*, pp. 71–118, 164–230; Caroline Brothers, *War and Photography: A Cultural History* (London, 1997), pp. 178–85; Michael Griffin, 'The Great War Photographs', in B. Brennen and H. Hardt, eds, *Picturing the Past* (Urbana, 1999), pp. 122–57, at pp. 137–8; Tagg, *The Burden*, p. 65.

7 Paul Thompson and Gina Harkell, *The Edwardians in Photographs* (London, 1979), p. 12; John Ruskin, *The Cestus of Aglaia* (1865–6: reprinted in his *Works*, vol. XIX [London, 1905], p. 150); M. D. Knowles, 'Air Photography and History', in J. K. S. St Joseph, ed., *The Uses of Air Photography* (Cambridge, 1966), pp. 127–37.

8 David Smith, 'Courtesy and its Discontents', *Oud-Holland* C (1986), pp. 2–34; Peter Burke, 'The Presentation of Self in the Renaissance Portrait', in Burke, *Historical Anthropology of Early Modern Italy* (Cambridge, 1987), pp. 150–67; Richard Brilliant, *Portraiture* (London, 1991).

9 Erving Goffman, *The Presentation of Self in Everyday Life* (New York, 1958); the English examples from Desmond Shawe-Taylor, *The Georgians: Eighteenth-*

Century Portraiture and Society (London, 1990).

10 Julia Hirsch, *Family Photographs: Content, Meaning and Effect* (New York, 1981), p. 70.

11 Michael Marrinan, *Painting Politics for Louis Philippe* (New Haven, 1988), p. 3.

12 J. Brian Harley, 'Deconstructing the Map' (1989: reprinted in T. J. Barnes and James Duncan, eds, *Writing Worlds* [London, 1992], pp. 231–47). Cf. Jürgen Schulz, 'Jacopo Barbari's View of Venice: Map Making, City Views and Moralized Geography', *Art Bulletin* LX (1978), pp. 425–74.

13 Ruth B. Yeazell, *Harems of the Mind: Passages of Western Art and Literature* (New Haven, 2000).

14 Jan Bialostocki, 'The Image of the Defeated Leader in Romantic Art' (1983: reprinted in his *The Message of Images* (Vienna, 1988), pp. 219–33; Arnold Hauser, *The Social History of Art* (2 vols, London 1951); cf. the criticism of Ernest H. Gombrich, 'The Social History of Art' (1953; reprinted in *Meditations on a Hobby Horse* [London 1963], pp. 86–94).

15 Keith Thomas, *Man and the Natural World* (London, 1983), p. 102.

16 Carlo Ginzburg, 'Clues: Roots of an Evidential Paradigm' (1978: reprinted in his *Myths, Emblems, Clues* [London 1990], pp. 96–125).

17 'Ivan Lermolieff' (Giovanni Morelli), *Kunstkritische Studien über italienische Malerei* (3 vols, Leipzig 1890–3), especially vol. I, pp. 95–9; cf. Hauser, *Social History*, pp. 109–10, and Ginzburg, 'Clues', pp. 101–2; Aby Warburg, *The Renewal of Pagan Antiquity* (1932: English trans Los Angeles 1999).

18 Siegfried Kracauer, 'History of the German Film', (1942: reprinted in his *Briefwechsel*, ed. V. Breidecker [Berlin 1996], pp. 15–18).

2 *Iconography and Iconology*

1 Erwin Panofsky, *Early Netherlandish Painting* (2 vols, Cambridge, MA, 1953); Eddy de Jongh 'Realism and Seeming Realism in Seventeenth-Century Dutch Painting', (1971: English trans. in Wayne Franits, ed., *Looking at Seventeenth-Century Dutch Art: Realism Reconsidered* [Cambridge, 1997], pp. 21–56); *idem*, 'The Iconological Approach to Seventeenth-Century Dutch Painting', in Franz Grijzenhout and Henk van Veen, eds, *The Golden Age of Dutch Painting in Historical Perspective* (1992: English trans. Cambridge, 1999), pp. 200–23.

2 Erwin Panofsky, *Studies in Iconology* (New York, 1939), pp. 3–31.

3 Ernest H. Gombrich, 'Aims and Limits of Iconology', in his *Symbolic Images* (London, 1972), pp. 1–25, at p. 6; de Jongh, 'Approach'. Cf. Robert Klein, 'Considérations sur les fondements de l'iconographie' (1963: reprinted in *La Forme et l'intelligible* [Paris 1970], pp. 353–74).

4 Panofsky, *Iconology*, pp. 150–5; Edgar Wind, *Pagan Mysteries in the Renaissance* (1958: second edn Oxford, 1980), pp. 121–8.

5 Aby Warburg, *The Renewal of Pagan Antiquity* (1932: English trans. Los Angeles, 1999), pp. 112–15.

6 Charles Hope, 'Artists, Patrons and Advisers in the Italian Renaissance', in Guy F. Lytle and Stephen Orgel, eds, *Patronage in the Renaissance* (Princeton, 1981), pp. 293–343.

7 Ernest H. Gombrich, *In Search of Cultural History* (Oxford, 1969); K. Bruce McFarlane, *Hans Memling* (Oxford, 1971).

8 Ronald Paulson, *Emblem and Expression* (London, 1975); Denis Cosgrove and Stephen Daniels, eds, *The Iconography of Landscape* (Cambridge, 1988).

9 Simon Schama, *Landscape and Memory* (London, 1995).

10 Barbara Novak, *Nature and Culture: American Landscape and Painting*

1825–1875 (1980: rev. edn New York, 1995).

11 R. Etlin, ed., *Nationalism in the Visual Arts* (London, 1991); Jonas Frykman and Orvar Löfgren, *Culture Builders: A Historical Anthropology of Middle-Class Life* (1979: English trans. New Brunswick, 1987), pp. 57–8; Albert Boime, *The Unveiling of the National Icons* (Cambridge, 1994).

12 David Matless, *Landscape and Englishness* (London, 1998).

13 Hugh Prince, 'Art and Agrarian Change, 1710–1815', in Cosgrove and Daniels, *Iconography*, pp. 98–118.

14 Keith Thomas, *Man and the Natural World* (London, 1983); Ann Bermingham, *Landscape and Ideology: The English Rustic Tradition, 1740–1860* (London, 1986)

15 Stephen Daniels, 'The Political Iconography of Landscape', in Cosgrove and Daniels, *Iconography*, pp. 43–82; Martin Warnke, *Political Landscape: The Art History of Nature* (1992: English trans. London, 1994), pp. 75–83; Schama, *Landscape*.

16 Novak, *Nature*, p. 189; Nicholas Thomas, *Possessions: Indigenous Art and Colonial Culture* (London, 1999), pp. 20–3.

3 The Sacred and the Supernatural

1 Jean Wirth, *L'image médiévale: Naissance et développement* (Paris, 1989); Françoise Dunand, Jean-Michel Spieser and Jean Wirth, eds, *L'image et la production du sacré* (Paris, 1991).

2 Jean-Claude Schmitt, *Ghosts in the Middle Ages* (1994: English trans. Chicago, 1998), p. 241; Luther Link, *The Devil: A Mask without a Face* (London, 1995); Robert Muchembled, *Une histoire du diable (12e–20e siècles)* (Paris, 2000).

3 Gaby Vovelle and Michel Vovelle, *Vision de la mort et de l'au-delà en Provence* (Paris, 1970), p. 61.

4 Heinrich Zimmer, *Myths and Symbols in Indian Art and Civilisation* (1946: second edn New York, 1962), pp. 151–5; Partha Mitter, *Much Maligned Monsters: History of European Reactions to Indian Art* (Oxford, 1977).

5 Lawrence G. Duggan, 'Was Art really the "Book of the Illiterate"?', *Word and Image* V (1989), pp. 227–51; Danièle Alexandre-Bidon, 'Images et objets de faire croire', *Annales: Histoire, sciences sociales* LIII (1998), pp. 1155–90.

6 Emile Mâle, *L'art religieux de la fin du Moyen Age en France* (Paris, 1908); id., *L'art religieux de la fin du seizième siècle: Etude sur l'iconographie après le concile de Trente* (Paris, 1932); Richard W. Southern, *The Making of the Middle Ages* (London, 1954); Mitchell B. Merback, *The Thief, the Cross and the Wheel: Pain and the Spectacle of Punishment in Medieval and Renaissance Europe* (London, 1999).

7 Richard Trexler, 'Florentine Religious Experience: The Sacred Image', *Studies in the Renaissance* XIX (1972), pp. 7–41.

8 Bernard Cousin, *Le Miracle et le Quotidien: Les ex-voto provençaux images d'une société* (Aix, 1983); David Freedberg, *The Power of Images* (Chicago, 1989), pp. 136–60.

9 Sixten Ringbom, *From Icon to Narrative* (Åbo, 1965); Hans Belting, *Likeness and Presence* (1990: English trans. 1994), pp. 409–57.

10 Freedberg, *Power*, pp. 192–201; cf. Merback, *Thief*, 41–6.

11 Samuel Y. Edgerton, *Pictures and Punishment: Art and Criminal Prosecution during the Florentine Renaissance* (Ithaca, 1985).

12 Mâle, *Moyen âge*, pp. 28–34; Michael Baxandall, *Painting and Experience in Fifteenth-Century Italy* (Oxford, 1972), p. 41.

13 Mâle, *Trente*; Freedberg, *Power*.

14 Millard Meiss, *Painting in Florence and Siena after the Black Death* (Princeton, 1951), pp. 117, 121; Frederick P. Pickering, *Literature and Art in the Middle Ages* (1970), p. 280.

15 Mâle, *Trente*, pp. 151–5, 161–2.

16 James Billington, *The Icon and the Ax* (New York, 1966), p. 158.

17 Walter Abell, *The Collective Dream in Art* (Cambridge, MA, 1957); Link, *Devil*, p. 180.

18 Abell, *Dream*, pp. 121, 127, 130, 194; Jean Delumeau, *La peur en occident* (Paris, 1978); W. G. Naphy and P. Roberts, eds, *Fear in early modern society* (Manchester, 1997).

19 Freedberg. *Power*; Serge Gruzinski, *La guerre des images* (Paris, 1990); Olivier Christin, *Une révolution symbolique: L'iconoclasme huguenot et la reconstruction catholique* (Paris, 1991).

20 Robert W. Scribner, *For the Sake of Simple Folk* (1981: second edn Oxford, 1995), p. 244.

21 Mikhail Bakhtin, *The World of Rabelais* (1965: English trans. Cambridge, MA, 1968); Scribner, *Folk*, pp. 62, 81.

22 Scribner, *Folk*, pp. 149–63.

23 *Ibid.*, pp. 18–22.

24 Belting, *Likeness*, pp. 14, 458–90; Patrick Collinson, *From Iconoclasm to Iconophobia: The Cultural Impact of the Second Reformation* (Reading, 1986).

25 Collinson, *Iconoclasm*, p. 8.

26 Mâle, *Trente*.

4 Power and Protest

1 André Grabar, *Christian Iconography: A Study of its Origins* (Princeton, 1968), pp. 78–9; Jas Elsner, *Imperial Rome and Christian Triumph: The Art of the Roman Empire, AD 100–450* (Oxford, 1998).

2 Frances A. Yates, *Astraea: The Imperial Theme in the Sixteenth Century* (London, 1975), pp. 78, 101, 109–10.

3 Peter Burke, *The Fabrication of Louis XIV* (New Haven, 1992), p. 9.

4 Toby Clark, *Art and Propaganda in the 20th Century: The Political Image in the Age of Mass Culture* (London, 1977); Zbynek Zeman, *Selling the War: Art and Propaganda in World War II* (London, 1978); R. Taylor, *Film Propaganda* (London, 1979); David Welch, *Propaganda and the German Cinema, 1933–1945* (Oxford, 1983); Igor Golomstock, *Totalitarian Art: In the Soviet Union, the Third Reich, Fascist Italy and the People's Republic of China* (London, 1990).

5 Quentin Skinner, 'Ambrogio Lorenzetti: The Artist as Political Philosopher', *Proceedings of the British Academy* LXXII (1986), pp. 1–56; Michael Walzer, 'On the Role of Symbolism in Political Thought', *Political Science Quarterly* LXXXII (1967), pp. 191–204; Murray Edelman, *Politics as Symbolic Action* (London, 1971); José M. González García, *Metáforas del Poder* (Madrid, 1998).

6 Ernst H. Gombrich, 'Personification', in Robert R. Bolgar, ed., *Classical Influences on European Culture*, (Cambridge, 1971), pp. 247–57: Marina Warner, *Monuments and Maidens: The Allegory of the Female Form* (London, 1985); Linda Colley, *Britons: Forging the Nation, 1707–1837* (New Haven, 1992).

7 Maurice Agulhon, *Marianne into Battle: Republican Imagery and Symbolism in France, 1789–1880* (1979: English trans. Cambridge, 1981), pp. 38–61; on the cap, James Epstein, 'Understanding the Cap of Liberty: Symbolic Practice and Social Conflict in Early Nineteenth-Century England', *Past and Present* CXXII (1989), pp. 75–118.

8 Marvin Trachtenberg, *The Statue of Liberty* (1974: reprinted Harmondsworth 1977); Warner, *Monuments*, pp. 3–17.

9 William J. T. Mitchell, 'The Violence of Public Art: *Do the Right Thing*', (1990: reprinted in W. J. T. Mitchell, ed., *Art and the Public Sphere* (Chicago, 1992), pp. 29–48; Longxi Zhang, *Mighty Opposites* (Stanford, 1998), pp. 161–72.

10 Desmond Rochfort, *Mexican Muralists: Orozco, Rivera, Siqueiros* (London, 1993), pp. 39ff.

11 Paul Zanker, *Augustus and the Power of Images* (1987: English trans. Ann Arbor, 1988), pp. 3, 98; Elsner, *Imperial Rome*, pp. 161–72.

12 Jas Elsner, *Art and the Roman Viewer* (Cambridge, 1995), p. 159; Burke, *Fabrication*, p. 16.

13 Michel Martin, *Les monuments équestres de Louis XIV* (Paris, 1986).

14 Welch, *Propaganda*, pp. 147–64.

15 Sergiu Celac, quoted in John Sweeney, *The Life and Evil Times of Nicolae Ceausescu* (London, 1991), p. 125.

16 Golomstock, *Totalitarian Art*.

17 Alison Yarrington, *The Commemoration of the Hero, 1800–1864: Monuments to the British Victors of the Napoleonic Wars* (New York, 1988), pp. 79–149, 277–325; J. Blackwood, *London's Immortals* (London, 1989).

18 Nicholas Penny, 'The Whig Cult of Fox in Early Nineteenth-Century Sculpture', *Past & Present* LXX (1976), pp. 94–105, at pp. 94, 100.

19 Gabriel Sprigath, 'Sur le vandalisme révolutionnaire (1792–94)', *Annales Historiques de la Révolution Française* LII (1980), pp. 510–35; Anne M. Wagner, 'Outrages. Sculpture and Kingship in France after 1789', in Ann Bermingham and John Brewer, eds, *The Consumption of Culture* (London, 1995), pp. 294–318.

20 Dario Gamboni, *The Destruction of Art: Iconoclasm and Vandalism since the French Revolution* (London, 1997), pp. 51–90.

21 P. Manzi, *Cronistoria di un monumento: Giordano Bruno in Campo de' Fiori* (Nola, 1963); Lars Berggren and Lennart Sjöstedt, *L'ombra dei grandi: Monumenti e politica monumentale a Roma (1870–1895)* (Rome, 1996), pp. 29–35, 123–36, 161–82.

22 James E. Young, 'The Counter-Monument: Memory against Itself in Germany Today', in Mitchell, *Art and the Public Sphere*, pp. 49–78.

23 Burke, *Fabrication*, p. 143.

24 M. Dorothy George, *English Political Caricature: A Study of Opinion and Propaganda* (2 vols, Oxford 1959); Herbert M. Atherton, *Political Prints in the Age of Hogarth: A Study of the Ideographic Representation of Politics* (Oxford, 1974); Michel Jouve, 'Naissance de la caricature politique moderne en Angleterre (1760–1800)', in Pierre Rétat, ed., *Le journalisme d'ancien régime*, (Paris, 1981), pp. 167–82; Michel Vovelle, ed., *Les Images de la Révolution Française* (Paris, 1988); James A. Leith, *The Idea of Art as Propaganda in France, 1750–1799* (Toronto, 1965).

5 *Material Culture through Images*

1 Fernand Braudel, *The Structures of Everyday Life* (1979: English trans. London, 1981), p. 318; Daniel Roche, *The Culture of Clothes* (1989: English trans. Cambridge, 1996); Bernard Cousin, *Le Miracle et le Quotidien: Les ex-voto provençaux images d'une société* (Aix, 1983), pp. 17–18.

2 Peter Paret, *Imagined Battles: Reflections of War in European Art* (Chapel Hill, 1997), p. 24; Osamu Oba, 'Scroll Paintings of Chinese Junks', *Mariner's Mirror* LX (1974), pp. 351–62.

3 H. D. Gower, L. Stanley Jast and W. W. Topley, *The Camera as Historian* (London, 1916).

4 Jacques Proust, ed., *L'Encyclopédie* (Paris, 1985), p. 16.

5 Oscar Handlin and John Burchardt, eds, *The Historian and the City* (Cambridge, MA, 1963), pp. 165–215; Cesare de'Seta, ed., *Città d'Europa: Iconografia e vedutismo dal xv al xviii secolo* (Naples, 1996).

6 Cynthia Lawrence, *Gerrit Berckheyde* (Doornspijk, 1991).

7 Svetlana Alpers, *The Art of Describing: Dutch Art in the Seventeenth Century* (Chicago, 1983).

8 De'Seta, *Città*; James Borchert, *Alley Life in Washington: Family, Community, Religion and Folklife in an American City* (Urbana, 1980); *idem*, 'Historical Photo-analysis: A research method', *Historical Methods* xv (1982), pp. 35–44.

9 Léon Lagrange, *Les Vernet et la peinture au 18e siècle* (second edn Paris, 1864), pp. 69–70, 85–7, 104, 115; cf. Jutta Held, *Monument und Volk: Vorrevolutionäre Wahrnehmung in Bildern des ausgehenden Ancien Regime* (Cologne and Vienna, 1990).

10 Susan D. Kuretsky, *The Paintings of Jacob Ochtervelt* (Oxford, 1979); Simon Schama, *The Embarrassment of Riches: An interpretation of Dutch Culture in the Golden Age* (London, 1987), especially pp. 570–96.

11 Peter Thornton, *Seventeenth-Century Interior Decoration in England, France and Holland* (New Haven, 1978).

12 Lisa Jardine, *Worldly Goods: A New History of the Renaissance* (London, 1996), pp. 6–8.

13 Eddy de Jongh, 'Realism and Seeming Realism in Seventeenth-Century Dutch Painting' (1971: English trans. in Wayne Franits, ed., *Looking at Seventeenth-Century Dutch Art: Realism Reconsidered* [Cambridge, 1997], pp. 21–56): Schama, *Embarrassment,* pp. 375–97.

14 Elizabeth A. Honig, 'The Space of Gender in Seventeenth-Century Dutch Painting', in Franits, *Looking at Seventeenth-Century Dutch Art*, pp. 187–201.

15 David M. Wilson, *The Bayeux Tapestry* (London, 1985), p. 218.

16 Claudia Kinmonth, 'Irish Vernacular Furniture: Inventories and Illustrations in Interdisciplinary Methodology', *Regional Furniture* x (1996), pp. 1–26.

17 Siegfried Giedion, *Mechanization Takes Command: A Contribution to Anonymous History* (New York, 1948), p. 288; Peter Thornton, *The Italian Renaissance Interior* (London, 1991); Dora Thornton, *The Scholar in his Study* (New Haven, 1998).

18 Francesca Bray, *Technology and Gender: Fabrics of Power in Late Imperial China* (Berkeley and Los Angeles, 1997), pp. 136–9; Erwin Panofsky, *Albrecht Dürer* (Princeton, 1948), p. 155; Giedion, *Mechanization,* p. 303.

19 Umberto Eco, *La struttura assente: Introduzione alla ricerca semiologica* (Milan, 1968), pp. 174–7.

20 Judith Williamson, *Decoding Advertisements: Ideology and Meaning in Advertising* (London, 1978), p. 25; cf. Erving Goffman, *Gender Advertisements* (London, 1976).

21 Jonas Frykman and Orvar Löfgren, *Culture Builders: A Historical Anthropology of Middle-Class Life* (1979: English trans. New Brunswick, 1987), pp. 127–9.

22 Thornton, *Interior,* fig. 317.

23 Gary Schwartz and Marten J. Bok, *Pieter Saenredam, the Painter and his Time,* (1989: English trans. London, 1990), especially pp. 74–6.

24 Keith Thomas, *Man and the Natural World* (London, 1983).

25 Krzysztof Pomian, *Collectors and Curiosities* (1987: English trans. Cambridge, 1990), pp. 49–53; Paula Findlen, *Possessing Nature: Museums, Collecting and*

Scientific Culture in Early Modern Italy (Berkeley, 1994).

26 Christopher H. Roads, 'Film as Historical Evidence', *Journal of the Society of Archivists* III (1965–9), pp. 183–91, at p. 187.

27 Erich Schön, *Die Verlust der Sinnlichkeit oder die Verwandlungen des Lesers*, (Stuttgart, 1987), especially pp. 63–72.

6 *Views of Society*

1 Roy E. Stryker and Paul H. Johnstone, 'Documentary Photographs', in Caroline Ware, ed., *The Cultural Approach to History* (New York, 1940), pp. 324–30, at p. 327; John Demos, 'George Caleb Bingham: The Artist as Social Historian', *American Quarterly* XVII (1965), pp. 218–28.

2 Horst Bredekamp, *Florentiner Fussball: Renaissance der Spiele* (Frankfurt, 1993).

3 W. H. Fox Talbot, *The Pencil of Nature* (London, 1844).

4 Quoted in Demos, 'Bingham', p. 218.

5 Elizabeth Johns, *American Genre Painting* (New Haven, 1991), p. 92; Andy Jones, 'Reading August Sander's Archive', *Oxford Art Journal* XXIII (2000), 1–22.

6 James Borchert, *Alley Life in Washington: Family, Community, Religion and Folklife in an American City* (Urbana, 1980), pp. 293–4.

7 Philippe Ariès, *Centuries of Childhood* (1960: English trans. London, 1965).

8 David Bindman, *Hogarth* (London, 1981), pp. 143–4.

9 François Garnier, 'L'iconographie de l'enfant au Moyen Age', *Annales de Démographie Historique* (1973), pp. 135–6, supports the views of Ariès; Ilene H. Forsyth, 'Children in Early Medieval Art: Ninth through Twelfth Centuries', *Journal of Psychohistory* IV (1976), pp. 31–70, criticizes them. Cf. Anthony Burton, 'Looking Forward from Ariès?', *Continuity and Change* IV (1989), pp. 203–29.

10 Mary Frances Durantini, *The Child in Seventeenth-Century Dutch Painting* (Ann Arbor, 1983); Simon Schama, *The Embarrassment of Riches: An interpretation of Dutch Culture in the Golden Age* (London, 1987), pp. 481–561; Burton, 'Ariès'.

11 Schama, *Embarrassment*, p. 483.

12 Karin Calvert, 'Children in American Family Portraiture, 1670 to 1810', *William and Mary Quarterly* XXXIX (1982), 87–113.

13 George Boas, *The Cult of Childhood* (London, 1966); Anne Higonnet, *Pictures of Innocence: The history and crisis of ideal childhood* (London, 1998).

14 Patricia Ebrey, *The Inner Quarters: Marriage and the Lives of Chinese Women in the Sung Period* (Berkeley, 1993), pp. 21–2; Richard Lane, *Masters of the Japanese Print* (London, 1962), pp. 237–40.

15 Donald J. Olsen, *The City as a Work of Art* (New Haven, 1986), pp. 246–7.

16 Ahsan Jan Qaisar, *Building Construction in Mughal India: The Evidence from Painting* (Delhi, 1988); Sarah Graham-Brown, *Palestinians and their Society, 1880–1946: A Photographic Essay* (London, 1980), pp. 49, 52, 132.

17 Michael Camille, *Mirror in Parchment: The Luttrell Psalter and the Making of Medieval England* (London, 1998), p. 196.

18 Elizabeth A. Honig, 'The Space of Gender in Seventeenth-Century Dutch Painting', in Wayne Franits, ed., *Looking at Seventeenth-Century Dutch Art: Realism Reconsidered* (Cambridge, 1997), pp. 187–201; Gaetano Zompini, *Le Arti che vanno per via nella città di Venezia* (1785: reprinted Milan, 1980); Shijian Huang and William Sargent, eds, *Customs and Conditions of Chinese City Streets* (Shanghai, 1999).

19 Mark Golden, *Children and Childhood in Classical Athens* (Baltimore, 1990), pp. 73–4.

20 Lesley Smith, 'Scriba, Femina: Medieval Depictions of Women Writing', in

Lesley Smith and Jane H. M. Taylor, eds, *Women and the Book: Assessing the Visual Evidence* (London, 1996), pp. 21–44; cf. Mary Kelley, 'Reading Women/Women Reading: The Making of Learned Women in Antebellum America', *Journal of American History* LXXXIII (1996), pp. 401–24.

21 Erich Schön, *Die Verlust der Sinnlichkeit oder die Verwandlungen des Lesers*, (Stuttgart, 1987).

22 Helen Langdon, 'Genre', *Dictionary of Art* XII (London, 1996), pp. 286–98.

23 Timothy J. Clark, *The Painting of Modern Life: Paris in the Art of Manet and his Followers* (New Haven, 1985); Robert L. Herbert, *Impressionism: Art, Leisure and Parisian Society* (New Haven, 1988).

24 S. J. Gudlaugsson, *De comedianten bij Jan Steen en zijn Tijdgenooten* (The Hague, 1945).

25 Ronald Paulson, *The Art of Hogarth* (London, 1975), 30–40.

26 David G. Troyansky, *Old Age in the Old Regime: Image and Experience in Eighteenth-Century France* (Ithaca, 1989), pp. 27–49.

27 Edgar Newman, 'L'image de la foule dans la révolution de 1830', *Annales Historiques de la Révolution Française* LII (1980), pp. 499–509; Raymond Grew, 'Picturing the People', in Robert I. Rotberg and Theodore K. Rabb, eds, *Art and History: Images and Their Meanings*, (Cambridge, 1988), pp. 203–31, especially pp. 226–31.

28 Camille, *Mirror*, p. 192.

29 Pierre Goubert, *The French Peasantry in the Seventeenth Century* (1982: English trans., Cambridge, 1986), p. 82; Neil MacGregor, 'The Le Nain Brothers and Changes in French Rural Life', *Art History* II (1979), pp. 401–12; cf. Pierre Rosenberg, *Le Nain* (Paris, 1993), and Pierre Deyon, 'Peinture et charité chrétienne', *Annales E. S. C.* XXII (1967), pp. 137–53.

30 Richard R. Brettell and Caroline B. Brettell, *Painters and Peasants in the Nineteenth Century* (Geneva, 1983).

31 Priscilla Roosevelt, *Life on the Russian Country Estate: A Social and Cultural History* (New Haven, 1995), pp. 121, 287.

32 Alan Trachtenberg, *Reading American Photographs: Images as History, Mathew Brady to Walker Evans* (New York, 1989), pp. 251–2.

7 *Stereotypes of Others*

1 Norman Bryson, *Vision and Painting: The Logic of the Gaze* (London, 1983); Peter Mason, 'Portrayal and Betrayal: The Colonial Gaze in Seventeenth-Century Brazil', *Culture and History* VI (1989), pp. 37–62; Stephen Kern, *Eyes of Love: The Gaze in English and French Paintings and Novels, 1804–1900* (London, 1996); Timon Screech, *The Western Scientific Gaze and Popular Imagery in Later Edo Japan* (Cambridge, 1996).

2 Bernard Smith, *European Vision and the South Pacific* (1960: second edn New Haven, 1985), pp. 24–5, 37–8.

3 Rudolf Wittkower, 'Marvels of the East: A Study in the History of Monsters', *Journal of the Warburg and Courtauld Institutes* V (1942), pp. 159–97; John B. Friedman, *The Monstrous Races in Medieval Art and Thought*, (Cambridge, MA, 1981); Debra Hassig, 'The Iconography of Rejection: Jews and Other Monstrous Races', in Colum Hourihane, ed., *Image and Belief*, (Princeton, 1999), pp. 25–37.

4 Hassig, 'Rejection'.

5 William Arens, *The Man-Eating Myth: Anthropology and Anthropophagy* (New York, 1979).

6 Raymond Schwab, *The Oriental Renaissance* (1950: English trans. New York 1984); Edward Said, *Orientalism* (1978: second edn London, 1995).

7 Said, *Orientalism*, pp. 3, 52.

8 Said, *Orientalism*, p. 26; Donald A. Rosenthal, *Orientalism: The Near East in French Painting 1800–80* (Rochester, NY, 1982); John M. MacKenzie, *Orientalism: History, Theory and the Arts* (Manchester, 1995).

9 Compare Alain Grosrichard, *Structure du serail: La fiction du despotisme asiatique dans l'occident classique* (Paris, 1979), and Ruth B. Yeazell, *Harems of the Mind: Passages of Western Art and Literature* (New Haven, 2000).

10 Sarah Graham-Brown, *Images of Women: Photography of the Middle East, 1860–1950* (London, 1988).

11 Smith, *European Vision*, pp. 108–14; Rosenthal, *Orientalism*.

12 Yeazell, *Harems*, pp. 25–8.

13 Teresa Carbone and Patricia Hills, eds, *Eastman Johnson: Painting America* (New York, 1999), 121–7.

14 James Carrier, ed., *Occidentalism* (Oxford, 1995).

15 L. Perry Curtis Jr, *Apes and Angels: The Irishman in Victorian Caricature* (Newton Abbot, 1971).

16 Jane P. Davidson, *David Teniers the Younger* (London, 1980).

17 Joshua Trachtenberg , *The Devil and the Jews: The Medieval Conception of the Jew and its Relation to Modern Antisemitism* (New York, 1943), p. 67; Sander L. Gilman, *The Jew's Body* (New York, 1991); Ruth Mellinkoff, *Outcasts: Signs of Otherness in Northern European Art of the Later Middle Ages* (Berkeley, 1993); Hassig, 'Rejection'.

18 Annie Duprat, 'La dégradation de l'image royale dans la caricature révolutionnaire', in Michel Vovelle, ed., *Images de la Révolution Française* (Paris, 1988), pp. 167–75; C. M. Armstrong, 'Edgar Degas and the Representation of the Female Body', in S. R. Suleiman, ed., *The Female Body in Western Culture* (New York, 1986); Hollis Clayson, *Painted Love: Prostitution in French Art of the Impressionist Era* (New Haven, 1991).

19 Jane P. Davidson, *The Witch in Northern European Art* (London, 1987); cf. Linda C. Hults, 'Baldung and the Witches of Freiburg: The Evidence of Images', *Journal of Inter-Disciplinary History* XVIII (1987–8), pp. 249–76, and Charles Zika, 'Cannibalism and Witchcraft in Early Modern Europe: Reading the Visual Evidence', *History Workshop Journal* XLIV (1997), pp. 77–106.

20 Hassig, 'Rejection', p. 33.

21 Michael Camille, *Mirror in Parchment: The Luttrell Psalter and the Making of Medieval England* (London, 1988), p. 210; Mellinkoff, *Outcasts*, p. 231.

22 Svetlana Alpers, 'Realism as a comic mode: Low-life painting seen through Bredero's eyes', *Simiolus* VIII (1975–6), pp. 115–39; Hessel Miedema, 'Realism and Comic Mode', *Simiolus* IX (1977), pp. 205–19; Margaret Sullivan, *Brueghel's Peasants* (Cambridge, 1994).

23 Peter C. Sutton, *Pieter de Hooch* (Oxford, 1980), p. 42.

24 Richard R. Brettell and Caroline B. Brettell, *Painters and Peasants in the Nineteenth Century* (Geneva, 1983).

25 Sander L. Gilman, *Health and Illness: Images of Difference* (London, 1995).

26 J. R. Ryan, *Picturing Empire* (London, 1997), p. 146.

27 Mellinkoff, *Outcasts*, p. li.

8 *Visual Narratives*

1 William A. Coupe, *The German Illustrated Broadsheet in the Seventeenth Century*

(2 vols, Baden-Baden, 1966).

2 Irma B. Jaffé, *John Trumbull: Patriot-Artist of the American Revolution* (Boston, 1975), p. 89.

3 Alison Kettering, 'Gerard ter Borch's "Beschwörung der Ratifikation des Friedens von Münster" als Historiebild', in Klaus Bussmann and Heinz Schilling, eds, *1648: Krieg und Frieden in Europa*, (Munich, 1998), pp. 605–14.

4 Erwin Panofsky, 'Style and Medium in the Moving Pictures', *Transition* (1937) pp. 121–33; Arnold Hauser, *The Social History of Art* (2 vols, London, 1951), the final chapter on 'the film age'; Otto Pächt, *The Rise of Pictorial Narrative in Twelfth-Century England* (Oxford, 1962).

5 A. H. M. Jones, 'Numismatics and History', *Essays in Roman Coinage presented to Harold Mattingly* (Oxford, 1956), pp. 13–33.

6 Peter Burke, *The Fabrication of Louis XIV* (New Haven, 1992) pp. 4–5.

7 David Kunzle, *The Early Comic Strip* (Berkeley, 1973); James A. Leith, *The Idea of Art as Propaganda in France, 1750–1799* (Toronto, 1965); *idem*, 'Ephemera: Civic Education through Images', in Robert Darnton and Daniel Roche, eds, *Revolution in Print*, (Berkeley and Los Angeles, 1989), pp. 270–89; Timothy J. Clark, *Image of the People: Gustave Courbet and the 1848 Revolution* (London, 1973).

8 Rolf Reichardt, 'Prints: Images of the Bastille', in Darnton and Roche, *Revolution*, pp. 223–51; cf. Hans-Jürgen Lüsebrink and Rolf Reichardt, *Die 'Bastille': Zur Symbolik von Herrschaft und Freiheit* (Frankfurt, 1990).

9 John R. Hale, *Artists and Warfare in the Renaissance* (New Haven, 1990), p. 137; Peter Paret, *Imagined Battles: Reflections of War in European Art* (Chapel Hill, 1997), pp. 5, 22; the quotation from Baudelaire on p. 81.

10 Arnold von Salis, *Antike und Renaissance* (Zürich, 1947), pp. 75–88; Hale, *Artists*, p. 191.

11 Christopher Prendergast, *Napoleon and History Painting* (Oxford, 1997).

12 Matthew P. Lalumia, *Realism and Politics in Victorian Art of the Crimean War*, (Epping, 1984), pp. 22, 35; Paret, *Battles*, p. 41.

13 Bernard Comment, *The Panorama* (1993: English trans. London, 1999).

14 Michael Marrinan, *Painting Politics for Louis Philippe* (New Haven and London, 1988), p. 187.

15 Alan Trachtenberg, *Reading American Photographs: Images as History, Mathew Brady to Walker Evans* (New York, 1989), p. 72.

16 Lalumia, *Realism*, over-emphasizing the place of the Crimean War in this development, pp. 54–5, 69, 107.

17 Charles C. Oman, 'Early Military Pictures', *Archaeological Journal* XCV (1938), pp. 337–54, at p. 347; Olle Cederlöf, 'The Battle Painting as a Historical Source', *Revue Internationale d'Histoire Militaire* XXVI (1967), pp. 119–44.

18 Fritz Saxl, 'A Battle Scene without a Hero', *Journal of the Warburg and Courtauld Institutes* III (1939–40), pp. 70–87; Stephen Crane quoted in C. Walcutt, *American Naturalism* (London, 1956), p. 89.

19 Lalumia, *Realism*, pp. 67, 71.

20 Caroline Brothers, *War and Photography: A Cultural History* (London, 1997), pp. 178–85.

21 Kunzle, *Comic Strip*; Sydney Anglo, 'A Rhetoric of Hate', in Keith Cameron, ed., *Montaigne and his Age* (Exeter, 1981), pp. 1–13.

22 Hendrik J. Horn, *Jan Cornelisz Vermeyen: Painter of Charles V and his Conquest of Tunis* (2 vols, Doornspijk 1989); Burke, *Fabrication* p. 97.

23 Sydney Anglo, ed., *The Great Tournament Roll of Westminster* (Oxford, 1968), especially pp. 75–9; Jean Jacquot, ed., *Fêtes et Céremonies au temps de Charles*

Quint (Paris, 1960).

24 C. H. Gibbs-Smith, 'The Death of Harold', *History Today* (1960), pp. 188–91; cf Suzanne Lewis, *The Rhetoric of Power in the Bayeux Tapestry* (Cambridge, 1999), pp. 127–8; Frank Stenton, 'The Historical Background', in F. Stenton, ed., *The Bayeux Tapestry: A Comprehensive Survey* (London, 1957), pp. 9–24; Pächt, *Narrative,* p. 9.

25 Christoph Strupp, *Johan Huizinga: Geschichtswissenschaft als Kulturgeschichte* (Göttingen, 1999), p. 249.

26 Christopher H. Roads, 'Film as Historical Evidence', *Journal of the Society of Archivists* III (1965–9), pp. 183–91, at p. 187; Anthony Aldgate, *Cinema and History: British Newsreels and the Spanish Civil War* (London, 1979), especially pp. 1–16; Jay Ruby, *Picturing Culture: Explorations of Film and Anthropology* (Chicago, 2000), p. 97.

27 Ruby, *Picturing Culture,* pp. 97–100; William Hughes, 'The Evaluation of Film as Evidence', in Paul Smith, ed., *The Historian and Film* (London, 1976), pp. 49–79; Nicholas Pronay, 'The Newsreels: The Illusion of Actuality', in Smith *Historian and Film,* pp. 95–119; Paret, *Battles,* p. 84.

9 *From Witness to Historian*

1 Peter Paret, *Imagined Battles: Reflections of War in European Art* (Chapel Hill, 1997), p. 65.

2 Paret, *Battles,* p. 85; Bernard Comment, *The Panorama* (1993: English trans. London, 1999), pp. 232–40.

3 Francis Haskell, 'The Manufacture of the Past in Nineteenth-Century Painting', *Past and Present* LIII (1971), pp. 109–20, at pp. 111–2.

4 Edward D. H. Johnson, *Paintings of the British Social Scene from Hogarth to Sickert* (London, 1986), p. 152.

5 H. D. Gower, L. Stanley Jast and W. W. Topley, *The Camera as Historian* (London, 1916).

6 David Herlihy, 'Am I a Camera?', *American Historical Review* XCIII (1988), pp. 1186–92; Robert A. Rosenstone, 'History in Images/History in Words' (1988: reprinted in Rosenstone, *Visions of the Past,* Cambridge, MA, 1995), pp. 19–44; Hayden V. White, 'Historiography and Historiophoty', *American Historical Review* XCIII (1988), pp. 1193–99.

7 Cf. Michael Rogin, '"The Sword Became a Flashing Vision": D. W. Griffith's *The Birth of a Nation*', *Representations* IX (1985), pp. 150–95.

8 Anthony Aldgate, *Cinema and History: British Newsreels and the Spanish Civil War* (London, 1979); John Grenville, 'The Historian as Film-Maker', in Paul Smith, ed., *The Historian and Film* (London, 1976), pp. 132–41.

9 White, 'Historiography'.

10 Herlihy, 'Camera'; Rosenstone, 'History'; White, 'Historiography'; Bertram Wyatt-Brown and Lawrence H. Suid, *Journal of American History* LXXXV (1998), pp. 1174–6 (*Amistad*) and 1185–6 (*Ryan*). On *Amistad,* cf. Natalie Z. Davis, *Slaves on Screen: Film and Historical Vision* (Toronto, 2000), pp. 69–93.

11 John C. Tibbetts, 'Kevin Brownlow's Historical Films', *Historical Journal of Film, Radio and TV* XX (2000), pp. 227–51.

12 David Desser, *The Samurai Films of Akira Kurosawa* (Ann Arbor, 1983); Stephen Prince, *The Warrior's Camera: The Cinema of Akira Kurosawa* (Princeton, 1991), pp. 200–49, especially pp. 202–5.

13 Stephen Bann, 'Historical Narrative and the Cinematic Image', *History & Theory Beiheft* XXVI (1987), pp. 47–67, at p. 67.

14 Siegfried Kracauer, *History: The Last Things before the Last* (New York, 1969).

15 Cf. Peter Brunette, *Roberto Rossellini* (New York, 1987), pp. 281–9; Peter Bondanella, *The Films of Roberto Rossellini* (Cambridge, 1993), pp. 125–37.

16 Natalie Z. Davis,'Who Owns History?' in Anne Ollila, ed., *Historical Perspectives on Memory* (Helsinki, 1999), pp. 19–34, at p. 29; Natalie Z. Davis, *The Return of Martin Guerre* (Cambridge, MA, 1983), p. viii.

17 John J. Michalczyk, *The Italian Political Film-Makers* (London, 1986), pp. 190–9; Davis, *Slaves*, pp. 43–4.

18 Timothy Garton Ash, 'The Life of Death' (1985: reprinted in Timothy Garton Ash, *The Uses of Adversity*: second edn Harmondsworth, 1999), pp. 109–29.

19 Ian C. Jarvie, '*Rashomon*: Is Truth Relative?', in I. C. Jarvie, *Philosophy of the Film* (London, 1987), pp. 295–307; K. G. Heider, 'The Rashomon Effect', *American Anthropologist* XC (1988), pp.75–81; Jay Ruby, *Picturing Culture: Explorations of Film and Anthropology* (Chicago, 2000), pp. 125–9.

10 *Beyond Iconography?*

1 Brendan Cassidy. ed., *Iconography at the Cross-Roads* (Princeton, 1993).

2 Carlo Ginzburg, 'Clues: Roots of an Evidential Paradigm' (1978: reprinted in C. Ginzburg, *Myths, Emblems, Clues* (London, 1990), pp. 96–125.

3 Louis Marin, *Etudes sémiologiques* (Paris, 1971), pp. 36–7.

4 Eddy de Jongh, 'Erotica in vogelperspectief', *Simiolus* III (1968), pp. 22–72.

5 Walter Abell, *The Collective Dream in Art* (Cambridge, MA, 1957).

6 Claude Lévi-Strauss, 'Split Representation in the Art of Asia and America', *Structural Anthropology* (1958: English trans. New York, 1963), pp. 245–68; Roland Barthes, *Mythologies* (1957: English trans. London, 1972), pp. 116, 119; on this image, Steve Baker, 'The Hell of Connotation', *Word and Image* I (1985), pp. 164–75.

7 Meyer Schapiro, 'On Some Problems in the Semiotics of Visual Art', *Semiotica* I (1969), pp. 223–42

8 Barthes, *Mythologies*; Judith Williamson, *Decoding Advertisements: Ideology and Meaning in Advertising* (London, 1978); Peter Burke, *The Fabrication of Louis XIV* (New Haven, 1992), p. 15.

9 Umberto Eco, *La struttura assente: Introduzione alla ricerca semiologica* (Milan, 1968), pp. 174–7.

10 Michel Foucault, *The Order of Things* (1966: English trans. London, 1970), pp. 3–16; cf Svetlana Alpers, 'Interpretation without Representation', *Representations* I (1983), pp. 30–42.

11 Wolfgang Kemp, 'Death at Work: A Case Study on Constitutive Blanks in Nineteenth-Century Painting', *Representations* X (1985), pp. 102–23.

12 Clifford Geertz, *Local Knowledge* (New York, 1983), p. 120.

13 Bernadette Bucher, *Icon and Conquest: A Structural Analysis of the Illustrations of de Bry's Great Voyages* (1977: English trans. Chicago, 1981), pp. xiii–xvi; Claude Lévi-Strauss, *Structural Anthropology* II (1973: English trans. London, 1977), p. 276; Barthes, *Mythologies*, pp.15–25; Clifford Geertz, 'Deep Play', in his *The Interpretation of Cultures* (New York, 1973), pp. 412–53.

14 Peter Wagner, *Reading Iconotexts: From Swift to the French Revolution* (London, 1995).

15 Sydney Anglo, *Spectacle, Pageantry and Early Tudor Policy* (Oxford and London, 1969), p. 81.

11 *The Cultural History of Images*

1 Griselda Pollock, 'What's Wrong with Images of Women?', reprinted in Rozsika Parker and Griselda Pollock, eds, *Framing Feminism* (London, 1977), pp. 132–8; *idem*, *Vision and Difference* (London, 1988); *idem*, 'What difference does feminism make to art history?', in Richard Kendall and Griselda Pollock, eds, *Dealing with Degas* (London, 1992), pp. 22–39; Linda Nochlin, 'Women, Art and Power', in Norman Bryson, Michael Holly and Keith Moxey, eds, *Visual Theory* (Cambridge, 1991), pp. 13–46; *idem*, *Representing Women* (London, 1999).

2 David Freedberg, *The Power of Images* (Chicago, 1989); Michael Fried, *Absorbtion and Theatricality: Painting and Beholder in the Age of Diderot* (Berkeley and Los Angeles, 1980); Wolfgang Kemp, 'Death at Work: A Case Study on Constitutive Blanks in Nineteenth-Century Painting', *Representations* X (1985).

3 Michael Baxandall, *Painting and Experience in Fifteenth-Century Italy* (Oxford, 1972); *idem*, *Lime-wood Sculptors in Renaissance Germany* (New Haven, 1980).

4 John Bargrave, *Pope Alexander VII and the College of Cardinals*, ed. James C. Robertson (London, 1862), pp. 8, 41; cf. Stephen Bann, *Under the Sign: John Bargrave as Collector, Traveler and Witness* (Ann Arbor, 1994), especially pp. 106, 115–6.

5 Gwyn A. Williams, *Goya and the Impossible Revolution* (London, 1976), p. 5; Maurice Agulhon, *Marianne into Battle: Republican Imagery and Symbolism in France, 1789–1880* (1979: English trans. Cambridge, 1981), pp. 38–61.

6 Peter Noble, *The Negro in Films* (London, 1948).

7 Enriqueta Harris, 'Velázquez's Portrait of Prince Baltasar Carlos in the Riding School', *Burlington Magazine* CXVIII (1976), pp. 266–75; John H. Elliott, *The Count-Duke of Olivares* (New Haven, 1986), p. 676; Anita Brookner, *David* (London, 1980), p. 153.

8 David Freedberg, *The Power of Images* (Chicago, 1989), pp. 378–428; Dario Gamboni, *The Destruction of Art: Iconoclasm and Vandalism since the French Revolution* (London, 1997).

9 James E. Young, 'The Counter-Monument: Memory against Itself in Germany Today', in William J. T. Mitchell, ed., *Art and the Public Sphere* (Chicago, 1992), pp. 49–78.

10 Peter Wagner, *Reading Iconotexts: From Swift to the French Revolution* (London, 1995); Maren Stange, *Symbols of Social Life: Social Documentary Photography in America, 1890–1950* (Cambridge, 1989), pp. 44, 117–8; Peter Burke, *The Fabrication of Louis XIV* (New Haven, 1992), pp. 97–8, 102.

11 Bann, *Under the Sign*, p. 122.

12 Peter Paret, *Imagined Battles: Reflections of War in European Art* (Chapel Hill, 1997), p. 14.

13 Cf. Francis Haskell, 'Visual Sources and *The Embarrassment of Riches*', *Past and Present* CXX (1988), 216–26.

14 Robert M. Levine, *Images of History: 19th and Early 20th-Century Latin American Photographs as Documents* (Durham, NC, 1989), pp. 75–146, which discusses problems of method in the form of responses to a questionnaire.

15 Paul Zanker, *Augustus and the Power of Images* (1987: English trans. Ann Arbor, 1988); Michel Vovelle and Gaby Vovelle, *Vision de la mort et de l'au-delà en Provence* (Paris, 1970); Michel Vovelle, ed., *Iconographie et histoire des mentalités* (Aix, 1979).

Select Bibliography

Abell, Walter, *The Collective Dream in Art* (Cambridge, MA, 1957)

Ades, Dawn, *et al.*, eds, *Art and Power* (London, 1996)

Agulhon, Maurice, *Marianne into Battle: Republican Imagery and Symbolism in France, 1789–1880* (1979: English trans. Cambridge, 1981)

Aldgate, Anthony, 'British Newsreels and the Spanish Civil War', *History* LVIII (1976), pp. 60–3

——, *Cinema and History: British Newsreels and the Spanish Civil War* (London, 1979)

Alexandre-Bidon, Danièle, 'Images et objets de faire croire', *Annales Histoire Sciences Sociales* LIII (1998), pp. 1155–90

Alpers, Svetlana, *The Art of Describing: Dutch Art in the Seventeenth Century* (Chicago, 1983)

——, 'Interpretation without Representation', *Representations* I (1983), 30–42

——, 'Realism as a comic mode: Low-life painting seen through Bredero's eyes', *Simiolus* VIII (1975–6), pp. 115–39

Anderson, Patricia, *The Printed Image and the Transformation of Popular Culture, 1790–1860* (Oxford, 1991)

Ariès, Philippe, *Centuries of Childhood* (1960: English trans. London, 1965)

——, *The Hour of Our Death* (1977: English trans. London, 1981)

——, *Un historien de Dimanche* (Paris 1980)

——, *Images of Man and Death* (1983: English trans. Cambridge, MA, 1985)

Armstrong, C. M. 'Edgar Degas and the Representation of the Female Body', in *The Female Body in Western Culture*, ed. S. R. Suleiman (New York, 1986)

Atherton, Herbert M, *Political Prints in the Age of Hogarth: A Study of the Ideographic Representation of Politics* (Oxford, 1974)

Baker, Steve, 'The Hell of Connotation', *Word and Image* I (1985), pp. 164–75

Bann, Stephen, 'Face-to-Face with History', *New Literary History* XXIX (1998), pp. 235–46

——,'Historical Narrative and the Cinematic Image', *History & Theory Beiheft* XXVI (1987), pp. 47–67

Barnouw, Dagmar, *Critical Realism: History, Photography and the Work of Siegfried Kracauer* (Baltimore, 1994)

Barnouw, Eric, *Documentary: A History of the Non-Fiction Film* (New York, 1974)

Barrell, John, *The Dark Side of the Landscape* (Cambridge, 1980)

Barthes, Roland, *Camera Lucida* (1980: English trans. London, 1981)

——, *Image, Music, Text*, ed. Stephen Heath (New York, 1977), pp. 32–51

——, *Mythologies* (1957: English trans. London, 1972)

——, 'The Reality Effect' (1968: English trans. in Barthes, *The Rustle of Language*, Oxford, 1986), pp. 141–8

Baxandall, Michael, *Limewood Sculptors in Renaissance Germany* (New Haven, 1980)

——, *Painting and Experience in Fifteenth-Century Italy* (Oxford, 1972)

Belting, Hans, *Likeness and Presence* (1990: English trans. London, 1994)

Benjamin, Walter, 'The Work of Art in the Age of Mechanical Reproduction' (1936: English trans. in *Illuminations*, London, 1968), pp. 219–44

Berggren, Lars, and Lennart Sjöstedt, *L'ombra dei grandi: Monumenti e politica monumentale a Roma (1870–1895)* (Rome, 1996)

Bermingham, Ann, *Landscape and Ideology: The English Rustic Tradition, 1740–1860* (London, 1986)

Białostocki, Jan, 'The Image of the Defeated Leader in Romantic Art' (1983: reprinted in Białostocki, *The Message of Images*, Vienna, 1988), pp. 219–33

Binski, Paul, *Medieval Death: Ritual and Representation* (London, 1996)

Blunt, Antony, *Poussin* (2 vols, London, 1967)

Boime, Albert, *The Unveiling of the National Icons* (Cambridge, 1994)

Bondanella, Peter, *The Films of Roberto Rossellini* (Cambridge, 1993)

Borchert, James, *Alley Life in Washington: Family, Community, Religion and Folklife in an American City* (Urbana, 1980)

——, 'Historical Photo-Analysis: A Research Method', *Historical Methods* XV (1982), pp. 35–44

Bredekamp, Horst, *Florentiner Fussball: Renaissance der Spiele* (Frankfurt, 1993)

Brettell, Richard R. and Caroline B. Brettell, *Painters and Peasants in the Nineteenth Century* (Geneva, 1983)

Brilliant, Richard, 'The Bayeux Tapestry', *Word and Image* VII (1991), pp. 98–126

——, *Portraiture* (London, 1991)

——, *Visual Narratives: Storytelling in Etruscan and Roman Art* (Ithaca, 1983)

Brothers, Caroline, *War and Photography: A Cultural History* (London, 1997)

Brown, Patricia F., *Venetian Narrative Painting in the Age of Carpaccio* (New Haven, 1988)

Brubaker, Leslie, 'The Sacred Image', in *The Sacred Image. East and West*, ed. Robert Ousterhout and L. Brubaker (Urbana and Chicago, 1995), pp. 1–24

Brunette, Peter, *Roberto Rossellini* (New York, 1987)

Bryson, Norman, *Vision and Painting: The Logic of the Gaze* (London, 1983)

Bucher, Bernadette, *Icon and Conquest: A Structural Analysis of the Illustrations of de Bry's Great Voyages* (1977: English trans. Chicago, 1981)

Burke, Peter, *The Fabrication of Louis XIV* (New Haven, 1992)

Cameron, Averil, 'The Language of Images: The Rise of Icons and Christian Representation', in *The Church and the Arts*, ed. Diana Wood (Oxford, 1992), pp. 1–42

Camille, Michael, *Mirror in Parchment: The Luttrell Psalter and the Making of Medieval England* (London, 1998)

——, 'The *Très Riches Heures*: An Illuminated Manuscript in the Age of Mechanical Reproduction', *Critical Inquiry* XVII (1990–1), pp. 72–107

Carteras, S. P., *Images of Victorian Womanhood in English Art* (London, 1987)

Cassidy, Brendan, ed., *Iconography at the Cross-Roads* (Princeton, 1993)

Cederlöf, Olle, 'The Battle Painting as a Historical Source', *Revue Internationale d'Histoire Militaire* XXVI (1967), pp. 119–44

Christin, Olivier, *Une révolution symbolique: L'iconoclasme huguenot et la reconstruction catholique* (Paris, 1991)

Clark, Timothy J., *The Absolute Bourgeois: Art and Politics in France, 1848–1851* (London, 1973)

——, *Image of the People: Gustave Courbet and the 1848 Revolution* (London, 1973)

——, *The Painting of Modern Life: Paris in the Art of Manet and his Followers* (New Haven, 1985)

Clark, Toby, *Art and Propaganda in the 20th Century: The Political Image in the Age*

of Mass Culture (London, 1977)

Clayson, Hollis, *Painted Love: Prostitution in French Art of the Impressionist Era* (New Haven, 1991)

Collinson, Patrick, *From Iconoclasm to Iconophobia: The Cultural Impact of the Second Reformation* (Reading, 1986)

Comment, Bernard, *The Panorama* (1993: English trans. London, 1999)

Cosgrove, Denis, and Stephen Daniels, eds, *The Iconography of Landscape* (Cambridge, 1988)

Coupe, William A., *The German Illustrated Broadsheet in the Seventeenth Century* (2 vols, Baden-Baden, 1966)

Cousin, Bernard, *Le Miracle et le Quotidien: Les ex-voto provençaux images d'une société* (Aix, 1983)

Curtis, L. Perry jr, *Apes and Angels: The Irishman in Victorian Caricature* (Newton Abbot, 1971)

Davidson, Jane P., *David Teniers the Younger* (London, 1980)

——, *The Witch in Northern European Art* (London, 1987)

Davis, Natalie Z., *Slaves on Screen: Film and Historical Vision* (Toronto, 2000)

Desser, David, *The Samurai Films of Akira Kurosawa* (Ann Arbor, 1983)

Dillenberger, John, *Images and Relics: Theological Perception and Visual Images in Sixteenth-Century Europe* (New York, 1999)

Dowd, D. L., *Pageant-Master of the Republic: Jacques-Louis David and the French Revolution* (Lincoln, NE, 1948)

Duffy, Eamon, *The Stripping of the Altars* (New Haven, 1992)

Durantini, Mary Frances, *The Child in Seventeenth-Century Dutch Painting* (Ann Arbor, 1983)

Eco, Umberto, *La struttura assente: Introduzione alla ricerca semiologica* (Milan, 1968)

Edgerton, Samuel Y., *Pictures and Punishment: Art and Criminal Prosecution during the Florentine Renaissance* (Ithaca, 1985)

Elsner, Jas, *Art and the Roman Viewer* (Cambridge, 1995)

——, *Imperial Rome and Christian Triumph: The Art of the Roman Empire, AD 100–450* (Oxford, 1998)

Etlin, R., ed., *Nationalism in the Visual Arts* (London, 1991)

Ferro, Marc, *Cinema and History* (English trans. London, 1988)

Forsyth, Ilene H., 'Children in Early Medieval Art: Ninth through Twelfth Centuries', *Journal of Psychohistory* IV (1976), pp. 31–70

Foucault, Michel, *The Order of Things* (1966: English trans. London, 1970)

Fox, Celina, 'The Development of Social Reportage in English Periodical Illustration during the 1840s and Early 1850s', in *Past and Present* LXXIV (1977), pp. 90–111

Franits, Wayne, ed., *Looking at Seventeenth-Century Dutch Art: Realism Reconsidered* (Cambridge, 1997)

——, *Paragons of Virtue* (Cambridge, 1993)

Freedberg, David, *The Power of Images* (Chicago, 1989)

Fried, Michael, *Absorbtion and Theatricality: Painting and Beholder in the Age of Diderot* (Berkeley and Los Angeles, 1980)

Friedman, John B., *The Monstrous Races in Medieval Art and Thought* (Cambridge, MA, 1981)

Gamboni, Dario, *The Destruction of Art: Iconoclasm and Vandalism since the French Revolution* (London, 1997)

Garton Ash, Timothy, 'The Life of Death' (1985: reprinted in Timothy Garton Ash, *The Uses of Adversity*: second edn Harmondsworth, 1999), pp. 109–29

Gaskell, Ivan, 'Tobacco, Social Deviance and Dutch Art in the Seventeenth
 Century' (1987: reprinted in Franits, 1997), pp. 68–77
——, 'Visual History', in *New Perspectives on Historical Writing*, ed. Peter Burke
 (1991: second edn, Cambridge 2000), pp. 187–217
George, M. Dorothy, *English Political Caricature: A Study of Opinion and
 Propaganda* (2 vols, Oxford, 1959)
Gilman, Sander L., *Health and Illness: Images of Difference* (London, 1995)
——, *The Jew's Body* (New York, 1991)
Ginzburg, Carlo, 'Clues: Roots of an Evidential Paradigm' (1978: reprinted in C.
 Ginzburg, *Myths, Emblems, Clues* [London, 1990]), pp. 96–125
Goffman, Erving, *Gender Advertisements* (London, 1976)
Golomstock, Igor, *Totalitarian Art: In the Soviet Union, the Third Reich, Fascist
 Italy and the People's Republic of China* (London, 1990)
Gombrich, Ernst H., 'Aims and Limits of Iconology', in *Symbolic Images* (London,
 1972), pp. 1–25
——, *The Image and the Eye* (London, 1982)
——, 'Personification', in *Classical Influences on European Culture*, ed. Robert R.
 Bolgar (Cambridge, 1971), pp. 247–57
——, *In Search of Cultural History* (Oxford, 1969)
——, 'The Social History of Art' (1953: reprinted in E. Gombrich, *Meditations on
 a Hobby Horse* [London, 1963]), pp. 86–94
Grabar, André, *Christian Iconography: A Study of its Origins* (Princeton, 1968)
Graham-Brown, Sarah, *Images of Women: Photography of the Middle East,
 1860–1950* (London, 1988)
——, *Palestinians and their Society, 1880–1946: A Photographic Essay* (London, 1980)
Grenville, John, 'The Historian as Film-Maker', in *The Historian and Film*, ed. Paul
 Smith (London, 1976), pp. 132–41
Grew, Raymond, 'Picturing the People', in *Art and History: Images and Their
 Meanings*, eds Robert I. Rotberg and Theodore K. Rabb (Cambridge, 1988), pp.
 203–31
Gruzinski, Serge, *La guerre des images* (Paris, 1990)
Gudlaugsson, S. J., *De comedianten bij Jan Steen en zijn Tijdgenooten* (The Hague,
 1945)
Hale, John R., *Artists and Warfare in the Renaissance* (New Haven, 1990)
Harley, J. B., 'Deconstructing the Map' (1989: reprinted in *Writing Worlds*, ed. T. J.
 Barnes and James Duncan [London, 1992]), pp. 231–47
Harris, Enriqueta, 'Velázquez's Portrait of Prince Baltasar Carlos in the Riding
 School', *Burlington Magazine* CXVIII (1976), pp. 266–75
Haskell, Francis, *History and its Images* (New Haven, 1993)
——, 'The Manufacture of the Past in Nineteenth-Century Painting', *Past and
 Present* LIII (1971), pp. 109–20
Hassig, Debra, 'The Iconography of Rejection: Jews and Other Monstrous Races',
 in *Image and Belief*, ed. Colum Hourihane (Princeton, 1999), pp. 25–37
Hauser, Arnold, *The Social History of Art* (2 vols, London, 1951)
Held, Jutta, *Monument und Volk: Vorrevolutionäre Wahrnehmung in Bildern des
 ausgehenden Ancien Regime* (Cologne and Vienna, 1990)
Herbert, Robert L., *Impressionism: Art, Leisure and Parisian Society* (New Haven,
 1988)
Herding, Klaus, and Rolf Reichardt, eds, *Die Bildpublizistik der Französischen
 Revolution* (Frankfurt, 1989)
Herlihy, David, 'Am I a Camera?', *American Historical Review* XCIII (1988), pp.
 1186–92

Higonnet, Anne, *Berthe Morisot's Images of Women* (Cambridge, MA, 1992)

——, *Pictures of Innocence: The history and crisis of ideal childhood* (London, 1998)

Hirsch, Julia, *Family Photographs: Content, Meaning and Effect* (New York, 1981)

Holliday, Peter J., ed., *Narrative and Event in Ancient Art* (Cambridge, 1993)

Honig, Elizabeth A., 'The Space of Gender in Seventeenth-Century Dutch Painting', in Franits, pp. 187–201

Honour, Hugh, *The First Golden Land: European Images of America* (London, 1975)

Hope, Charles, 'Artists, Patrons and Advisers in the Italian Renaissance', in *Patronage in the Renaissance*, ed. Guy F. Lytle and Stephen Orgel (Princeton, 1981), pp. 293–343

Horn, Hendrik J., *Jan Cornelisz Vermeyen: Painter of Charles V and his Conquest of Tunis*, (2 vols, Doornspijk, 1989)

Hughes, Diane O., 'Representing the Family', in *Art and History*, eds Robert I. Rotberg and Theodore K. Rabb, (Cambridge, 1988), pp. 7–38

Hughes, William, 'The Evaluation of Film as Evidence', in *The Historian and Film*, ed. Paul Smith (London, 1976), pp. 49–79

Huizinga, Johan, *The Autumn of the Middle Ages* (1919: English trans. Chicago, 1996)

Hults, Linda C., 'Baldung and the Witches of Freiburg: The Evidence of Images', *Journal of Inter-Disciplinary History* XVIII (1987–8), pp. 249–76

Hurley, F. J., *Portrait of a Decade: Roy Stryker and the Development of Documentary Photography* (London, 1972)

Ivins, William H., Jr, *Prints and Visual Communication* (Cambridge, MA, 1953)

Jaffé, Irma B., *John Trumbull: Patriot-Artist of the American Revolution* (Boston, 1975)

Jarvie, Ian C., Seeing through Movies', *Philosophy of Social Science* VIII (1978)

Johns, Elizabeth, *American Genre Painting* (New Haven, 1991)

——, 'The Farmer in the Works of William Sidney Mount', in *Art and History*, eds Robert I. Rotberg and Theodore K. Rabb (Cambridge, 1988), pp. 257–82

Johnson, Edward D. H., *Paintings of the British Social Scene from Hogarth to Sickert* (London, 1986)

Jongh, Eddy de, 'Erotica in Vogelperspectief', *Simiolus* III (1968), pp. 22–72

——, 'The Iconological Approach to Seventeenth-Century Dutch Painting', in *The Golden Age of Dutch Painting in Historical Perspective*, ed. Franz Grijzenhout and Henk van Veen (1992: English trans. Cambridge, 1999), pp. 200–23

——, 'Realism and Seeming Realism in Seventeenth-Century Dutch Painting' (1971: English trans. in Franits), pp. 21–56

Jouve, Michel, 'Naissance de la caricature politique moderne en Angleterre (1760–1800)', in *Le journalisme d'ancien régime*, ed. Pierre Rétat (Paris, 1981), pp. 167–82

Kemp, Wolfgang, 'Death at Work: A Case Study on Constitutive Blanks in Nineteenth-Century Painting', *Representations* X (1985), pp. 102–23

Kern, Stephen, *Eyes of Love: The Gaze in English and French Paintings and Novels, 1804–1900* (London, 1996)

Kestner, Joseph, *Masculinities in Victorian Painting* (Aldershot, 1995)

Kinmonth, Claudia, 'Irish Vernacular Furniture: Inventories and Illustrations in Interdisciplinary Methodology', *Regional Furniture* X (1996), pp. 1–26

Klein, Robert, 'Considérations sur les fondements de l'iconographie' (1963: reprinted in *La Forme et l'intelligible*, Paris 1970), pp. 353–74

Kracauer, Siegfried, 'History of the German Film' (1942: reprinted in his *Briefwechsel*, ed. V. Breidecker, Berlin 1996), pp. 15–18

——, *History: The Last Things before the Last* (New York, 1969)

Kunzle, David, *The Early Comic Strip* (Berkeley, CA, 1973)

Kuretsky, Susan D., *The Paintings of Jacob Ochtervelt* (Oxford, 1979)

Lalumia, Matthew P., *Realism and Politics in Victorian Art of the Crimean War* (Epping, 1984)

Landau, David and Peter Parshall, *The Renaissance Print 1470–1550* (New Haven, 1994)

Lane, Richard, *Masters of the Japanese Print* (London, 1962)

Lawrence, Cynthia, *Gerrit Berckheyde* (Doornspijk, 1991)

Leith, James A., 'Ephemera: Civic Education through Images', in *Revolution in Print*, ed. Robert Darnton and Daniel Roche (Berkeley and Los Angeles, 1989), pp. 270–89

——, *The Idea of Art as Propaganda in France, 1750–1799* (Toronto, 1965)

Levine, Robert M., *Images of History: 19th and Early 20th Century Latin American Photographs as Documents* (Durham, NC, 1989)

Lévi-Strauss, Claude, 'Split Representation in the Art of Asia and America', in *Structural Anthropology* (1958: English trans. New York, 1963), pp. 245–68

Lewis, Suzanne, *Reading Images: Narrative discourse and reception in the 13thc illuminated Apocalypse* (Cambridge, 1995)

——, *The Rhetoric of Power in the Bayeux Tapestry* (Cambridge, 1999)

Link, Luther, *The Devil: A Mask without a Face* (London, 1995)

Lüsebrink, Hans-Jürgen, and Rolf Reichardt, *Die 'Bastille': Zur Symbolik von Herrschaft und Freiheit* (Frankfurt, 1990)

MacKenzie, John M., *Orientalism: History, Theory and the Arts* (Manchester, 1995)

Mâle, Emile, *L'art religieux de la fin du Moyen Age en France* (Paris, 1908)

——, *L'art religieux de la fin du seizième siècle: Etude sur l'iconographie après le concile de Trente* (Paris, 1932)

——, *The Gothic Image: Religious Art in France of the Thirteenth Century* (1902: English trans. New York, 1913)

Marin, Louis, *Etudes sémiologiques* (Paris, 1971)

Marrinan, Michael, *Painting Politics for Louis Philippe* (New Haven and London, 1988)

Mason, Peter, 'Portrayal and Betrayal: The Colonial Gaze in Seventeenth-Century Brazil', *Culture and History* VI (1989), pp. 37–62

Matless, David, *Landscape and Englishness* (London, 1998)

Meiss, Millard, *Painting in Florence and Siena after the Black Death* (Princeton, 1951)

Mellinkoff, Ruth, *Outcasts: Signs of Otherness in Northern European Art of the Later Middle Ages* (Berkeley, 1993)

Merback, Mitchell B., *The Thief, the Cross and the Wheel: Pain and the Spectacle of Punishment in Medieval and Renaissance Europe* (London, 1999)

Michalczyk, John J., *The Italian Political Film-Makers* (London, 1986)

Miles, Margaret R., *Image as Insight* (Boston, 1985)

Mitchell, William J. T., *Iconology* (Chicago, 1986)

——, ed., *Landscape and Power* (Chicago, 1994)

Mitter, Partha, *Much Maligned Monsters: History of European Reactions to Indian Art* (Oxford, 1977)

Monaco, James, *How to Read a Film* (New York, 1977)

Newman, Edgar, 'L'image de foule dans la révolution de 1830', *Annales Historiques de la Révolution Française* LII (1980), pp. 499–509

Nochlin, Linda, *Representing Women* (London, 1999)

——, 'Women, Art and Power', in *Visual Theory*, ed. Norman Bryson, Michael Holly and Keith Moxey (Cambridge, 1991), pp. 13–46

Novak, Barbara, *Nature and Culture: American Landscape and Painting 1825–1875* (1980, revised edn New York 1995)

Pächt, Otto, *The Rise of Pictorial Narrative in Twelfth-Century England* (Oxford, 1962)

Panofsky, Erwin, *Early Netherlandish Painting* (2 vols, Cambridge, MA, 1953)

——, *Gothic Architecture and Scholasticism* (1951: reprinted New York)

——, *Studies in Iconology* (New York, 1939)

——, 'Style and Medium in the Moving Pictures', *Transition* (1937) pp. 121–33

Paret, Peter, *Art as History: Episodes from 19th-Century Germany* (Princeton, 1988)

——, *Imagined Battles: Reflections of War in European Art* (Chapel Hill, 1997)

Pickering, Frederick P., *Literature and Art in the Middle Ages* (London, 1970)

Pollock, Griselda, *Vision and Difference* (London, 1988)

——, 'What difference does feminism make to art history?', in *Dealing with Degas*, ed. Richard Kendall and Griselda Pollock (London, 1992), pp. 22–39

——, 'What's Wrong with Images of Women?', reprinted in *Framing Feminism*, ed. Rozsika Parker and Griselda Pollock (London, 1977), pp. 132–8

Pomian, Krzysztof, *Collectors and Curiosities* (1987: English trans. Cambridge 1990)

Porter, Roy, 'Seeing the Past', *Past and Present* CXVIII (1988), pp. 186–205

Prendergast, Christopher, *Napoleon and History Painting* (Oxford, 1997)

Prince, Stephen, *The Warrior's Camera: The Cinema of Akira Kurosawa* (Princeton, 1991)

Pronay, Nicholas, 'The Newsreels: The Illusion of Actuality', in *The Historian and Film*, ed. Paul Smith (London, 1976), pp. 95–119

Qaisar, Ahsan Jan, *Building Construction in Mughal India: The Evidence from Painting* (Delhi, 1988)

Rabb, Theodore K. and Jonathan Brown, 'The Evidence of Art: Images and Meaning in History', in Rotberg and Rabb, pp. 1–7

Reichardt, Rolf, 'Prints: Images of the Bastille', in Robert Darnton and Daniel Roche, *Revolution in Print* (Berkeley and Los Angeles, 1989), pp. 223–51

Ringbom, Sixten, *From Icon to Narrative* (Åbo, 1965)

Roads, Christopher H., 'Film as Historical Evidence', *Journal of the Society of Archivists* III (1965–9), pp. 183–91

Rochfort, Desmond, *The Murals of Diego Rivera* (London, 1987)

Rogin, Michael, '"The Sword Became a Flashing Vision": D. W. Griffith's *The Birth of a Nation*', *Representations* IX (1985), pp. 150–95

Rosenberg, Pierre, *Le Nain* (Paris, 1993)

Rosenstone, Robert A., *Visions of the Past* (Cambridge MA, 1995)

Rosenthal, Donald A., *Orientalism: The Near East in French Painting 1800–80* (Rochester, NY, 1982)

Rotberg, Robert I., and Theodore K. Rabb, eds, *Art and History: Images and their Meanings* (Cambridge, 1988)

Ruby, Jay, *Picturing Culture: Explorations of Film and Anthropology* (Chicago, 2000)

Ryan, J. R., *Picturing Empire* (London, 1997)

Said, Edward, *Orientalism*, (1978: second edn London, 1995)

Samuel, Raphael, 'The Eye of History', in his *Theatres of Memory*, vol. 1 (London, 1994), pp. 315–36

Saxl, Fritz, 'A Battle Scene without a Hero', *Journal of the Warburg and Courtauld Institutes* III (1939–40), pp. 70–87

Schama, Simon 'The Domestication of Majesty: Royal Family Portraiture, 1500–1850', in Rotberg and Rabb, pp. 155–84

——, *The Embarrassment of Riches: An Interpretation of Dutch Culture in the Golden Age* (London, 1987)

——, *Landscape and Memory* (London, 1995)

Schapiro, Meyer, 'On Some Problems in the Semiotics of Visual Art', *Semiotica* I (1969), pp. 223–42

Schön, Erich, *Die Verlust der Sinnlichkeit oder die Verwandlungen des Lesers* (Stuttgart, 1987)

Schulz, Jürgen, 'Jacopo Barbari's View of Venice: Map Making, City Views and Moralized Geography', *Art Bulletin* LX (1978), pp. 425–74

Schwartz, Gary, and Marten J. Bok, *Pieter Saenredam: The Painter and his Time* (1989: English trans. Maarssen, 1990)

Screech, Timon, *The Western Scientific Gaze and Popular Imagery in Later Edo Japan* (Cambridge, 1996)

Scribner, Robert W., *For the Sake of Simple Folk* (1981: second edn Oxford, 1995)

Seidel, Linda, *Jan van Eyck's Arnolfini Portrait: Stories of an Icon* (Cambridge, 1993)

Seta, Cesare de', ed., *Città d'Europa: Iconografia e vedutismo dal xv al xviii secolo* (Naples, 1996)

Shawe-Taylor, Desmond, *The Georgians: Eighteenth-Century Portraiture and Society* (London, 1990)

Skinner, Quentin, 'Ambrogio Lorenzetti: The Artist as Political Philosopher', *Proceedings of the British Academy* LXXII (1986), pp. 1–56

Smith, Bernard, *European Vision and the South Pacific* (1960: second edn New Haven, 1985)

Smith, David, 'Courtesy and its Discontents', *Oud-Holland* C (1986), pp. 2–34

Smith, Lesley, 'Scriba, Femina: Medieval Depictions of Women Writing', in Lesley Smith and Jane H. M. Taylor, eds, *Women and the Book: Assessing the Visual Evidence* (London, 1996), pp. 21–44

Sprigath, Gabriel, 'Sur le vandalisme révolutionnaire (1792–94)', *Annales Historiques de la Révolution Française* LII (1980), pp. 510–35

Stange, Maren, *Symbols of Social Life: Social Documentary Photography in America, 1890–1950* (Cambridge, 1989)

Sullivan, Margaret, *Brueghel's Peasants* (Cambridge, 1994)

Sutton, Peter C., *Pieter de Hooch* (Oxford, 1980)

Tagg, John, *The Burden of Representation: Essays on Photographies and Histories* (Amherst, 1988)

Taylor, R., *Film Propaganda* (London, 1979)

Thomas, Keith, *Man and the Natural World* (London, 1983)

Thomas, Nicholas, *Possessions: Indigenous Art and Colonial Culture* (London, 1999)

Thompson, Paul, and Gina Harkell, *The Edwardians in Photographs* (London, 1979)

Thornton, Dora, *The Scholar in his Study* (New Haven, 1998)

Thornton, Peter, *The Italian Renaissance Interior* (London, 1991)

——, *Seventeenth-Century Interior Decoration in England, France and Holland* (New Haven, 1978)

Trachtenberg, Alan, *Reading American Photographs: Images as History, Mathew Brady to Walker Evans* (New York, 1989)

Trachtenberg, Joshua, *The Devil and the Jews: The Medieval Conception of the Jew and its Relation to Modern Antisemitism* (New York, 1943)

Trachtenberg, Marvin, *The Statue of Liberty* (1974: reprinted Harmondsworth, 1977)

Trexler, Richard, 'Florentine Religious Experience: The Sacred Image', *Studies in the Renaissance* XIX (1972), pp. 7–41

Vecchi, Alberto, *Il culto delle immagini nelle stampe popolari* (Florence, 1968)

Vovelle, Gaby, and Michel Vovelle, *Vision de la mort et de l'au-delà en Provence*

(Paris, 1970)

Vovelle, Michel, ed., *Iconographie et histoire des mentalités* (Aix, 1979)

——, ed., *Images de la Révolution Française* (Paris, 1988)

Wagner, Peter, *Reading Iconotexts: From Swift to the French Revolution* (London, 1995)

Warburg, Aby, *The Renewal of Pagan Antiquity* (1932: English trans. Los Angeles, 1999)

Warnke, Martin, *Political Landscape: The Art History of Nature* (1992: English trans. London, 1994)

Welch, David, *Propaganda and the German Cinema, 1933–1945* (Oxford, 1983)

White, Hayden, 'Historiography and Historiophoty', *American Historical Review* XCIII (1988), pp. 1193–99

Williamson, Judith, *Decoding Advertisements: Ideology and Meaning in Advertising* (London, 1978)

Wind, Edgar, *Pagan Mysteries in the Renaissance* (1958: second edn Oxford, 1980)

Wirth, Jean, *L'image médiévale: Naissance et développement* (Paris, 1989)

Yarrington, Alison, *The Commemoration of the Hero, 1800–1864: Monuments to the British Victors of the Napoleonic Wars* (New York, 1988)

Yates, Frances A., *Astraea: The Imperial Theme in the Sixteenth Century* (London, 1975)

Yeazell, Ruth B., *Harems of the Mind: Passages of Western Art and Literature* (New Haven, 2000)

Zanker, Paul, *Augustus and the Power of Images* (1987: English trans. Ann Arbor, 1988)

Zeman, Zbynek, *Selling the War: Art and Propaganda in World War II* (London, 1978)

Zika, Charles, 'Cannibalism and Witchcraft in Early Modern Europe: Reading the Visual Evidence', *History Workshop Journal* XLIV (1997), pp. 77–106

Zimmer, Heinrich, *Myths and Symbols in Indian Art and Civilisation* (1946: second edn New York, 1962)

Photographic Acknowledgements

The author and publishers wish to express their thanks to the following sources of illustrative material and/or permission to reproduce it (excluding sources credited in full in the captions):

Auckland Art Gallery Toi o Tamaki (presented by the Rutland Group): 13; Bibliothèque Nationale de France, Paris: 9 (Cabinet d'Estampes), 29, 33, 34, 76 (Cabinet d'Estampes, Collection de Vinck); Bildarchiv Marburg: 15; Gérard Blot: 61; photo by permission of the British Library, London: 19; photo © The British Museum (Department of Prints and Drawings): 3, 60; Cambridge University Library: 64; photo © Fitzwilliam Museum, University of Cambridge: 11; photo © The British Museum (Department of Prints and Drawings): 3, 60; by permission of the Syndics of Cambridge University Library: 64; Fogg Art Museum, Cambridge, MA (bequest of Grenville L. Winthrop): 65; Goethe-Nationalmuseum, Weimar (Nationale Forschungs- und Gedenkstätten der klassischen deutschen Litteratur): 50; Library of Congress, Washington, DC, Prints and Photographs Division (US Farm Security Administration Collection): 63; National Gallery of Art, Washington, DC (Samuel H. Kress Collection): 27 (photo © 2001 Board of Trustees, National Gallery of Art, Washington, DC); National Gallery, London: 52 (presented by Lord Duveen through the NACF), 75 (Presented by Sir Richard Wallace); New York Public Library: 5; Nordiska Museets bildbyrå: 46; Philadelphia Museum of Art (John G. Johnson Collection): 67; photo © Photothèque des Musées de la Ville de Paris/Habouzit: 8; RMN, Paris: 1, 61; Royal Archives, Photograph Collection, Windsor Castle: 74 (photo, The Royal Archives © Her Majesty Queen Elizabeth II); Statens Konstmuseer/© Nationalmuseum, Stockholm: 57; Stiftung Weimarer Klassik: 50; Tate Britain, London (Agnes Ann Best bequest): 51 (© Tate, London 2000); University of Pennsylvania Library, Philadelphia, PA (Edgar Fahs Smith Collection: Smith Folio 542.1 G363): 41; Utrecht University Library (Ms. 842): 40; V&A Picture Library/© The Board of Trustees of the Victoria & Albert Museum: 39, 55; photo courtesy of the Warburg Institute, London: 18.

Index

absences 45, 94, 174–5
Ackermann, Rudolf (1764–1834),
 German engraver 84
advertisements 94–7, 107, 173–4
aerial photography 25
Aldgate, Anthony, British historian 160
Alpers, Svetlana, American art historian
 84
Antal, Frederick (1887–1954),
 Hungarian art historian 178
anti-heroic style 79, 149–50
Ariès, Philippe (1914–1984), French
 historian 12, 104–7, 114
Asch, Timothy, American film director
 167
Ast, Friedrich (1778–1841), German
 classical scholar 36
Augustus (ruled 27 BC–AD 14), Roman
 emperor 65–7, 75

Bachofen, Johann Jacob (1815–1887),
 Swiss philologist 170
Bakhtin, Mikhail (1895–1975), Russian
 cultural theorist 55
Bann, Stephen (1942–), English critic
 and historian 13, 183–4
Barbari, Jacopo (died c. 1516), Venetian
 artist 31
Bargrave, John (1610–1680), canon of
 Christ Church 180
Barker, Henry Aston (1774–1856),
 British painter 148
Barker, Robert (1739–1806), British
 painter 148
Barthes, Roland (1915–1980), French
 semiotician 22, 35, 169, 172, 176–7,
 179
Bartholdi, Frédéric Auguste
 (1834–1904), French sculptor 62
Baxandall, Michael (1933–), British art
 historian 180

Bayeux Tapestry 10, 91–2, 96, 100,
 153–4
Bellotto, Bernardo (1721–1780),
 Venetian painter 84–5
Belting, Hans, German art historian 57
Benjamin, Walter (1892–1940), German
 critic 17
Berckheyde, Gerrit (1638–1698), Dutch
 painter 85–6
Bernini, Gian Lorenzo (1598–1680),
 Roman sculptor 50, 53, 171
Bertolucci, Bernardo (1940–), Italian
 film director 166–7, 173
Bilac, Olavo (1865–1918), Brazilian
 journalist 140
Bingham, George Caleb (1811–1879),
 American artist 103–4
Boas, Franz (1858–1942), German-
 American anthropologist 155
Bosch, Hieronymus (c. 1450-1516),
 Netherlandish painter 53
Bosse, Abraham (1602–1676), French
 engraver 115-17
Botticelli, Sandro (1445–1510),
 Florentine painter 33, 37, 39
Bourke-White, Margaret (1904-1971),
 American photographer 23, 120
Brady, Mathew (1823–1896), American
 photographer 148
Brahe, Tycho (1456–1601), Danish
 astronomer 82
Braudel, Fernand (1902–1985), French
 historian 81
Brazil 60, 82, 124, 126–8, 188–9
Brownlow, Kevin (1938–), English film
 director 162
Brueghel, Pieter, the Elder
 (c. 1520–1569), Netherlandish
 painter 137–8, 173
Bruno, Giordano (1548–1600), Italian
 heretic 78–9

Buddhism 47, 162
Buñuel, Luis (1900–1983), Spanish film director 171
Burckhardt, Jacob (1818–1897), Swiss cultural historian 11, 33, 41, 186
Burke, Edmund (1729–1797), Irish political thinker 44

Callot, Jacques (c. 1592–1635), artist from Lorraine 50, 150, 152
Camille, Michael, American art historian 17, 109
Canal, Giovanni Antonio ('Canaletto', 1697–1768), Venetian painter 84
cannibals 126–8
Capa, Robert (1913–1954), Hungarian-American photographer 23–4
caricature 79, 122
Carpaccio, Vittore (c. 1465–1525), Venetian painter 14, 84, 92, 97
Carr, Edward H. (1892–1982), British historian 19, 160
Cassirer, Ernst (1874–1975), German philosopher 35
Cavell, Edith (1865–1915), English nurse 76
Ceaușescu, Nicolae (1918–1989), Romanian dictator 74
Cederström, Gustav (1845–1933), Swedish painter 158
Cerquozzi, Michelangelo (1602–1660), Italian painter 142
Certeau, Michel de (1925–1986), French theorist 178
Charles V (ruled 1516–55), emperor, 25, 60, 67–9, 141, 145, 148, 151–3
Chéret, Jules (1836–1932), French designer of posters 94
children 104–7, 114
China 63–4, 93, 108–10, 113, 123, 132
Constable, John (1776–1837), English painter 44
Constantine (ruled AD 312–337), Roman emperor 67
context 178–89
Cranach, Lucas (1472–1553), German artist 55–6, 151, 173
Crane, Stephen (1871–1900), American writer 149
Crivelli, Carlo (c. 1430–1495), Venetian painter 88
crowds 117

Daguerre, Louis (1787–1851), French inventor of the daguerreotype 23
Dalì, Salvador (1904–1989), Spanish painter 41
Dardel, Fritz Ludvig von (1817–1901), Swedish soldier and artist 97–8, 122
Daumier, Honoré (1808–1879), French artist 79, 180
David, Jacques-Louis (1748–1825), French painter 69–70, 73, 140, 160, 182
Davis, Natalie Z. (1929–), American historian 164
Debret, Jean-Baptiste (1768–1848), French artist 82
deconstruction 176–7
Degas, Edgar (1834–1917), French artist 136
Delacroix, Eugène (1798–1863), French painter 15–16, 61–2, 129–31, 180
Delaroche, Paul (1797–1856), French painter 158
Delumeau, Jean (1923–), French historian 54
Deneuve, Catherine (1943–), French actress 95
Depardieu, Gérard (1948–), French actor 164
Derrida, Jacques (1930–), French philosopher 176
Desjardins, Martin (1637–1694), Flemish-French sculptor 69
Desmoulins, Camille (1760–1794), French journalist 79
details, significant 32–3, 52, 62, 81, 93–4, 102, 188–9
documentary style 14, 22, 130, 159
doubling 146, 172
Douglas, David (1898–1982), British historian 10
Doyle, Sir Arthur Conan (1859–1930), British writer 32–3, 81
Drebbel, Cornelis (c. 1572–1633), Dutch inventor 84
Dryden, John (1631–1700), English poet 126
Dürer, Albrecht (1471–1528), German artist 93
Duplessis, Joseph-Siffred (1725–1802), French painter 28

Eco, Umberto (1932–), Italian semiotician and novelist 32, 96, 174

Eisenstein, Sergei (1898–1948), Russian director 161, 180

Elizabeth I (ruled 1558–1601), Queen of England 59

Erlanger, Philippe (1903–), French historian 163

ethnographic style 14, 130

Eugen of Sweden (1865–1947), prince and artist 43

ex-votos 50–51

Eyck, Jan van (c. 1389–1441), Flemish painter 14

eye, innocent 19

eyewitnessing (see documentary, ethonographic styles) 14, 143, 162, 179–80

Falconet, Etienne-Maurice (1716–1791), French sculptor 67

Félibien, André (1619–1695), French art critic 119

Fellini, Federico (1920-1993), Italian director 161

feminism 179

Fenton, Roger (1819–1869), English photographer 148

formula 96, 144, 146–7, 154, 156

Foucault, Michel (1926–1984), French philosopher 34, 174

Fox, Charles James (1749–1806), English politician 76–7

Fox-Talbot, William Henry (1800–1877), English photographer 103–4

Fragonard, Jean-Honoré (1732–1806), French artist 114

Frederick William of Brandenburg (ruled 1640–88), the 'Great Elector' 67

Freedberg, David, British art historian 57, 179

Freud, Sigmund (1856–1939), Austrian psychoanalyst 32, 169–71

Freyre, Gilberto (1900–1987), Brazilian sociologist-historian 11–12

Fried, Michael, American art historian 179

Friel, Brian (1929–), Northern Irish playwright 167

Gainsborough, Thomas (1727–1788), English painter 26

Gama, Vasco da (c. 1469–1525), Portuguese voyager 123

Gardner, Robert, American film director 156

gaze 125–6, 135

Geertz, Clifford (1926–), American anthropologist 175–6

genre 114–16, 159

Gérard, François (1770–1837), French painter 71

Gerasimov, Aleksandr (1881–1963), Russian painter 74

Gerasimov, Sergei (1885–1964), Russian painter 120

Géricault, Théodore (1791–1824), French painter 129

Gérôme, Jean-Léon (1824–1904), French painter 129–30

Gerz, Jochen and Esther, German sculptors 79

Gillray, James (1756–1815), English artist 79

Gilman, Sander, American art historian 139

Gilpin, William (1724–1804), English writer 44

Ginzburg, Carlo (1939–), Italian historian 32, 170

Giorgione (c. 1478–1510), Venetian painter 43

Goethe, Johann Wolfgang von (1749–1832), German writer 101

Goffman, Erving (1922–1982), American sociologist 26

Gombrich, Ernst H. (1909–), Austrian-British art historian 14, 32, 36, 41

Goubert, Pierre (1915–), French historian 118

Goya, Francisco de (1746–1828), Spanish painter 25, 140, 149, 180

Graham-Brown, Sarah, historian of photography 22

Grégoire, Henri (1750–1831), French revolutionary priest 78

Gregory the Great (c. 540–604), pope 35, 46, 48, 54

Grenville, John (1928–), British historian 160

Grien, Hans Baldung (c. 1476–1545),

German artist 136
Griffith, D. W. (1875–1948), American director, 157, 159, 181
Gros, Antoine-Jean (1771–1835), French painter 147
Grosz, Georg (1893–1959), German artist 135–6
Guicciardini, Francesco (1483–1540), Italian historian 147
Guys, Constantin (1802–1892), French artist 15, 130, 148

Hale, John (1923–2000), English historian 146
Hamdi, Osman ('Hamdi Bey', 1842–1910), Ottoman painter 130
Haskell, Francis (1928–2000), British art historian 10, 13, 158, 178
Hauser, Arnold (1892–1978), Hungarian art historian 31–2, 178
Hellqvist, Carl (1851–1890), Swedish painter 158
Herodotus (c. 484–c. 420 BC), Greek historian 124
heroic style 65–8, 73, 148–50, 156
Hersent, Louis (1777–1860), French painter 29, 182
Hill, Christopher (1912–), British historian 162
Hinduism 47, 123
Hine, Lewis (1874–1940), American photographer 21-2
Hitler, Adolf (1889–1945), German dictator 71, 72, 74–5
Hogarth, William (1697–1764), English artist 104–5, 115, 117, 134, 144, 151, 173, 183
Holmes, Sherlock, fictional detective 32, 81
Hooch, Pieter de (1629–1684), Dutch painter 87, 89
Huizinga, Johan (1879–1945), Dutch cultural historian 11, 41, 155
Hunt, William Holman (1827–1910), English painter 157–8

iconoclasm 54–5, 78, 182
iconography 34–45
iconology 34, 36
iconotexts 39, 143, 159, 183
icons, iconostasis 54
idealization 25–6, 117–19, 153, 187

image management 73, 77
Ingres, Jean-Auguste-Dominique (1780–1867), French painter 73, 129–30
intertextuality 97, 104
Ivins, William H., Jr (1881–1961), American curator of prints 17
Izquierdo, Sebastian (1601–1681), Spanish Jesuit 52

Jancsó, Miklós (1921–), Hungarian film director 165–6
Japan 82, 94, 108-9, 123, 132, 162, 167
Jaucourt, Louis (1704–1779), French man of letters 59–60
Jews 135–6
Joan of Arc (c. 1412–1431), French holy woman 52–3
Johnson, Eastman (1824–1906), American painter 14, 131–2
Jongh, Eddy de, Dutch art historian 36, 88, 107

Klee, Paul (1879–1940), Swiss artist 46
Kleiner, Solomon (1703–1761), German artist 108
Kracauer, Siegfried (1889–1966), German film historian and theorist 23, 33, 163, 166
Kurosawa, Akira (1910–1998), Japanese director 162, 167

Lacan, Jacques (1901–1981), French psychoanalyst 125
landscapes 42–5
Lange, Dorothea (1895–1965), American photographer 22, 120
Le Nain brothers (Antoine, Louis and Mathieu, fl. c. 1620–48), French painters 105, 117–19
Lenin, Vladimir Ilych (1870–1924), Russian revolutionary 71–5, 78
Leonardo da Vinci (1452–1519), Tuscan artist 147, 171
Lessing, Gottfried Ephraim (1729–1781), German critic 175
Lévi-Strauss, Claude (1908–), French anthropologist 146, 172, 175–6
Levine, Robert, American historian 12
liberty 61–4, 146
Loggan, David (1634–1692), German engraver 32, 84

Lorrain, Claude (1600–1682), painter from Lorraine 43
Louis XIII (ruled 1610–1643), King of France 67, 152
Louis XIV (ruled 1643–1715), King of France 28–9, 59–60, 67, 69, 73, 78, 145, 147–8, 152, 162–4, 174, 183
Louis XV (ruled 1715–74), King of France 29, 87
Louis XVI (ruled 1774–92), King of France 28–9, 59, 135
Louis XVIII (ruled 1815–24), King of France 71, 182
Louis Philippe (ruled 1830–48), King of France 29, 62, 69, 79, 181
Low, David (1892–1963), English cartoonist 79
Loyola, Ignatius (1491–1556), Spanish saint 52, 54
Luther, Martin (1483–1546), German reformer 55–6, 141

Mâle, Emile (1862–1954), French art historian 35
Manet, Edouard (1832–1883), French painter 115, 136, 140
Manuel, Niklaus (c. 1484–1530), Swiss painter 148
Manzoni, Alessandro (1785–1873), Italian writer 119, 157
Mao Zedong (1893–1976), Chinese dictator 78
maps 17, 31
Marcus Aurelius (ruled AD 161–180), Roman emperor 67–8
Matejko, Jan (1838–1893), Polish painter 158
McCahon, Colin (1919–1987), New Zealand painter 44
medals 144–5, 152, 177
Meissonier, Ernest (1815–1891), French painter 158
Mellinkoff, Ruth, American historian 135, 139
Menzel, Adolph (1815–1905), German painter 158
Merian, Matthäus, the Elder (1593–1650), Swiss engraver 141
Metsu, Gabriel (1629–1669), Dutch painter 105
Millais, John (1829–1896), British painter 108

Millet, Jean-François (1814–1875), French painter 119
misunderstandings 40, 181
Mitchell, William, American critic 12
Monet, Claude (1840–1926), French painter 42–3, 115
monstrous races 126–8
Montagu, Lady Mary Wortley (1689–1762), English traveller 129
Morelli, Giovanni (1816–1891), Italian connoisseur 21, 32–3, 39, 170
Mucha, Alphonse (1860–1939), Czech designer of posters 94–5
Mussolini, Benito (1883–1945), Italian dictator 71, 74

Napoleon Bonaparte (1769–1821), French emperor 69–70, 73, 78, 147–8, 182
Nelson, Horatio (1758–1805), British admiral 76
Nightingale, Florence (1820–1910), English nurse 76
Nikon, Russian patriarch (1605–1681) 53
Nochlin, Linda, American art historian 179
nudity 38–9

Ochtervelt, Jacob (1634–1682), Dutch painter 88, 186
Olier, Jean-Jacques (1608–1657), French religious writer 119
Olivares, Count-Duke of (1587–1645), Spanish statesman 181–2
Ophuls, Marcel (1927–), French film director 155
Orientalism 128–31
Organ, Bryan (1935), British painter 26
O'Sullivan, Timothy (1840–1882), American photographer 24

Panofsky, Erwin (1892–1968), German art historian 34–45, 168–9, 176, 178
panorama 147–8, 158
Paret, Peter, American historian 185
Pasini, Alberto (1826–1899), Italian painter 130–31
peasants 120, 122, 136–8
Penny, Nicholas (1949–), English art historian 77
period eye 180

picturesque 44, 110
Pliny the Elder (AD 23–79), Roman writer 127
point of view 30–31, 121–2
police records 14
Pollock, Griselda (1949–), art historian 179
Pontecorvo, Gillo (1919–), Italian film director 164–5
portraits 25–30
Poussin, Nicolas (1594–1665), French painter 35
printing 16–17, 83
programme, pictorial 36
propaganda 58, 79, 87, 145, 153
Pronay, Nicholas, British historian 160
Propp, Vladimir (1895–1970), Russian folklorist 172–3
psychology, psychonalysis 95, 125, 169–71
Puenzo, Luis (1945–), Argentinian film director 167

Quadros, Jánio (1917–92), president of Brazil 60

Ranke, Leopold von (1795–1886), German historian 23
reading images 35, 143, 177
reading, images of 100–102, 113–14
realism (see also Socialist Realism) 30, 149
reality effect 22
Reformation 55–7
Reitz, Edgar (1932–), German film director 166
Rejlander, Oscar Gustav, Swedish photographer 23
Rembrandt (1606–1669), Dutch painter 76, 114
Renier, Gustaaf (1892–1962), Dutch historian 13
Renoir, Auguste (1841–1919), French painter 115
representations 174
Reynolds, Joshua (1723–1792), English painter 27, 76
Richard II (ruled 1377–1399), King of England 28, 59
Riefenstahl, Leni (1902–), German film director 72
Rigaud, Hyacinthe (1659–1743), French painter 28
Riis, Jacob A. (1849–1914), Danish-American photographer 22
Ripa, Cesare (c. 1555–1622), Italian writer on art 34, 61
Rivera, Diego (1886-1957), Mexican painter 43, 64–5, 135
Rizi, Francisco (1614–1685), Spanish painter 140
Roche, Daniel (1935–), French historian 81
Rossellini, Roberto (1906–1977), Italian film director 157, 162–4
Roubaud, Franz (1856–1928), German painter 158
Ruskin, John (1819–1900), British art critic 25

Saavedra Fajardo, Diego de (1584–1648), Spanish political thinker 61
Saenredam, Pieter (1597–1665), Dutch painter 97–9
Said, Edward (1935–), Palestinian-American critic 128–9, 134
Samuel, Raphael (1934–1996), English social historian 10, 23
Sander, August (1876–1964), German photographer 103–4
satire, pictorial 25, 116–17, 122, 144, 187
Saxl, Fritz (1890–1948), German art historian 35
Schama, Simon (1945–), British historian 12, 105, 107, 187
Schapiro, Meyer, American art historian 172
Schön, Erich, German historian of literature 101
Scorsese, Martin (1942–), American director 161
Scott, Sir Walter (1771–1832), Scottish writer 157, 161
Scribner, Robert (1941–1998), Australian historian 55, 168
semiotics 95–6, 146, 151, 171–7
series of images 46–7, 151–2, 187–8
Serov, Vladimir (1910–1968), Russian painter 71–2
Shurpin, Fyodor (1904–), Russian painter 30, 73
Skinner, Quentin (1940–), English

historian 60
snapshot culture 21
social photography 22
Socialist Realism 64, 120
Song of Roland 123–4
Spielberg, Stephen (1946–), American
 director 161
split representation 146, 172
Stahl, Augusto, Brazilian photographer
 188
Stakhanov, Gregor, Russian miner 76,
 160
Stalin, Joseph (1879–1953), Russian
 dictator 30, 71–2, 73, 74–5, 78, 180
Steen, Jan (1626–1679), Dutch painter
 90, 105
stereotype (*see* formula) 125–39,
structuralism 95–6, 146, 151, 171–7
Stryker, Roy (1882–1975), American
 photographer 23, 103
studies, scholars in 92–4
Swammerdam, Jan (1637–1680), Dutch
 anatomist and entomologist 84

Tasso, Torquato (1544–1595), Italian
 poet 147
Tenniel, John (1820–1914), English
 artist 60, 134–5
Ter Borch, Gerard (1617–1681), Dutch
 painter 143
Teresa of Avila (1515–1582), Spanish
 saint 53
Thomas, Keith (1933–), British
 historian 32
Tibet 124–5
Tischbein, Wilhelm (1751–1829),
 German artist 101
Titian (*c.* 1488–1576), Venetian painter
 26, 37–40, 140
Torii Kiyomasu (1697–1722), Japanese
 artist 110
townscape 84–7, 108
Trachtenberg, Alan, American critic
 122
Trumbull, John (1756–1843), American
 painter 142–3
typicality 102–3, 122

Uccello, Paolo (1397–1475), Florentine
 painter 82

Valentino, Rudolph (1895–1926),
 Italian-American actor 130
Valéry, Paul (1871–1945), French poet
 21
vandalism *see* iconoclasm
van der Meulen, Adam-Frans
 (1632–1690), Flemish war artist 148
Vasari, Giorgio (1511–1574), Tuscan
 artist 147
Velázquez, Don Diego de Silva y
 (1599–1660), Spanish painter 61,
 140, 174, 181–2
Vermeyen, Jan (*c.* 1500–1559), Flemish
 war artist 148, 151–2
Vernet, Horace (1789–1863), French
 painter 147, 148
Vernet, Joseph (1714–1789), French
 artist 11, 86–7, 148
Vigne, Daniel (1942–), French film
 director 164
Visconti, Luchino (1906–1976), Italian
 director 161
Vovelle, Michel (1933–), French
 historian 46–7

Wagner, Peter, art historian 39, 144
Wajda, Andrzej (1926–), Polish film
 director 160, 164
Wallenstein, Albrecht von (1583–1634),
 Bohemian general 141
Warburg, Aby (1866–1929), German
 cultural historian 11, 33, 35, 39–40,
 189
Warburg Institute 35
Warner, Marina (1946–), English writer
 62
Webber, John (1752–1798), English
 draughtsman 130
Wellington, Duke of (1769–1852) 76
West, Benjamin (1738–1820), American
 painter 73, 77
Westmacott, Richard (1775–1856),
 English sculptor 76–7
Whistler, James A. M. (1834–1903),
 American painter 41
White, Hayden (1928–), American critic
 160, 176
White, John (fl. 1584–93), English
 artist 18–19, 81, 130
Widerberg, Bo (1930–1997), Swedish
 director 166
Wilkie, David (1785–1841), Scottish

painter 97, 115, 158–9
Williamson, Judith, 95–6
Wind, Edgar (1900–1971), German art
 historian 35
Witt, Johannes de, Dutch visitor to
 England 90–91
Witte, Emmanuel de (c. 1617–1692),
 Dutch painter 110
women 108–14, 135–6, 179
Wright, Joseph (1734–1797), English
 painter 101–2

Xavier, Francis (1506–1552), Spanish
 saint 123

Zabolotsky, Petr Efimovich (c. 1803–
 1866), Russian painter 120
Zanker, Paul, German ancient historian
 65, 187
Zeitgeist 31, 36, 40
Zhang Zeduan, Chinese artist 108–9
Zompini, Gaetano (1700–1798),
 Venetian artist 110